FUTURE LIBRARIES

DATE DUE

MY3 0'01			
AP2 3 05			

DEMCO 38-296

REPRESENTATIONS BOOKS

Future Libraries

R. Howard Bloch and
Carla Hesse, editors

University of California Press

BERKELEY LOS ANGELES LONDON

The essays in this book, except for "Future Librarians" by Robert Berringer, were originally published as a special issue of *Representations*, Spring 1993, No. 42.

University of California Press
Berkeley and Los Angeles, California

University of California Press, Ltd.
London, England

Library of Congress Cataloging-in-Publication Data

Future libraries / R. Howard Bloch and Carla Hesse, editors.
p. cm. — (Representations books ; 7)
Includes bibliographical references (p.).
ISBN 0-520-08810-7 (alk. paper). — ISBN 0-520-08811-5 (pbk. : alk. paper)
1. Libraries—Automation. 2. Libraries and electronic publishing.
3. Libraries. 4. Bibliothèque de France. I. Bloch, R. Howard.
II. Hesse, Carla Alison. III. Series.
Z678.9.F88 1995
025'.00285'536—dc20 94-29447
 CIP

Printed in the United States of America
9 8 7 6 5 4 3 2 1

The paper used in this publication meets the minimum requirements of American National Standard for Information Sciences—Permanence of Paper for Printed Library Materials, ANSI Z39.48-1984.

Contents

R. HOWARD BLOCH AND CARLA HESSE

Introduction

WE LIVE AT A THRESHOLD moment in the history of libraries and the forms of knowledge they imply—a moment comparable to that of early antiquity when the clay tablets of the pre-Christian era were replaced by papyrus rolls; or when these rolls gave way, in the fourth century A.D., to parchment leaves bound in codex; comparable, finally, to the transformation of the great monastic libraries of the Middle Ages, where manuscripts were chained to desks, into the Renaissance humanist libraries in which the numerous books made available by printing came to be stacked along the walls, configuring the library as we know it. One cannot but see significant links between new technologies of information, the most diverse cultural forms, and the deepest social structures caused by such large transformations in the techniques of both writing and of storing and making writing available. The library, as a place for the definition and the preservation of cultural and scientific memory, has always had as much to do with the construction of the present and future as with the past.

It is for this reason that we have given pride of place in this volume to the Bibliothèque de France—the library project of the decade, the library of the twenty-first century, the "global library." It is for that reason too that the birth of the Bibliothèque de France has not been without controversy. The debate it has provoked in newspapers as well as in the intellectual press on both sides of the Atlantic, and bearing on its architecture as well as its contents and its function, has raised a myriad of questions having to do with the public organization of and access to knowledge at century's end. The "Très Grande Bibliothèque" has become a lightning rod for issues raised by the electronic revolution. Indeed, as the organizers of a conference held at the University of California, Berkeley, on the "Très Grande Bibliothèque and the Future of the Library," we were originally swept into a force field of passions. Not only did almost all involved seek to draw us to one side of a controversy whose stakes were at first only vaguely discernible, but even the editors of *Representations*—to our surprise—debated mightily the few givens which seemed self-evident from the beginning: that something profound is happening within the world of libraries; that most humanists or even social scientists are only dimly aware of it; that such awareness makes both those who use and those who run libraries to some degree anxious; that all arguments in favor or against such a shift have little purchase upon it, given the fact, as Dominique Jamet and Hélène Waysbord make clear in their article on the Bibliothèque de France, that it is already well underway; and, finally, that regardless of one's

own feelings—and God knows we love the atmosphere of the reading room of the Bibliothèque nationale as much as anyone who has ever set foot in Paris's 2e arrondissement—it is better to know what the future holds than to ignore it.

All of which led us to an editorial decision: that *Representations* would not simply re-present the debate over the Bibliothèque de France, but would treat the controversy that the project has elicited as itself a symptom of the passions summoned by the library—as a repository and dispensary of knowledge—in an age in which real power is increasingly associated with information.

This volume of essays is unique not only because of the topic, but also because of the fact that it contains articles that can be considered documents of our time as well as interpretive essays. We have sought to provide a balance between presentations that in some very real sense belong to the history of the present and essays that seek to focus the terms of a debate whose boundaries have not been fully determined. This means that we have invited the participation not only of scholars but of public officials, librarians, library administrators, lawyers, computer specialists, and architects, many of whom are distinguished scholars, but who are also engaged practically in the process of creating the architectural spaces, the classificatory categories, the hardware and the software, the legal framework, and the links to other public institutions of future libraries.

The reader will find here presentations of those involved in conceiving and building the Bibliothèque de France—the president of the project Dominique Jamet, Chief Scientific Consultant Hélène Waysbord, Head Librarian Gérald Grunberg, and Head of Information Sciences Alain Giffard. One will find here the presentations of those shaping radically different library projects—Prosser Gifford, Director of Scholarly Programs at the Library of Congress, who has been enlisted to help recreate the parliamentary libraries of Eastern Europe, and architect Cathy Simon of the new San Francisco Public Library; one will also find here those, who, like Emmanuel Le Roy Ladurie, Administrator of the Bibliothèque Nationale, and Robert Berring, Law Librarian at the University of California, Berkeley, are responsible for and speak to the everyday inner workings of the library world; all of these alongside the speculation of those who have for some time now been thinking about the history and the future of the book, the nature of literary and scientific property, the future shape of libraries, and the shaping effect of libraries on the wider world. It is our intent, then, less to rekindle the ardor of a debate, with which most are by now familiar, than to place its very fury within some significant historical and social perspective, to burrow beneath its terms in order to identify and to contextualize its stakes and motivations.

What, then, are the issues and the passions, the anxieties and the fantasies, the projections and the metaphoric renderings—in short, the imaginary—in and around the future of the library?

Almost all who speculate about future libraries express some version of worry about the future of the book, and more precisely, about the fate of the book as

an object. Geoffrey Nunberg begins his essay "The Places of Books in the Age of Electronic Reproduction" with a review of several worst-case scenarios: Patrice Higonnet's fear that the builders of the Bibliothèque de France secretly plot to convert books into databases and the library into an office building, Raymond Kurzweil's prediction "that the paper book will be obsolescent by the early twenty-first century"—both, Nunberg maintains, fed by older fantasies from the bookless utopia of *Star Trek* to the bookless dystopias of *1984* or Wells's *Time Machine*. So too, Alain Giffard, who is one of the designers of the computer-assisted workstations of the Bibliothèque de France, insists that "libraries and more generally the world of writing itself are the scene of a major technological transformation sometimes characterized imprecisely in terms of the 'electronic book,' the electronic or 'virtual' library, multimedia, etc."

Giffard notes that electronic publications are increasingly popular, that libraries are acquiring more of them, and that computer companies have invested heavily in the hardware that makes possible electronic reading techniques. Giffard, like Nunberg, wonders if we should "take seriously the hypothesis according to which we are witnessing the advent of a completely new medium comparable to the invention of printing," one that menaces the integrity of the hard-cover, hard-copy, paper book, replaced by a less spatially bound free electronic movement between library catalogs, dictionaries, indexes, image banks, various databases, multimedia services, and "this or that section of a particular work," the whole conducted on screen through interactive CDs and video discs. Berring conceives of this moment in terms of "a shift in the paradigm of information."

Yet, if the future of the material book appears increasingly uncertain in the face of new media, its image symbolically hovers in and around the architecture of the future library. Indeed, Berring recounts an amusing tale in which electronic publishers, encountering mistrust of information presented as it appears on a computer screen, repackaged the very same information to give it the look of the printed page. The consumer's suspicion of digital modes of representation was thus dispelled by reformatting it in the comforting shape of the book. Architect Cathy Simon describes her conception of the main hall of the new San Francisco Main Library building as a kinetic "table of contents of a book, in which chapter headings lay out the order or structure of the work to follow and give a sense of the complexity contained within." In this scenario the electronic library is a book come to life, which readers can enter, inhabit, and move about in freely. Anthony Vidler, in contrast, is worried that the embodiment of the form of the book in the very architectural design of the Bibliothèque de France transmits the symbolic message of a book, not come to life, but rather frozen in stone, a closed book, a book which has either already been read or will be without readers. Vidler is disturbed by what he sees as the potential "disappearance of the reader in a post-structuralist world," a concern which vexes many humanists, living like marsupials in a mammal's environment, and which emanates from what is perceived to be

the latent loss of literary culture. In an article titled "Copyright Without Walls?: Speculation on Literary Property in the 'Library of the Future,'" Jane Ginsburg demonstrates just how hard it is to dispense with the hard-cover model of the book in a universe increasingly dominated by digital forms, and just how difficult it is to imagine the laws governing intellectual property in the absence of that concept. The apprehension and caution of many of the authors represented here is captured nicely by Nunberg, who maintains that "the question comes down to, Can there be print culture after print?"

Both Nunberg and Roger Chartier endow the anxiety surrounding the book with a physical, and even a corporeal, dimension. The threatened loss of the book—these "implausible objects of desire" (Nunberg), these volumes that in the electronic revolution will be detached from their texts, that in the future will be less fetishized than digitized—cannot be detached from a fear of loss of bodily integrity. Berring lets us in on "the dirty secret of anyone who works with the collections of books in great research libraries": due to the acid content of most paper, the books are already rotting on the shelves. Even without digitalization, the morbidity of the book is inevitable. Chartier reminds us in his essay that books not physically delimited by covers, texts "emancipated from the form that has conveyed them since the first centuries of the Christian era," signify "the loss of acts and representations of . . . the cosmos, nature, and the human body" as we know them. If the book, bound and bounded, should disappear, what future will there be for that comforting vision of two bonded selves—reader and author— whose intimate communion, fulcrum-like, it sustained?

Nunberg's and Chartier's evocation of the body in relation to the book makes explicit a metaphor that haunts many of the articles contained in the present volume. The electronic book and the electronic library are seen to be permeable in ways that are analogous to the physical permeability of the individual body. The visual display screen on which books will be read in the future is viewed as a threat to the book as a distinct object. The VDS or reader's "interface," as it is delicately phrased by those in the electronic book trade, is the great leveler of discourses. Genres until now considered to be discrete suddenly will mingle indiscreetly on the screen; any text will be able to mate electronically with any other text in what looms as the specter of a great miscegenation of types brought about by digitalization, and whose ultimate fantasy is the evaporation of boundaries, the decomposition of a textual corpus that carries the charge of physical decomposition as well. "A mass-produced book," Nunberg reminds us,

is both bound and bounded in a way that's replicated for all its instances: each copy contains the same text in the same order. But the computational representations of texts can be divided and reassembled in an indefinitely large number of documents, with the final form left to the decision of the individual user. To say that the reader "writes" an electronic text is not simply a conceit of reception theory. This feature of the technology has figured

4　Bloch and Hesse

prominently in the speculations of visionaries, who foresee a day when categories like "literature" and "knowledge" are freed from the trammels of narrativity and decomposed into a set of propositional atoms that readers can reassemble *ad libitem*. Reading what people have had to say about the future of knowledge in an electronic world, you sometimes have the picture of somebody holding all the books in the library by their spines and shaking them until the sentences fall out loose in space.

Electronic reading necessarily evokes images of uncontrollability, of promiscuity even: in the words of Grunberg and Giffard, "the same work can be read simultaneously by as many readers as request it" and "over distances that until now have made circulation by more mechanical means cumbersome or impossible." Jane Ginsburg too reminds us that such a "multiplication of user copies" necessarily takes us beyond the bounds of the current copyright law as well as beyond existing notions of free copying and fair use to a place where even technical definitions governing books as property, definitions with a long past, must suddenly be rethought in ways which, until the advent of the photocopy machine, were taken for granted—and in ways which, in light of the electronic revolution, have become the object of intense legal speculation. Thus, where the future of books and the library is concerned, even the law is in some deep sense out of control.

Those who focus upon the uncontrollable aspects of print culture replicating and mutating wildly via the electronic revolution also seek to reassure us that the endpoint of such an evolution is less chaos than new forms for the dissemination of knowledge that are as yet simply unforeseeable. Despite the currently unsettled nature of copyright law, Ginsburg suggests that a new and presently unimaginable level of empowerment of authors and publishers will be possible once the technological means for such added control are available online. "Today, I will not know if a library user in Berkeley, in Boston, in Bonn, or in Brisbane is photocopying this article," Ginsburg writes. "But tomorrow, when 'we are all connected,' and this article is available world-wide online, I will have the means to know who is reading the article on screen, and who is downloading or printing out excerpts or complete copies. Here, as elsewhere, knowledge is power: I (or my digital publisher) can condition online access to my article on compliance with whatever restrictions I wish to impose."

Several authors emphasize the fact that the electronic archive can be seen as a return to the Enlightenment ideal of encyclopedism. They stress the extent to which the power of the computer fulfills a much older dream of a universal library. Grunberg, Giffard, and Berring all argue convincingly that it is not the electronic library that poses a threat, but rather the proliferation of printed matter that has outstripped the means of conventional libraries to classify, catalog, or provide access to holdings. "The realization of this encyclopedic ideal has become increasingly difficult" due to the fact that industrial printing in the course of the nineteenth century and especially in the twentieth" has outpaced "the traditional economy of libraries. . . . The book is in competition with other means

of communication." All of which are the symptoms of an "end of master narratives" (Marc Augé) characteristic of our own "fin de siècle," which is also "not without its effect upon the disappearance of the notion of a stable canon."

Things have been out of control for a long time, only we haven't realized it until now; and if the potential loss of the book is linked psychologically to the fear of loss of bodily wholeness, self-possession, and control, the builders of the future library remind us of the ways in which technology also enables control over that which we have already lost. The use of medical language is hardly insignificant. "Each document will be assigned a 'medical chart [*fiche santé*],'" Grunberg and Giffard write, "that will be filled out at the time of the regular check-ups of the holdings. . . . The system will channel requests to the various storage areas; it will 'know' the status of each document, not only in the stacks, but also at every stage of transfer. In principle, it should know where a document is to be found at any given moment." It is interesting to note too—and here we touch on an image that runs throughout the following articles—that the issue of control or lack of control is most frequently mediated through the architectural image of the wall that figures so powerfully in the historian Roger Chartier's "Library Without Walls," the librarians of the Bibliothèque de France's "ubiquitous library without walls," the architect Anthony Vidler's focus on transparency, and even the notion in lawyer Jane Ginsburg's essay of legal walls, erected where older ones no longer function:

Several accommodations [to the uncontrollable copying of books] just proposed have this in common: they attempt to respond to the transition to "wall-less" libraries by erecting "walls" wherever possible. . . . That means, for example, that the law imposes a wall between the first, free, digital on-screen copy and the subsequent multiple copies that can be viewed simultaneously. The law retains walls between documents and users by obliging libraries to limit user access to views or short printouts, because access by downloading too easily lends itself to generation of uncontrollable user copies.

Roger Chartier is optimistic about the ways in which technology might further the encyclopedic ideal:

In the universe of remote communications made possible by digital and electronic communications, texts are no longer prisoners of their original physical, material existence. Separated from the objects on which we are used to finding them, texts can be transmitted; there is no longer a necessary connection between where they are conserved and where they are read. The opposition long held to be insurmountable between the closed world of any finite collection, no matter what its size, and the infinite universe of all texts ever written is thus theoretically annihilated: now the catalog of all catalogs ideally listing the totality of written production can correspond to a universal access to texts available for consultation at the reader's location.

The electronic library will thus make it possible for readers to respond to the dizzying boundlessness of knowledge itself. In the face of the apparently endless proliferation and fragmentation of new and ever more specialized forms of knowledge, Chartier, Grunberg, Giffard, and Berring believe that the electronic

library may make it possible to recover the Enlightenment dream of a library that offers not only comprehensive or universal access to knowledge but also the power to move freely within its perimeters. It will become possible for readers to integrate older and newer bodies of knowledge into ever-changing synthetic forms. Newer disciplines within the social and natural sciences, as well as ethnography and law, can at last be brought into active relation with venerable collections in classics, history, and literature. Like the *philosophes* of yore, we can again hope for a science that is more humane and a humanities that is more precise.

Yet for some, this conception of the library as an ever-expanding web of intellectual freeplay is, again, the source of profound anxiety, rooted in the fear of losing a cherished liberal conception of cultural authority: the self-contained individually authored text, whose author can be held accountable to a reading public. The electronic library can be viewed analogously in economic terms as signaling the displacement of a production-centered culture by a consumer-oriented one, with all the cultural conservatism that this might imply. In such a reader-centered scenario the library represents potentially just one more aspect of contemporary consumer culture—a postmodernist shopping mall of knowledge boutiques and endlessly customized products. Robert Berring warns that the future librarian in this scenario will either be left out of a more direct relationship between the producer and consumer of information or will become simply a "retailer of data" rather than a gatherer, guardian, and diffuser of knowledge. Geoffrey Nunberg views such a threat, in fact, as a simply perceived horror of a collective historical regression to the conditions of medieval book production:

Electronic reproduction has more in common with the fourteenth century scriptorium than with the print capitalism that replaced it. In the electronic world, as in the scriptorium, texts are "copied" (that is, transferred, downloaded, displayed, or printed) by individual users when and where they are needed. For this reason it makes no sense to talk about the "printings" or "editions" of an electronic document, all the more so because the master or source file of a text can be changed at any time. As in the scriptorium, the physical properties of the document can vary from one copy to the next: it can be left to the user or the local environment to determine the binding, paper stock, size, and even fonts of the printed volume, or the layout and appearance of a screen representation. Finally, it is the individual user who determines the modularity of the document, that is, the particular chunk of text that it contains.

The aura of anxiety surrounding the library of the future is, of course, intensified by the fact that new technologies for organizing the activity of electronic reading have not yet been fully socialized. The authority with which the electronic archive invests individual readers along with the new possibilities it offers of publication independent of print, such as the electronic bulletin board or the scientific network, signals a return to the culture of the pamphlet, which, as Nunberg observes, "hasn't played an important role in English-language public discourse since the time of Shelley," and, as the vehicle of an uncontrollably powerful

political voice, has never regained the significance it had in pre-Revolutionary France.

The vertiginous possibilities of access to and manipulation of original texts offered by the library of the future implies a loss of both the concept of the author and of originality. In a future dominated by electronic reproduction and transfer of documents, we face the difficulty of distinguishing between what has counted—since the eighteenth-century copyright laws—as an authorized, authentic work and its digitalized, downloaded, displayed, or even mechanically recreated virtual forms. The imagined impossibility of associating the particular work with an individual agency entails a loss of the writer's, and even the reader's, individuality, a disappearance of the Enlightenment sense of self and of a sociability based upon a Rousseauesque model of an intimate intellectual community, and a liberal model of public life rooted in individualism and private property.

As Jane Ginsburg's essay makes vivid, the body of intellectual property law that has offered a stable regulatory framework for this liberal print culture for the past two hundred years is itself in the process of profound reevaluation and reform. The traditional notion of copyright, which is a property right good "against the world" for regulating things, will, she maintains, eventually become assimilable to—displaced by?—the historically fragile law of contract, which governs relationships between people and not things. Indeed,

in the digital environment posited here, contract protection may not be the fragile creature presumed in prior intellectual property preemption decisions. If access to works could be obtained only through the information provider (directly or through an authorized online distributor), and if copying could be electronically tracked or prevented, no "third parties" to the contract exist. When "we're all connected," no functional difference may exist between a "contract" and a "property right."

The potential loss of the object book, the disappearance of the author and reader as coherent imagined selves constituted through the stabilizing form of the bound book, the disordering of authorial agency in favor of an increasingly active reader (or alternatively, the empowerment of the "online" author in control of the uses and distribution of texts), the displacement of a hermeneutical model of reading by one premised on absorption, the transformation of copyright into contract: all point toward the subsuming fear of a loss of community, something expressed in different ways in almost every article contained in the present volume. Robert Berring regrets what he sees as an inevitable loss of the librarian's tradition of service: "There may continue to be library schools, but they will train information workers who will be clerical and who will never hope to aspire to the humanitarian goal of public enlightenment." For Emmanuel Le Roy Ladurie, the library of the future is imagined in terms of the disappearance of the warm, personal, human, village-like environment of the library as it currently exists in the Bibliothèque Nationale. "I enjoyed, and still nostalgically recall," he writes,

"meeting different people in the workplaces and gathering places of the village. I found at the BN an urban version of this same sense of community."

Anthony Vidler sees in the "transparent" library—an epic version of the electronic book—a displacement of the dense urban space of Paris, with its monuments and inhabited streets, by the principle of open space, a triumph of "ineffable" space over buildings and inhabitants, and, ultimately, of architecture over books and reading culture. Both Nunberg and Vidler quite independently hone in upon the famous passage from Victor Hugo's *Notre Dame de Paris* in which a scholar holds up a bound volume before the cathedral and affirms that "this will kill that"—"the book will kill the building, printing will kill architecture." And while Nunberg is somewhat skeptical about the relation of the present moment in the history of the book and of libraries to that determining Hugolian moment, that embryonic avatar of the Enlightenment, Vidler sees the contemporary move toward the transparent library as architecture's revenge against the book. He identifies a series of recent architectural projects with the modernist contempt for the city that menaces a more human, organic dimension of traditional urban experience not terribly different from Le Roy Ladurie's village. What Vidler and Le Roy Ladurie mourn is at once the daily life—whether expressed in terms of a city or a village—and the imagined community that, mediated through printed forms like books as well as the daily newspaper, can assume proportions as large as those of a nation of readers. The loss of print culture associated by some with the global library thus threatens the coherence of the body politic of the nation state, an observation that is not without relevance for Europe after 1992.

Every national situation is, of course, particular; and the potential of libraries for creating communities and nations is nowhere more apparent than in Prosser Gifford's discussion of the reconstitution of libraries in the countries of the former eastern bloc. "The Libraries of Eastern Europe: Information and Democracy" illustrates the importance of libraries in the nuts-and-bolts legislative structuring of the state. And we see that the parliamentary libraries of Eastern Europe have, in the context of what Gifford identifies as a devaluation of empirical data during the Communist era, become the nodal points, the nerve centers often linked to the West, for the drafting of laws, the retrieval of "a depth of historical, demographic, sociological, and economic information," and the communication of parliaments with each other. Gifford's recounting of international collaboration to convert Cold War information networks, such as Radio Free Europe and Voice of America, that were once used for surveillance and propaganda, into bibliographic databases for renascent constitutional states should give pause to technological determinists of both utopian and dystopian stripes.

The French situation too is particular, and, again, the creators of the Bibliothèque de France remind us that the loss of one community entails the creation of another. Rather, the electronic library is the potential site of a commingling of communities—scholarly and popular—which in France, unlike the United States,

have historically lived quite apart. For, as Dominique Jamet and Hélène Waysbord note, the Bibliothèque de France, "as President Mitterrand has defined it, is . . . an entirely new type of library" in that it "will welcome readers from all walks of life," as the new French national library assumes to some extent the acculturative function U.S. libraries have historically exercised. Grunberg and Giffard also emphasize the degree to which France's new library seeks to "reconcile the archival mission of a national library with the democratic ideal of greater access," and they describe the spatial, conceptual, and electronic means toward that goal. Indeed, the distinction between the professional researcher and the amateur reader is no longer conceived in hierarchical terms, but becomes in the library of the future less a question of social distinction than of different reading practices, distinguished temporally rather than spatially, as "long- and short-term researchers," rather than "scholarly and popular" reading publics.

With the global library also comes a widening of the range of materials to be housed in the Bibliothèque de France, which will not only supplement the essentially humanistic holdings of the Bibliothèque Nationale, based upon superb collections in literature and history, with collections in the hard sciences, political science or management, and law, but will integrate print to images and sound—records, CDs, photos, videotapes, and digitalized images. The traditional phono- and phototèque will, moreover, not be relegated to separate divisions but will be accessible at workstations in all the main reading rooms. "Henceforth," Jamet and Waysbord affirm, "research in all disciplines will be based increasingly on the study of audio-visual documents, which, along with books, constitute objects of knowledge and of memory in their own right. Pictures and sounds in their diverse fixed, moving, recorded, and digitalized forms constitute a documentary stratum which will be integrated in the new library across the range of specific departments." Thus, if the electronic book poses the specter of a loss of bodily wholeness, the electronic library holds the promise of restoring a fuller body politic, along with something for all the senses: the intellect of the reader, the eyes of the viewer, the ears of the listener, and the fingertips that touch the keyboards and screens of a multimedia environment. In Jane Ginsburg's phrase, which transmits the yearning for new community, someday we may "all be connected."

What we are witnessing in the remaking of the library at the end of the twentieth century is not so much a technological revolution (which has already occurred) but the public reinvention of intellectual community in its wake. The electronic revolution of the past half century has not so much changed modes of human inquiry as it has rendered opaque some of the most seemingly transparent and fundamental cultural choices faced by modern societies: how we determine—as individuals, communities, and nations, and perhaps a globe—to use these information technologies and toward what ends. By what rules, under what con-

ditions, and in what forms will knowledge circulate and be exchanged in the modern world? These questions have less to do with the technology of the microchip per se than with the forms of knowledge and modes of its exchange that the microchip's purpose and design, both wittingly and unwittingly, make possible. Again, as Jane Ginsburg maintains, it is only when the law ceases to function that it becomes apparent.

Though some of the essays gathered in this issue are programmatic in nature, taken as a whole their intellectual excitement is to be found less in the institutional models that some of them may offer for future communities than in the new languages and modes of imagining that they deploy in their attempts to create and interpret emergent cultural forms. Most striking throughout is the impulse to reconceptualize the library in terms of time, motion, and modes of action, rather than space, objects, and actors. Thus, Vidler powerfully defines Perrault's great rhetorical achievement with the design of the Bibliothèque de France as a despatialization of the library's form, the articulation of an "architecture of the void," a building without walls, a library that is a non-space. Cathy Simon, though speaking in a radically different idiom, also repudiates a rhetoric of space, conceiving of the new San Francisco library instead as exemplifying "an architecture of motion," a "kinetic architecture," comprised, weblike, of nodes, intersections, and passages, rather than a volume delimited by walls. Prosser Gifford's new libraries of Eastern Europe become no more than a series of globally coordinated satellite networks linking far-flung databases that are not really located anywhere at all except in the hands of their users. Jane Ginsburg too speaks to the question of the legal delocalization of knowledge in a library conceived as a conduit between readers and publishers/authors—a library which, at an extreme, is merely a "full-service help-line," an index to other sources of information rather than their container.

As with the rhetoric of the architecture, so too with the rhetorical construction of the knowledge that will no longer lie within, but rather circulate through these non-spatial libraries: the language used to describe the forms of knowledge of the electronic library metaphorically draws our gaze from the spaces delimited by classificatory grids to the lines of the grid themselves, to the trajectories of those boundary lines, and to the relations constituted at their points of intersection. In fact, knowledge is no longer conceived and construed in the language of forms at all ("bodies of knowledge," or a "corpus," bounded and stored), but rather as modes of thought, apprehension, and expression, as techniques and practices. Knowledge is no longer that which is contained in space, but something that passes through it, like a series of vectors, each having direction and duration yet without precise location or limit. In the future there will be, the essays in the present volume seem to suggest, no fixed canons of texts and no fixed epistemological boundaries between disciplines, only paths of inquiry and modes of integration. Librarians, in Robert Berring's eyes, will have a new role as servants

in the transmission of information rather than as keepers of the gate to the once sacred places where knowledge resided.

We can detect a recasting of the notion of the writer and reader within this temporal idiom. Indeed, Giffard and Grunberg redefine the reader in terms of the kind of reading s/he practices. Gone are the social (learned and popular), political (public and private), or economic (fee-paying versus non-fee-paying) categories that once described the constituencies of old spatial libraries. The imagined writer-reader of the future library is recast in terms of a mode of action in time. The crucial distinction in the world of electronic readers will be, as the builders of the library of the future insist, between the long- and the short-term researcher. The long-term researcher at the new Bibliothèque de France will move in an ever-expanding web of vectors. S/he will have a sense of direction, because s/he will be "competent" in the technologies of research, but like an explorer who at once creates and charts a path, will not yet know where s/he is going to end up. Metaphorically, then, to enter this world of cyberspace is to journey out of space, and into the dimension of time.

These essays also offer reassurance that we will not be entirely at a loss in the spaceless, authorless, bookless, and readerless libraries of the future. Indeed, it is at once comforting and intriguing to hear this rhetoric of motion and time refracted through cultural idioms deeply rooted in our past. We have seen the extent to which the project of the global library links up with the encyclopedism of the eighteenth century. Anthony Vidler points out, further, that the continuity of the French tradition is even stronger: the Bibliothèque de France represents both architecturally and conceptually a return to the universalism of the Classic age as well as the Enlightenment, a universalism that has also exuded into republican and, ultimately, Socialist rejection of the "particularisms based in identity politics." Jane Ginsburg too claims that we have, *mutatis mutandi*, "already been there," that we have, in some profound sense, come full circle from the 1710 Statute of Anne, precursor to our copyright law, to the as-yet-untested exercise of a necessary voluntary restraint on the part of publishers, like their eighteenth-century predecessors increasingly capable of controlling the digitalized book market, and thus the price of books.

The library projects discussed in the present volume all offer some version of a return to earlier concepts of the relation between library and state. We can see in Cathy Simon's "architecture of motion" an elegant reprisal of the mission of civic humanism, carried forward from the Italian city-states through the French neo-classical tradition, reworked to serve the needs of another century at the antipodes of the West. We recognize the voice of pragmatic American federalism in Prosser Gifford's description of efforts to convert the weapons of the Cold War into the libraries of constitutional states. And, finally, we admire in the Bibliothèque de France the dream of recovering, through the transcendent rhetoric of time, the ideal of universal equality in the face of proliferating and irreducible difference.

GEOFFREY NUNBERG

The Places of Books in the Age of Electronic Reproduction

The Future of Books

ACCORDING TO PATRICE HIGONNET, an outspoken critic of the new Bibliothèque de France project, its controversial architectural scheme may answer to a secret belief that the building will not have to serve for very long as a library:

> The architects and managers of this devastating project simply think that books are on their way out. They may well believe that what would once have been in print will soon be electronified, microfilmed, and microfiched. In this view there will never be many books in the towers, and if there are and they do decompose, it won't matter because all those pages will soon be on CD-ROMs, on-line periodicals, and computer screens. Such suspicions are given support by some of the early plans for the library, which call for a heavy emphasis on converting books into a data base.[1]

And Higonnet goes on to speculate that the project is designed to "permit cheap conversion of the towers to office space, when books have disappeared into dust."

Now whatever reservations one might have about the program of the library, it is hard to find anything in it that would justify conclusions like these. If the French government were really convinced that books were on their way out, it would make little sense to spend seven billion francs on a new building to house them. But as the saying goes, even paranoids have enemies: Higonnet would not have had to look hard to find enthusiasts of information technologies who do in fact take it for granted that both the book and the physical library are on their last legs. In a recent article in the *Library Journal* called "The End of Books," for example, the artificial intelligence entrepreneur Raymond Kurzweil predicts that the paper book will be obsolescent by the early twenty-first century, "although because of its long history and enormous installed base, it will linger for a couple of decades before reaching antiquity." With the passage of books, he suggests, new uses will have to be found for library buildings (though probably not as offices, which Kurzweil predicts will themselves be made obsolete by high-definition holographic video conferencing).

"The end of books"—the phrase must be irresistible to any writer who wants

to make his name as a visionary. No prediction could be more evocative of the changes that technology will work on culture, or better calculated to contrast the New Man's easy confidence in the face of the future with the timorous anxiety of the old-style humanist, whose vision of the bookless utopia of *Star Trek* is clouded by the specters of the bookless dystopias of *1984* or H. G. Wells's *The Time Machine*.[2] And bibliophiles like Higonnet inevitably rise to the bait, because their fetishism makes them susceptible to the same technological Darwinism the visionaries trade in: once the new artifacts are given a foothold they will move with remorseless logic to displace the old. You think of the passage in *The Hunchback of Notre Dame* where a scholar holds up an early printed book as he looks at the cathedral and says: "Ceci tuera cela." Except that now he's holding an Apple Powerbook, and the building in the background is the Bibliothèque nationale.

There's a temptation to respond to this with a reassuring ecumenism: "Not to worry; in the future we'll have books *and* electronic texts, the old alongside the new," and so on. This isn't wrong, but the propitiatory tone is misleading; it implies that you can introduce new communication technologies without transforming existing cultural forms. Clearly new technologies will have an effect on the book and the institutions that surround it. The trick is to try to consider these changes without slipping into a totalizing determinism, and above all without assuming that what is at stake is just a matter of artifacts. Quantitatively, the enthusiasts are unquestionably right: most books are likely to be replaced by electronic representations in the near future. But books as such—that is, bound and printed documents—are not an interesting category. In modern industrial societies, the vast majority of books bear no cultural burden at all: they are parts catalogs, census reports, Department of Agriculture pamphlets, tide tables, tax codes, repair manuals, telephone directories, airline schedules—documents whose appearance as books rather than in some other form has mostly to do with the practical requirements of display and diffusion and the limits of available technologies. The Travelers Insurance Company produces printed output at a rate of roughly a billion impressions a month, enough to fill all the shelves of the new Bibliothèque de France every six months or so. The printed documentation that accompanies the delivery of a single Boeing 747 weighs about 350 tons, only slightly less than the airplane itself. Who would have any reservations about putting texts like these into electronic form, if it will make the world a roomier and greener place?

But of course when people talk about the future of the book they have something else in mind: works of literature, belles lettres, scholarship, and criticism, as well as the sorts of journalism, reportage, and general informative writing that the Germans call *Sachprosa*. These are the works that constitute the "patrimony" that an institution like the Bibliothèque de France is charged with conserving, the works that carry on a line of public discourse. Understood in this way, concerns about the future of the book are something more than reflexes of the nostalgia

we feel for threatened artifacts like the steam locomotive or the pinball machine. "The book" here stands in a metonymy for all of the material circumstances of print culture—not just the artifacts it is inscribed in, but the forms and institutions that have shaped its use. In this broader sense, the question becomes, Can there be print culture after print?

The visionaries' answer is generally No, and a good thing, too. The coming replacement of the book by the computer will lead to an efflorescence of new discursive genres that are more versatile, more expressive, and more democratic than traditional print forms. For example, here is the classicist Jay David Bolter, an articulate enthusiast of the new technology:

The printed book . . . seems destined to move to the margin of our literate culture. The issue is not whether print technology will completely disappear; books may long continue to be printed for certain kinds of texts and for luxury consumption. But the idea and the ideal of the book will change: print will no longer define the organization and presentation of knowledge, as it has for the past five centuries. The shift from print to the computer does not mean the end of literacy. What will be lost is not literacy itself, but the literacy of print, for electronic technology offers us a new kind of book and new ways to write and read. . . . The computer is restructuring our current economy of writing. It is changing the cultural status of writing as well as the method of producing books. It is changing the relationship of the author to the text and of both author and text to the reader.[3]

I expect that most people who have worked with information technologies will share this enthusiasm about the new forms of expression and new channels of communication that they make possible. But at the same time, these technologies have certain features that force us to temper any millenarian expectations that they will wholly replace the book as vehicles for the conduct of public discourse. I am thinking here not so much of technical limitations that are likely to be overcome in time, but of features inherent in the very properties that make these media seem so superior to print—their ability to store, manipulate, and transmit huge amounts of information at a very low cost; the immateriality of the representations they traffic in; their versatility as tools for the production, diffusion, and reception of texts. What I want to argue here is that it is precisely because these technologies transcend the material limitations of the book that they will have trouble assuming its role. "The book" will change, of course, and the character of public discourse along with it, both in ways that it would be idle to try to predict in any detail. But two things are clear. First, the future of both will be shaped, not just by the available technologies, but by our ingenuity in deploying them. As Raymond Williams wrote thirty years ago about a very different set of technologies, "the crisis in communications has been caused by the speed of invention and by the difficulty of finding the right institutions in which these technical means are to be used."[4] And second, if history is any guide, the future will be populated with a more varied and complicated collection of forms and institutions than the present is, and we are likely to find it no less uncanny

for what it preserves than for what it alters. (What made Wells a true visionary was not his ability to predict so many of the technological marvels of the late twentieth century, but his prescience in setting them in a world where men were still wearing neckties.)

The Future of Reading

The argument that the computer will replace the printed book is simple enough. Everyone seems to be agreed that within a short time, electronic displays will be the equal of printed text—as light and as portable as books, with screen resolution and contrast roughly comparable to that of the printed page.[5] At that point, the argument goes, the versatility of the computer will give it a decisive edge over the book as a reading medium. As Kurzweil puts it: "The personal computer of the early 2000s will . . . have enormous advantages, with pictures that can move and interact with the user, increasingly intelligent search paradigms, simulated environments that the user can enter and explore, and vast quantities of accessible material. Yet vital to its ability to truly make the paper book obsolete is that the essential qualities of paper and ink will have been fully matched."[6]

There is no question that over the coming decades electronic displays will come to be an increasingly important medium for reading and manipulating texts of all kinds, including the kinds of books associated with literary culture. There are a lot of reasons why you might want to have Proust online, after all. You can search the text for words and phrases, you can copy passages into other documents, you can annotate the text extensively (electronic representation makes it possible to prepare critical editions of a thoroughness and complexity that are unattainable in print).[7] And what is most important, you can carry it around in a very small space or access it from anywhere with a very small device. In the end, the choice will come down to putting into your briefcase a two-pound copy of *Swann's Way* or a two-pound computer that contains the whole *Remembrance of Things Past*, not to mention all of the *Nouvelle Revue Française* and the *Grand Larousse*.

Still, most people are usually content to carry around one book of Proust at a time, and their interest in manipulating the text stops at being able to sit somewhere and turn its pages. And for these purposes, I think it is very unlikely that the computer will replace the book as a reading tool in the way that it has replaced the typewriter as a writing tool. The argument that Kurzweil gives presupposes a greatly oversimplified picture of what happens when we read. On this account, the chief function of a medium of presentation is to deliver a text directly to consciousness in a transparent way, so as to establish an unmediated psychological relation between the author and the reader. This is a common understanding of

the process of reading; Georges Poulet spoke about it in terms of the phenomenal disappearance of the book at the moment we engage the text: "Such is the initial phenomenon produced whenever I take up a book, and begin to read it. . . . Where is the book that I held in my hands? It is still there, and at the same time it is there no longer, it is nowhere. That object wholly object, that thing made of paper, as there are things made of metal or porcelain, that object is no more, or at least it is as if it no longer existed, as long as I read the book. For the book is no longer a material reality. It has become a series of words, of images, of ideas which in their turn begin to exist."[8]

If one accepts that the physical volume plays no part in interpretation once the text is delivered to the eye, then it seems to make sense to frame the contrast between the book and the computer in terms of an opposition between the purely perceptual properties of the page and the screen. But there is more to reading than this. As Roger Chartier puts it, "Reading is not just an abstract operation of intellection: it is an engagement of the body, an inscription in space, a relation to oneself and others."[9] And even when the electronic display has achieved perceptual parity with the printed page, it will not be equivalent to the book with regard to these other aspects of reading—corporeal, spatial, and social.

Let us begin with the body. Defenders of the book often stress the "pleasure of handling books" as a reason for their continued use. Of course this argument sometimes amounts to little more than an appeal to the bibliophile's pleasure in handling his possessions. And while we are all susceptible to this sensation, it has little to do with reading as such, and it is unlikely to play much of a role in the future of books. In purely economic terms, the interests of bibliophiles will support only a limited production of gift books, luxury editions, and the like, and in fact collectors should secretly welcome the general disappearance of the book, which would invest their possessions with added rarity and their preoccupations with the distinction of conspicuous impracticality. Then too, a portable computer is itself an eminently fetishizable commodity—not exactly the same as a book, perhaps, but both objects keep one's hands agreeably busy in one's lap.[10]

But there is another way in which books engage us physically, not as commodities, but as embodiments of particular texts; and this affects even books that are implausible objects of desire, like textbooks or paperback mysteries. The connection between the text and the volume has its origin in the ontogeny of reading. Before children learn to decipher books—quite probably, in order to learn to decipher them—they assign them magical power according to physical particularities that somehow enable each of them to evoke its own unique story. And these are properties that an electronic representation, being immaterial, cannot have. (It is unlikely that virtual reality will soon be developed to the point of being able to render *Pat the Bunny* in all its sensory complexity.)

It's true that the book is demystified when we learn to decode the written language—must be demystified, so that we can take up the mystery of the story

in earnest. But the book remains crucially an "inscription in space," whose physical presence is a constant element in the process of interpretation. For in fact the disappearance of the book that Poulet describes is illusory. However engaged we may feel by the text, the volume never is completely absent from perception. That is why we can often close our eyes and recover the image of a passage we have read according to what part of the page it appears on, and why our custom of saying that we have read something *in* a book is more than mere idiom. What makes possible the impression that Poulet reports is the way the book is absorbed (or "compiled") in the act of reading. But that is possible only because of the particular correspondence the volume bears to the text. A book doesn't simply contain the inscription of a text, it *is* the inscription. It is as fat as the text is long, it opens at the beginning of the text, and if we break off our reading, we are left literally *in media res*. This property is crucial to the way we read any book whose content is essentially linear or narrative, as we subconsciously register the external boundaries of the volume in terms of the space between our thumb and forefinger, and reckon our place in the text accordingly. As Jane Austen wrote in the final chapter of *Northanger Abbey*, "My readers . . . will see in the tell-tale compression of the pages before them, that we are all hastening together to perfect felicity."

A computer doesn't have to store texts in a form that corresponds to the space they occupy when they are displayed; that is the source of all its informational capacity. But for just this reason, there is no perceptible correlation between the boundaries of the texts we read on a computer and the physical properties of the artifact or the display itself. So there is inevitably a sense of disconnection between the text that is immediately present to the senses and the text that stretches out indefinitely and invisibly on either side of it—reading Proust in a window is like viewing Normandy through a bombsight. Of course windows with scroll bars don't exhaust the devices for representing the reader's place in an electronic text, and other visual metaphors may be more intuitive and less intrusive. But however ingenious these interfaces are, they remain representations, at a physical remove from the boundaries of the text itself. You literally cannot grasp an electronic text in its entirety.[11]

Perhaps someday the book and the electronic display will converge in an electronic display so thin and flexible that it is all but indiscernible from a printed page. At that point we might speak of a genuine electronic book—something that has most of the useful physical properties of a traditional book, but which can also be erased, updated, annotated, searched, and so forth. But if such a convergence does take place, it will be because the technology has become for all purposes invisible. Phenomenally, the electronic book will have to handle like a book, just as the electronic piano has to handle like a piano. And in the meantime it's likely that the printed book will remain the preferred medium for sustained, serious reading of the kinds of texts associated with literary culture, with elec-

tronic versions of these texts becoming available for other purposes. This by no means precludes an increasing role for documents involving multimedia, interactivity, hypertext, and other features that can only be engaged in electronic form. Up to now most of the work on these media has concentrated on resource documents like encyclopedias, image catalogues, critical editions, and textbooks, partly because their print equivalents already have relatively nonlinear structures, and partly because there is a more mature market for documents like these among institutions like schools and libraries, who are in a position to acquire the equipment and software required to read them. As the technology becomes more widely available and standardized, however, we can expect to see much more of the new forms that people have been experimenting with: hypertext fictions, multimedia travel books, and the rest.[12] But there is no reason to suppose that these genres will replace traditional textual forms. The mere fact that a modality is available doesn't mean that authors or readers will find it generally convenient or necessary. Novelists may chafe under the tyranny of linearity, for example, and long for forms that make the spatialization of narrative something more than a metaphor, but when it comes to the crunch, it's a safe bet that most of them will be unwilling to throw linearity over the side. In short, the bookless library is a very unlikely prospect, just like the paperless office that a number of people were enthusiastically predicting around fifteen years ago.

The Future of Publishing

But as I said earlier, it is not books as such we are interested in, but the forms and institutions that surround their use. And here technology promises to have more significant effects, even on traditional "print-and-distribute" publishers. Some of the most significant changes will come from the introduction of high-resolution digital printers, for example, that permit demand printing of copies from electronically stored files—a boon to university presses, reprint houses, and scientific publishers, who have relatively small press runs and who now have to maintain costly inventories over a long backlist life. (The Harvard Business School has already adopted this method for publishing its case studies, for example.)[13] But certainly the most far-reaching changes in publishing will come when these technologies are combined with the technologies of electronic diffusion, so that texts can be delivered over an electronic net to users who can either view them on screen or send them to a local printer to make high-quality bound paper copies. At this point publishing seems no longer to be subject to many of the laws that govern the production and distribution of physical commodities.

Speaking very roughly, the electronic corpus consists of two types of texts. First, there are the secondary or derivative representations of traditionally pub-

lished books, or of texts intended primarily for print publication, some of them available as images and some as structured texts.[14] These include texts drawn from compositors' tapes, newspaper and magazine stories prepared for news wire distribution, and library holdings that have been scanned for purposes of conservation or for electronic use and dissemination, for example the 200,000 volumes to be scanned by the Bibliothèque de France. The electronic versions of texts like these circulate in what is basically a secondary market, not necessarily in terms of their economic importance, but in terms of the way we interpret them. Whatever the form in which we actually encounter *Moby-Dick*, we read it as a traditionally published book.

But electronic distribution is increasingly becoming a primary means for publishing new materials. Established scientific and scholarly publishers have already begun to experiment with this form of distribution, largely for economic reasons.[15] The economics of electronic publishing also makes it easier for individuals and organizations to take control of the publication process and cut traditional publishers out of the loop, so that jobs of editor and publisher coalesce. Institutions like libraries or research projects now can assume the publisher's role. The multinational Human Genome Project has established an extensive internal system for publication and information management, with an internal refereeing process, nomenclature committees, and so forth. And a task force of the American Physical Society has proposed establishing a worldwide physics information system that would include all of the formal literature in the field as well as a variety of databases and informal communication. At the other end of the scale, there's the electronic samizdat of Internet and the other net services, which offer a welter of discussion groups, bulletin boards, information services, databases, and electronic magazines and journals, together with individual publications that range from software to cookbooks.

Over the short run, to be sure, these forms of publication are subject to a number of technical and economic constraints. For one thing, electronic distribution is only possible within communities that have general access to the relevant hardware and to network facilities. And even within such communities, most users don't have the capacity to handle large files or complex documents (for example, documents with elaborate formatting, or which contain graphics or color), partly because of limits of hardware and partly because of a number of difficulties in standardizing document interchange. Then too, electronic publishing raises vexed economic and legal questions. For example, how should the publishers of an electronic journal charge for the use of their product? Should subscribers pay for a site license that allows them unlimited access to the files, for the time they spend logged in to the journal's server, for every shipment of a file to a printer or local station, or for every search they make in the journal's files? How does the publisher control unauthorized access or reproduction? What rights do authors and publishers have over the use and reuse of electronic doc-

uments? Who will pay for building and maintaining the extensive infrastructure that makes electronic diffusion possible?[16]

These problems suggest the need for wide changes in the economic and legal structures of publishing. And to the extent that one believes that it is these institutions that determine discursive roles like the "author," the cultural implications could be considerable. My own sense is that while the technologies will require extensive revisions in conceptions of intellectual property and the like, they are unlikely to require thorough transformation, precisely because forms of public discourse will remain heterogeneous and variegated, with print continuing to play a central role. But these are more complicated issues than I can go into here. For the present I am simply going to assume that the problems will solve themselves over the course of time—that most people will have access to computers, high-speed networks, and high-resolution printers, either at home, in libraries, or at work; and that publishers and users will be able to work out economic and legal arrangements that make this sort of distribution a practicable alternative to the traditional print-and-distribute model. Ultimately, the role that electronic reproduction will play as a vehicle for public discourse will be determined by the inherent properties of the medium and by the institutions that grow up around its use. It is to these that I now turn.

Electronic Reproduction

Two features, more than anything else, set electronic technologies apart from the technologies of mechanical reproduction that have shaped the cultural role of the book. The first is the versatility of the technology: unlike mechanical antecedents like the printing press, the typewriter, or the telegraph, the computer isn't restricted to a single role in production or diffusion. In fact, the technology tends to erase distinctions between the separate processes of creation, reproduction, and distribution that characterize the classic industrial model of print commodities, not just because the electronic technology employed is the same at each stage, but because control over the processes can be exercised at any point. There's a nice indication of this in the way the names of modes of distribution undergo a semantic shift when they are applied to electronic domains. The difference between "posting" and "sending" an electronic memo has mostly to do with what commands a user has to enter to see the document; it is nothing like the difference between tacking a paper memo to an office bulletin board and putting copies of it in everyone's mailbox.

The second important difference between the two technologies follows from the immateriality of electronic representations and the resulting reductions in the cost of reproduction. It remains to be seen whether information technology will substantially lower the initial costs of producing electronic documents—there

is not a lot of large-scale experience to go by here, and the sobering lesson of the past ten years is that savings and productivity gains expected from the introduction of office automation have generally proven to be elusive. One thing is certain: electronic technology reduces the incremental costs of reproduction by eliminating the economies of scale associated with the mass production of books. So the unit cost of making a copy or printout of an electronic file doesn't decrease with the number of copies made.

One important consequence of these differences is that with electronic reproduction, the user has a much greater role in the process of reproduction. In this sense electronic reproduction has more in common with the fourteenth-century scriptorium than with the print capitalism that replaced it. In the electronic world, as in the scriptorium, texts are "copied" (that is, transferred, downloaded, displayed, or printed) by individual users when and where they are needed. For this reason it makes no sense to talk about the "printings" or "editions" of an electronic document, all the more so because the master or source file of a text can be changed at any time. And as in the scriptorium, the physical properties of the document can vary from one copy to the next. It can be left to the user or the local environment to determine the binding, paper stock, size, and even fonts of the printed volume, or the layout and appearance of a screen representation. Finally, it is the individual user who determines the modularity of the document, that is, the particular chunk of text that it contains.

All of this affects the way documents are used and reproduced. Let me begin with modularities. A mass-produced book is both bound and bounded in a way that's replicated for all its instances: each copy contains the same text in the same order. But the computational representations of texts can be divided and reassembled in an indefinitely large number of documents, with the final form left to the decision of the individual user. To say that the reader "writes" an electronic text is not simply a conceit of reception theory. This feature of the technology has figured prominently in the speculations of visionaries, who foresee a day when categories like "literature" and "knowledge" are freed from the trammels of narrativity and decomposed into a set of propositional atoms that readers can reassemble *ad libitem*. Reading what people have had to say about the future of knowledge in an electronic world, you sometimes have the picture of somebody holding all the books in the library by their spines and shaking them until the sentences fall out loose in space: "Transclusion is a way to include, to quote, parts of a document without losing its current (or any subsequent) contexts, and without it becoming a physical part of the new text (which could be a movie, hyperfiction document, you name it). In this fashion one might see all newly formulated or recorded texts, data, sounds, pictures as future 'boilerplate paragraphs' or fragments, available for viewing, digesting, and transclusion in new works."[17] This makes for an appealing tableau: technology administering the death blow to the *grand récit* and ushering in the golden age of appropriation. As

a purely practical matter, though, decomposition has its limits. In most forms of discourse there is a basic integrity to a certain unit of content—the article, the short story, the book section, the encyclopedia entry—that will continue to be the natural module of distribution. But modularities above that level are strictly optional and *ad hoc*. And this has important consequences for many of the traditional publishing genres where the modularity of the volume doesn't coincide with the atomic modularities of the texts they contain: serials, newspapers, anthologies, and so on.

When a journal is electronically distributed, for example, there is no point to issuing individual numbers of the publication—that is, collections of articles bound and distributed together. Articles can still be released in bunches, but the contiguity of articles is no longer an important feature of their representation. So electronic journals will be published simply as periodically updated lists of titles and abstracts. Taken together with the reductions in production and distribution costs that accompany electronic reproduction, this change in the form of publication is likely to result in a diminution of the editorial role of the publisher of the electronic journal. Of course there are still crucial filtering functions that someone has to fill. In scientific and scholarly publishing, peer review is presumed in the collective conception of knowledge, not to mention the system of material rewards. But there is no particular reason why journal publishers should be required as middlemen in the process, particularly when the field itself has a set of institutions that can fill this role. And for the rest, electronic publication presents few disincentives to publishing large amounts of material. An electronic literary journal has no reason to decline to run a competent 10,000-word article about an obscure author simply because it is of interest only to a few subspecialists, because no one else is likely to call it up anyway. An electronic newsmagazine article on the civil war in Somalia can include forty columns of background material as a kind of sidebar interested readers can open by clicking an icon. Readers will need tools to comb through all this material, of course, but here they will be helped by a variety of new interfaces and search techniques; individual user profiles set to flag articles on certain topics and ignore others; automatic summarizers; full-text retrieval systems that pair an article with others in a database appearing to have the same content; "knowbots" they can send out to comb through a database for information on the Icelandic noun or the declining use of musk in the late eighteenth century.[18] In the course of things, then, electronic journals and newspapers will become more inclusive, on the reasonable assumption that readers can ignore irrelevant information much more easily in electronic formats than if it were included in a 400-page volume stuffed in their mailbox every month.

Among other things, this entails that few readers will ever see most of the articles in an electronic journal, much less read them. So it will be hard for electronic journals to preserve the immanent intertextuality a print journal achieves

by binding articles physically together, where a reader can get to one only by traversing another. This effect is compounded by other features of electronic publication that blur the distinctions between one periodical or journal and another. Electronic search mechanisms enable readers to look for material in a number of sources with a single query or operation, so that "the literature" comes to seem a vast undifferentiated database, rather than a collection of diverse editorial streams. At the same time, texts from a single journal are less likely to have a distinctive appearance, partly because the appearance of documents will be determined by the user's preferences and local computing and printing environments, and partly because the requirements of electronic publishing encourage the standardization of features like typography and paper size.

All of these considerations conspire to muffle the corporate voice of electronic serials, and to make it unlikely that they can come to fill the role of the traditional periodical in the sense the term has had since the eighteenth century—that is, an ongoing publication imposing a certain interpretation on texts in virtue of their physical and temporal contiguity. Nor, for the same reason, are there likely to be exact electronic equivalents of print anthologies or readers. Of course, electronic reproduction makes possible other genres of publication that print does not easily support. The most notable success to date is the kind of informal public exchange that we find in electronic bulletin boards, discussion groups, and the like. And these in turn make possible a variety of forms of self-publishing. If you've written an article about the Gulf War or about object-oriented programming that you want to make available to a large readership, you can simply post it where other people can get access to it and send the equivalent of a publication notice to all the relevant distribution lists and bulletin boards. In a sense, this signals the reappearance of the pamphlet, a publication genre that hasn't played an important part in English-language public discourse since the time of Shelley—though the effectiveness of this kind of publication is limited to certain kinds of discourse, as we will see in a moment.

For many communities and discourses, the advantages of electronic publishing will make the transition worthwhile. It is not surprising that scientific and scholarly communities have taken the lead here. They have a number of economic and practical motivations for replacing print publication: the spiraling costs of journals, the inefficiency of long publication delays in fields where research progresses rapidly, the need for more effective search procedures to keep track of research.[19] But the shift to electronic publication wouldn't be possible in the absence of a social organization that enables scientific communities to compensate for features of print discourse that are lost in the transition. For example, electronic publication by itself can't canonize an article in the way that publication in a prestigious print journal or review can, partly because of the reduction of editorial authority, and partly because the form of publication provides no guarantee that other members of the community will have seen the

article. In scientific communities, however, formal publication isn't the only or even the most important way of bringing research to the attention of the relevant audience. A large part of scientific discourse is transacted through seminars, conference papers, exchanges of photocopies, and most important, in informal discussions among practitioners (a type of discourse that electronic communication extends and enhances in very useful ways). So by the time an important paper appears in press, it's usually old news to most of the people who matter—the final publication of a result or theory confirms its status as a public fact rather than creating it.

Yet even in the scientific community the complete disappearance of the bound journal number would have some unhappy consequences. Scientific journals make use of the modularity of the number when they publish special numbers, for example. And it's striking that the most prestigious places for scientific publication are general journals that run articles on a range of topics transcending even the broadest delineation of scientific fields. A microbiologist who publishes an article in *Science* or *Nature* knows that at least 90 percent of the readership will not be in a position to read it critically. But she will also have the satisfaction of appearing on the dais alongside luminaries from other fields, in plain view of university colleagues from remote departments who will be suitably impressed by her association with *their* big names—a reciprocal exchange of reputation that allows scientists to taste the pleasures of purely literary fame. Then too, journals like *Science* provide readers with an opportunity for making serendipitous discoveries about topics whose relevance to their own work they may not have suspected, a kind of reading that tends to be discouraged by electronic journals, where search procedures generally presume that readers know in advance what they are interested in. So it is unlikely that science will wholly abandon traditional print-and-distribute publication, though versions of these journals will be available in secondary electronic representations as well.

Other Discourses, Other Publics

The features of print that make it a superior medium for journals like *Science* become still more conspicuous when we move to other kinds of discourse where the modularity of the number does more important work, and where there is no obvious social mechanism to compensate for its loss. It is hard to imagine journals like *Representations* or *Les Annales* moving to online publication, for example, at the cost of the immanent intertextuality that physical binding imposes. In fact, electronic publication will have problems adapting to any discourse in which the reader's interests are shaped less by explicit topicality than by tone or point of view. The type is epitomized by the *Atlantic Monthly* or the *New Yorker*, say, whose chief purpose is to bring us articles we had no idea we wanted

to read, about subjects we would never search out or set our reader profiles to flag for us—and more to the point, to bring no advertisements for commodities we had no idea we wanted to buy. In this regard, general-circulation magazines are much like the nineteenth-century newspaper, about which Richard Terdiman has observed that both their form and format are determined by the physical contiguities of "editorial" and "commercial" content.[20] The transformation of such genres to electronic distribution is not just a question of finding other ways to present advertising or new economic models for publication. When the physical contiguities of texts are altered or removed, the discursive forms themselves may become pointless or uninterpretable.

This takes me to the most basic question about electronic publication: Under what circumstances can it replace print as an instrument of publicity, in the older sense of the term; that is, as a means of making texts public objects? In its broadest form, the problem affects not just journals and periodicals but other kinds of books as well. The crucial distinction here is between two realizations of the public. The first is the intimate public whose members are connected by a welter of personal and institutional ties, where written discourse floats over a sea of conversation that adjudicates literary reputation. The scientific community is one example of this type, but so too was the classical public sphere that emerged at the beginning of the eighteenth century in the "Town" of coffeehouses, clubs, and salons, whose oral discourse was amplified and broadcast by new forms like the newspaper and the periodical. Addison estimated that every copy of *The Spectator* reached twenty readers in the coffeehouses—probably an exaggeration, but still an indication of the degree to which print discourse was regarded as an adjunct and accompaniment to oral discussion. (In the same way, when a well-established scientist sends photocopies or electronic versions of a new paper to colleagues at other labs, he can expect to precipitate flurries of reproduction at the other end.) In this context, works could become public without having been formally published—and nothing would be published, in any event, before it was submitted to the critical discussion of a coffeehouse, club, or salon, the equivalents of the modern scientific conference and system of peer review.[21]

In such communities—that is, communities constituted independently of their participation in a published discourse—electronic reproduction can accomplish most of the important work of publicity by making texts widely available to an audience that already knows how to receive them. A number of other things being equal, I see no reason why *The Spectator* and *The Tatler* could not have been distributed electronically. But it is harder to imagine electronic equivalents for the new periodicals that began to appear in the mid eighteenth century, like *The Gentleman's Magazine* or Johnson's *Rambler*, when the booksellers became the mediators of a public discourse that had been transformed into an exchange between a putatively anonymous author and the "reading public," a community defined primarily by its participation in the print discourse itself.[22] This is what

Johnson was getting at when he said that Britain had become "a nation of readers," with the implication that books and periodicals had become the primary agents in creating the common sense of community that was constitutive of the national identity.

Benedict Anderson has given account of the formation of "imagined communities" like the nation, and of the role the book plays in their formation. Take the newspaper, which as Anderson observes is merely "an extreme form of the book," a "one-day bestseller . . . of ephemeral popularity." He describes the reading of the morning newspaper as a paradoxical mass ceremony:

> It is performed in silent privacy, in the lair of the skull. Yet each communicant is well aware that the ceremony he performs is being replicated simultaneously by thousands (or millions) of others of whose existence he is confident, yet of whose identity he has not the slightest notion. Furthermore, this ceremony is incessantly repeated at daily or half-daily intervals throughout the calendar. What more vivid figure for the secular, historically-clocked, imagined community can be envisioned? At the same time, the newspaper reader, observing exact replicas of his own paper being consumed by his subway, barbershop, or residential neighbors, is continually reassured that the imagined world is visibly rooted in everyday life . . . creating that remarkable confidence of community in anonymity which is the hallmark of modern nations.[23]

The book has several properties that make it a locus around which the nation of readers can discover and declare itself. First, it is widely distributed in identical copies over a large geographical or social territory, which ensures the replication of experience. Second, and no less important, its extension is a matter of common knowledge, in a technical sense of the term: readers in London know the paper is being read by people in Leeds, and know the people in Leeds know the paper is being read in London, and so on. Finally, readers can reach this conclusion without any direct knowledge of one another's circumstances. This is what distinguishes the imagined community of the nation from the early eighteenth-century town. Here, the extension of the community of readers is implicit in the books themselves, or in what is said about them in other books about whose diffusion readers can have a similar confidence. (You might learn that a book was a bestseller in a private conversation with a publisher, but this information wouldn't permit you to presuppose familiarity with it in talking to other people, the way you could if the title had appeared on a newspaper bestseller list.)

The Places of Books

Historically, these properties of the book have been intimately connected to its mode of existence. A traditional mass-produced book is two kinds of object, whose relation is determined by the uniformity of the print edition. One is the set of copies or instances that readers actually engage, objects that belong

to private life, even if they happen to be shelved in public places. The other is the work or type, a scattered object that inherits a spatial location from the locations of its copies and a temporal location from the date of their production. This is the object that can come to have a public life, as when we talk about the book as a "locus" for a certain idea; that is, a linguistic fixed point that we can use to calibrate our subsequent discourse. But our access to these public places is always mediated through copies; as the eighteenth-century philosopher George Campbell characterized it, a public locus is a "certain, steady, and well-known standard . . . which every one hath access to canvass and examine." In ordinary speech, in fact, we often seem to refer to both kinds of objects at the same time. When we say that *L'Education sentimentale* is in the Bibliothèque nationale, for example, we imply that the work itself acquires a certain property (of distinction, accessibility, or whatever) from the location of one of its copies, a property that doesn't apply, say, to the *User's Guide to Microsoft Flight Simulator*.

But electronic documents involve a very different sort of ontology. Here, too, documents are realized by two kinds of objects, but these do not correspond to the instances or the types of a print work. First, there are the screen displays or printouts that individual users produce, the private objects in which readers physically encounter a work. But unlike copies of print works, these are generally too labile, too evanescent, and too partial to stand as surrogates for the type—an electronic work, we feel, is something more than an abstraction over the content of all the windows it is displayed in, and would exist even if no one happened ever to have called it up. Second, there are the source files in which texts are stored. These have physical locations, of course; they sit somewhere on a disk, for example. But these locations are in principle independent of the locations of displays or printouts where people encounter the text, and setting aside some practical considerations, it is of no consequence to a user to know where the source file is, or how many other versions of it exist.[24] What is important here is not the relation of inclusion but the relation of access: we no longer ask whether a text is "in" the Bibliothèque nationale, but whether and how easily we can get to it from there.

These properties of electronic documents raise several problems for establishing them as public loci. As we've already seen, the source files of electronic documents don't impose the same kind of uniformity on particular instances that print editions do. One telling example of this is the "individualized electronic newspaper" which has been popularized by people at the MIT Media Lab, and of which one prototype version has been developed at the IPSI Institute in Darmstadt (fig. 1).[25] The system enables readers to look at news stories that fit their pre-set interest profiles, or to display other stories listed in directories. It has an impressive range of functionalities: the screen can be customized according to the user's preferences, users can call up additional information or earlier stories about a topic they are interested in, and there is provision for including audio

FIGURE 1. Interface for an "individualized" electronic newspaper designed by the IPSI Institute, Darmstadt. Clicking the buttons on the right brings up screen displays of different sections of the paper, or services like dictionaries and the user's private archive. Clicking buttons marked "background," "interview," and so on brings up new windows containing related stories or information. The picture is actually a single frame of a video. The newspaper is available in several display formats.

and video materials. But precisely because of its power and versatility, this form of publication will have difficulty in filling the role of the traditional newspaper as a guarantor of uniform experience. A reader has no way of knowing whether other people are reading the same stories that he is, or whether they are being given the same evaluation of the relative importance of news as conveyed by the page layout of the conventional newspaper. By the same token, the electronic newspaper will not be a "daily newspaper," with all that that entails for the construction of the modern notion of "daily life."[26] On the one hand, stories can be filed or updated as needed; on the other, relevant stories can be kept online and available until the reader decides to get to them. After all, breaking news is only a small part of the content of a modern newspaper, particularly in America; as I heard an Englishman say when a newsdealer handed him a copy of the Sunday *New York Times*, "Dear me, what can have happened since yesterday?" So the electronic newspaper will be a document that changes by gradual substitution and accretion of its parts, which readers can consult at any time of the day or week. (This has other formal consequences: as writers begin to prepare their stories

directly for electronic delivery, for example, deictic expressions like "today" and "next week" must be replaced by descriptions that presuppose no common time of utterance.) To be sure, none of this is strictly necessary. The electronic newspaper could be arbitrarily constrained to reproduce all the limitations of the daily newspaper. But it isn't clear why readers would want this. Why should I have to wait until tomorrow morning to find out whether the Giants won this afternoon, or have to rifle through screenfuls of sports or shipping news that doesn't interest me, or be prevented from postponing reading of the science section until I have some free time? Left to their own devices, readers will always choose personal convenience over the abstract benefits of collective uniformity.

However and whenever readers encounter the online newspaper, it will probably still count as "the" newspaper, a common point of reference for the community, if only because these services will be underwritten or by existing news-gathering organizations. In general, though, the properties of electronic documents may make it more difficult for them to achieve this kind of public status. The problem here is a kind of paradox of accessibility. The great virtue of these technologies is that they allow us to make a document "accessible" without having physically to reproduce or distribute it—it is enough to post it on a server where users can get to it. (That is, the technologies break the historical connection between reproduction and publicity implicit in the etymology of the word *publish*.) This is what makes possible the conception of "libraries without walls," which in turn has led librarians to take up in earnest the development of standardized union catalogues.[27] Over the long run, though, and looking at the full range of electronic publications, the number of collections and catalogs is sure to multiply. Electronic libraries, after all, can dispense not just with walls but with all physicality; anyone can assemble a new "collection" by publishing a bibliography annotated with pointers to the electronic locations of the source files. The physicists will have their library, the Dickensians theirs, and the Freudians theirs, each group organizing the relevant literature according to its immediate interests.[28] In the course of things, the "electronic library" will be realized as an aggregation of catalogs, lists, and indexes of documents of every imaginable type, organized according to myriad schemes of classification, and linked and cross-indexed for search, so that they come to behave as a single database in which the lines between individual collections and catalogs are blurred. (It is an inevitable feature of the library without walls that the porosity goes both ways.)

Like Pascal's infinite sphere, the space inhabited by electronic documents can be either exhilarating or unsettling to contemplate. On the one hand, it offers universal access to information, freedom from all constraints of space and time, even a kind of purification from the taint of embodiment:

Cyberspace: A world in which the global traffic of knowledge, secrets, measurements, indicators, entertainments, and alter-human agency takes on form. . . . A place, one place, limitless; entered equally from a basement in Vancouver, a boat in Port-au-Prince, a cab in

New York. . . . From vast databases that constitute the culture's deposited wealth, every document is available, every recording is playable, and every picture is viewable. . . . The realm of pure information, filling like a lake, siphoning the jangle of messages transfiguring the physical world, decontaminating the natural and urban landscapes, redeeming them . . . from all the inefficiencies, pollutions (chemical and informational), and corruptions attendant to the process of moving information attached to *things*.[29]

But "cyberspace" can also evoke a tohu-bohu of databases, catalogs, newsgroups, and net services extending indefinitely in all directions, a fortuitous concourse of the scholarly and the popular, the public and the private, the perduring and the ephemeral, which presents a different aspect to every observer. And in such a world, the very fact that every text is accessible makes it difficult to privilege any of them as public objects.[30]

To a certain extent, it is true, this chaotic impression is exaggerated by current technical limitations. When documents are all represented simply as strings of text characters with minimal formatting, collections become very difficult to browse: wandering around in a variegated document database like Dialog can feel a bit like browsing in a bookstore in which all the volumes have been stripped of their covers and reproduced with identical typographies on paper stock of the same size and quality, to the point where you cannot tell the difference between *The Great Tradition* and *The Great Train Robbery*.[31] Doubtless this effect will be ameliorated as communications bandwidths grow and document interchange systems become more robust. Browsing a document database will never be quite as informative as browsing a bookstore or library stacks, since electronic documents don't bear physical traces of their provenance the way print books do—the price we pay for delivering them of their bodies. But it may not be much different from browsing around in a video rental outlet.

In the end, though, it will be not technology but discursive institutions that impose a discernible public order on the electronic literature, just as they do in the world of print. In the intimate publics of scientific and scholarly communities, as we've seen, professional organizations can play this role: one assumes that the electronic library of the physicists will be managed by librarians working under the aegis of institutions like the American Physics Society, who will be in a position to circumscribe and standardize the collection. For more general discourse, though, the question here is whether the electronic medium can support communities of reception that can mediate public literary reputation.

This is of course a great hope of enthusiasts, who point to electronic discussion groups and bulletin boards where "virtual communities" can take shape around a general critical discussion. The phenomenon is undeniable, but it is not clear whether these communities can be assembled at the scale of the modern reading public—the assumption that is implicit, say, in the claim that the "electronic town hall" will become the functional equivalent of the discursive institutions of the nineteenth-century American small town, but conducted over a

continent. The difficulties here are analogous to the problems we have seen with other electronic forms. For one thing, the absence of material constraints on participation tends to make these discussion groups unmanageably prolix when they get over a certain size. You can see the effect even in the discussion groups of small professional communities. From the linguists' list, for example, I receive the equivalent of ten to twenty four-page newsletters every week—and this is a moderated discussion, all of whose participants could probably be assembled in a single hotel ballroom. In larger groups unmediated discourse gets very quickly out of hand, and invariably breaks up into a number of separate conversations. The largest American commercial network service, Prodigy, has 1.5 million users. Its "arts club" contains 420 bulletin boards, which collectively receive around 22,000 messages a day; its "music club" receives another 9,000.[32] It is hard to see how any critical consensus or sense of general community could emerge from such a colloquy.

The second difficulty follows from the indifference of electronic publication to constraints of time and space. It can be difficult to project the "virtual communities" of the net into actual communities that are "rooted in everyday life," to use Anderson's term—another difference between the electronic newspaper and its print equivalent, which circulates in an actual public space. The participants in electronic discussions can be anywhere, and the ease with which messages can be duplicated, forwarded, and reposted makes it very difficult to estimate the size or location of their audience. (Many users of electronic discussion groups and bulletin boards are familiar with the experience of posting a message to what they assumed was a local group only to receive a response a few days later from somebody in Prague or Sydney.) Once again, this problem is tractable for small groups: one famous case is the San Francisco area net group called The Well, whose members get to know each other face-to-face at regular parties. But larger electronic communities may be condemned to perpetual virtuality; once in cyberspace, it may be hard to find the road back to the world of effective action.

The End of the Book

The fragmentation of discourse, the blurring of traditional discursive roles—we have heard all this before. "The public" has always appeared an unstable aggregation. Walter Benjamin seemed to welcome the centrifugal effect of new discursive forms in "The Work of Art in the Age of Mechanical Reproduction:"

With the increasing extension of the press, which kept placing new political, religious, scientific, professional, and local organs before the readers, an increasing number of readers became writers. . . . Today there is hardly a gainfully employed European who could not, in principle, find an opportunity to publish somewhere or other comments on

his work, grievances, documentary reports, or that sort of thing. Thus the distinction between author and public is about to lose its basic character. The difference becomes merely functional.[33]

and Thomas Carlyle remarked on the same phenomenon a hundred years earlier in "Signs of the Times":

Mark, too, how every machine must have its moving power, in some of the great currents of society; every little sect among us, Unitarians, Utilitarians, Anabaptists, Phrenologists, must have its Periodical, its monthly or quarterly magazine;—hanging out, like its windmill, into the *populari s aura*, to grind meal for the society.[34]

Eighteenth-century authors made the point even more vociferously, for example, in Johnson's famous remark in *The Adventurer* that "there was never a time when men of all degrees of ability, of every kind of education, of every profession and employment were posting with ardour so general to the press."[35] In retrospect, of course, these comments reveal more about the changing composition and widening of the reading public than about its imminent disintegration, which is as much a misperception as its retrospective unity.[36] And here, too, I suspect that the impression of disorder is likely to recede, not just because of the emergence of new institutions of reception, but because of a growing understanding that the electronic domain is not an autonomous discursive sphere, but one of a number of channels that collectively mediate public discourse.

For the foreseeable future, it is safe to assume that public texts will require as their primary avatars the kinds of print-and-distribute books that can serve as loci for all the practices associated with publicity and anti-publicity—objects that can be reviewed in other print organs, browsed in bookstores in the congenial company of like-minded clerks and shoppers, given as gifts, or publicly burned.[37] But as I have been at pains to point out here, none of this precludes an important role for electronic media. Conventional print-and-distribute publication may be required to establish the public presence of a text, but it isn't necessary to sustain it. Texts will have primary, secondary, and tertiary lives, moving back and forth over scanners and printers, and each version will take on a part of the communicative work that was associated with the traditional published book. In some cases, print publication may become largely ceremonial, analogous to the common American practice of first releasing a book in hardcover to establish its claim to serious critical attention, then publishing it several months later in paperback, where it enjoys its widest circulation after its locus has been fixed. Or it may be that university presses and scholarly publishers will find it expedient to print a small initial press run using digital printers for distribution to reviewers and display at conventions, while simultaneously shipping an electronic version to university bookstores and libraries for local demand printing. In the same way, the apparatus of reception will be increasingly distributed over both media. Already the professional lists on Internet run book announcements and reviews,

and there are print publications devoted to finding one's way around the net. At some point we may in fact be justified in talking about the end of the book—not in an apocalyptic sense, but simply because the connections between cultural forms and technologies will have become so contingent and ramified that "the book" is no longer an especially interesting category.

Notes

1. Patrice Higonnet, "Scandal on the Seine," *New York Review of Books*, 15 August 1991, 32–33.
2. In the original *Star Trek* television series, book-reading was associated with antiquarian eccentricity. The subsequent series *Star Trek: The Next Generation*, set a hundred years further in the future, has an ironic strain that was largely absent in the original: the captain is sometimes shown reading a book, and the ship has acquired a staff psychologist.
3. Jay David Bolter, *Writing Spaces: The Computer, Hypertext, and the History of Writing* (Hillsdale, N.J., 1991), 2–3. Bolter is one of a number of humanists who have seen the future in the works. Richard Lanham writes that "Electronic information . . . changes the central humanistic artifacts (the CPU, we might call it) from printed book to digital display. . . . It metamorphizes the *marketplace* of humanistic inquiry in ways so radical we can scarcely yet find our way"; The Implications of Electronic Information for the Sociology of Knowledge," Paper presented at conference on Technology, Scholarship, and the Humanities, National Academies of Science and Engineering, 30 September–2 October, 1992.
4. Raymond Williams, *Communications* (London, 1962), 20.
5. The screen resolution of a typical laptop computer is 72 dots per inch (dpi). Displays are already commercially available with resolutions of 300 dpi, the same as most laser printers, and screen resolutions several times better than that are possible using technology that is either already available or likely to be available soon. At 600 dpi, the resolution of current digital printers, most readers are hard put to distinguish digital and offset representations of black-and-white text, though there is still a small but perceptible difference in the display quality of halftones or color images.
6. Raymond Kurzweil, "The Future of Libraries, Part 2: The End of Books," *Library Journal*, 15 February 1992, 140–41.
7. For a discussion of the role of computers in the preparation of critical editions, see Wilhelm Ott, "Software Requirements for Computer-Aided Critical Editing," in Sharon Butler and William P. Stoneman, eds., *Editing, Publishing, and Computer Technology* (New York, 1988).
8. Georges Poulet, "Criticism and the Experience of Interiority," in Jane P. Tompkins, ed., *Reader-Response Criticism* (Baltimore, 1980).
9. Roger Chartier, *L'Ordre de livres* (Aix-en-Provence, 1992), 20.
10. The argument against electronic representations is often put: "You can't take a computer to bed with you." Bolter has a stern answer to this objection: "The great advantage of the first printed books was that you could *not* read them in bed. Gutenberg might well have been appalled at the thought of someone taking his beautiful folio-

sized Bible to bed. For generations, most important printed books remained imposing volumes that had to be read on bookstands, so that people often read (and wrote) standing up. . . . The book in whatever form is an intellectual tool rather than a means of relaxation. If the tool is powerful, writers will put up with inconveniences to use it"; *Writing Spaces*, 4. But not all of us can measure up to so austere a standard, and in any case the response is wrong. Writing in bed on a laptop is quite as comfortable as writing on a pad. The only problem is that the computer folds horizontally, rather than vertically, so that the device sits on one's lap, rather than in it.

11. Even experienced programmers usually prefer to print out a long prose text in order to read it, far more often than they will print out a program to debug it. The difference is that a program doesn't have the kind of linear structure that a narrative does: the interpretation of a line of code doesn't depend crucially on how far it is from the beginning of the program.

12. For a stimulating survey of some of these possibilities, see George P. Landow, *Hypertext: The Convergence of Contemporary Critical Theory and Technology* (Baltimore, 1992).

13. Demand printing also makes possible the emergence as publishers of institutions like libraries, which have *only* backlists, so to speak. In the current state of the art, it costs around fifty dollars to hand-scan a 300-page book, say for purposes of electronic access or conservation (the scanning process is difficult to automate without risk to delicate originals, and advances in the mechanical technology of paper handling are likely to be slow and incremental in the immediate future). But additional bound copies can be produced for less than ten dollars, so it will be relatively cheap and easy to make copies of rare books available to other collections or to individual scholars, even assuming that these are to be distributed by conventional nonelectronic means.

14. It is likely to be a while before optical character recognition software reaches the point of being able to render imaged pages as text in a reliably automatic way, particularly with older books that have been printed with uneven lines and nonstandard fonts.

15. It has been observed that journal publishers have traditionally existed in a perfect colonial relationship to universities: academics produce the raw material and do the local administration, and the publishers refine the product and resell at a high markup to universities, who before now have not been in a position to avail themselves of the ordinary economic response of import substitution.

16. For detailed discussions of some of these questions, see the papers collected in Czeslaw Jan Grycz, ed., *Economic Models for Networked Information*, special number of *Serials Review* 18, no. 2 (1992).

17. Ian Feldman, "First Xanadu stand opens Jan. 1993, El Camino Rd, Palo Alto CA. Be there," in *TidBITS* 30/Xanadu.etx (undated net publication; c.1990, <ace @tidbits.uucp—CIS:72511,306—AOL:Adam Engst>).

18. The first three of these are already operational in experimental versions that work more or less well. The fourth is still something of an artificial intelligence pipe dream, though there are other search-and-retrieval techniques that can approximate this kind of functionality with the active collaboration of a human user.

19. Then too, scientific authors don't expect to be paid royalties for their work, and access to publications is usually mediated by libraries and other institutions, which makes it simpler to monitor use and collect fees for it. And finally, scientists have a particular interest in some of the forms of representation that are only possible with electronic publications—images of time-dependent data, dynamic equations that allow readers to assign arbitrary values to parameters, and "floated" diagrams that can be consulted whenever they are referred to in the accompanying text.

20. "Its form *denies form*, overturns the consecrated canons of text structure and coherence which had operated in the period preceding its inception. . . . The newspaper is built by addition of discrete, theoretically disconnected elements which juxtapose themselves only in response to the abstract requirements of 'layout'—thus of a disposition of space whose logic, ultimately, is commercial"; Richard Terdiman, *Discourse/Counter-Discourse* (Ithaca, N.Y., 1985), 122.

21. Even then, writers often refused to allow their names to be attached to the published version; Gray not only insisted that his "Elegy" be published anonymously, but asked the printer to add a note "to say that the work had come into his hands by accident." For an excellent discussion of the ways in which print discourse was dependent on and largely subordinate to the oral substrate before Johnson's time, see Alvin Kernan's *Printing Technology, Letters, and Samuel Johnson* (Princeton, N.J., 1987).

22. In this new public discourse, it was not necessary to maintain even a fiction of personal communication. Johnson acknowledged the new relationship in the *Rambler*, no. 23, remonstrating with readers who "were angry that the Rambler did not, like the Spectator, introduce himself to the acquaintance of the publick, by an account of his own birth and studies, an enumeration of his adventures, and a description of his physiognomy," as well as with those who "had admonished [the Rambler] to have a special eye upon the clubs of this great city, and informed him that much of the Spectator's vivacity was laid out upon such assemblies." In W.J. Bate and Albrecht B. Strauss, eds., *The Yale Edition of the Works of Samuel Johnson*, vol. 3, *The Rambler* (New Haven, 1969), 128–29. The shift has a mirror image in the development of electronic net discussions, where participants tend to take a highly personal and informal tone even when the forum has a large audience whose members are personally unknown to one another. Convention dictates, moreover, that interlocutors shall address their remarks to each other directly, rather than referring to other participants in the third person, as one would do in writing a letter to the editor of a periodical; in this way the audience is treated as an eavesdropper to a private conversation. For a discussion of some of the properties of electronic discourse, see Lee Sproull and Sara Kiesler, *Connections* (Cambridge, Mass., 1991).

23. Benedict Anderson, *Imagined Communities* (London, 1983), 39–40.

24. From the standpoint of the user, there are some reasons for wanting to know where a text is, at least to the degree that the systems we use to manipulate and access texts are likely to behave—or more to the point, to misbehave—in different ways according to whether the text is mounted on the user's own hard disk, on a machine somewhere else in the building, or on a distant file server. But for all its diagnostic interest, this information is irrelevant to the metaphysical status of the text.

25. A description of this system can be found in Christoph Hüser and Anja Weber, "The Individualized Electronic Newspaper: An Application Challenging Hypertext Technology," in R. Cordes and N. Streitz, eds., *Hypertext und Hypermedia 1992: Konzepte und Anwendungen auf dem Weg in die Praxis* (Munich, 1992), 62–74.

26. In addition to these remarks by Anderson, see Terdiman, *Discourse/Counter-Discourse*, for a discussion of the part that the daily newspaper played in shaping the conception of daily life.

27. This activity has been given first priority in the Libraries Program of the Commission of the European Community. See Gitte Larson, "The CEC Libraries Program," *Bulletin of the American Society for Information Science* (June–July 1991): 25–26.

28. Inasmuch as the elements of the collection have no inherent physical location, or at least none that matters to users, collections can be organized in an unlimited number

of ways: the contiguities among titles are entirely the creations of the cataloguer. A text that appears in the Dickens catalog under the heading "*Bleak House*, criticism of" can appear in the Freud catalog under "*Das Unheimlich*, literary examples of."

29. Michael Benedikt, "Introduction," in Benedikt, ed., *Cyberspace: First Steps* (Cambridge, Mass., 1991).

30. One can get a sense of the intricacies of the problem from the occasional eruptions of net discussions over how to cite electronic documents, given basic uncertainties about how they should be classified and which versions or source files should be taken as authoritative. See, for example, John.M.Lawler (<John.M.Lawler@um.cc.umich. edu>), "Citing LINGUIST," in *Linguist List* 3 (July 1992):575 (<linguist@tamvm1. tamu.edu>); archive ftp (ascii) anonymous@linguistics.archive.umich.edu: linguis- tics/linguist.list/volume.3/no.551–600; and for further comments, contributions to *Linguist List* (July 1992): 593.

31. One ancillary effect of this homogenization of the appearance of electronic documents is to blur the sense of provenance that we ordinarily register subconsciously when we are reading. As a colleague said to me not long ago, "Where did I see something about that the other day? I have a clear mental picture of a UNIX window."

32. These figures are drawn from William Grimes, "Computer Networks Foster Cultural Chatting for Modern Times," *New York Times*, 1 December 1992, B1.

33. Walter Benjamin, "The Work of Art in the Age of Mechanical Reproduction," *Illumi- nations*, ed. Hannah Arendt (New York, 1969), 232.

34. Thomas Carlyle, "Signs of the Times," *Critical and Miscellaneous Essays: Collected and Republished*, vol. 2, (Boston, 1860), 140.

35. Cf. also Pope's remarks in the *Dunciad* (I, 37–44):

> Hence Bards, like Proteus long in vain ty'd down,
> Escape in Monsters, and amaze the town.
> Hence Miscellanies spring, the weekly boast
> Of Curl's chaste press, and Lintot's rubric post:
> Hence hymning Tyburns elegiac lines,
> Hence Journals, Medleys, Merc'ries, Magazines,
> Sepulchral Lyes, our holy walls to grace,
> And New-year Odes, and all the Grub-street race.

36. To be sure, contemporary electronic discourse isn't quite so clearly in the line of Long Revolution as the nineteenth-century popular press, say, particularly in America, where its use has been largely restricted to a highly educated, technically sophisticated elite. But this may change if access to the technology can be made more democratic, as in the French Minitel experiment.

37. Of course someone might want to censor an electronic text, or even to eradicate all of its representations, say by means of a selective virus. But in that case each instance would die a private death. There would be occasion for public ceremonies of confis- cation and destruction, and no point to them either. The purpose of such ceremonies, after all, is not to eliminate all the private copies of a book—burning is a singularly inefficient way of accomplishing that—but to symbolically purge its public presence, like pulling down a statue. And at this time, electronic books don't have this kind of presence to begin with.

Libraries Without Walls

> These examples made it possible for a librarian of genius to discover the
> fundamental law of the Library. This thinker observed that all the books, no
> matter how diverse they might be, are made up of the same elements: the
> space, the period, the comma, the twenty-two letters of the alphabet. He also
> alleged a fact which travelers have confirmed: *In the vast Library there are no
> two identical books.* From these two incontrovertible premises he deduced that
> the Library is total and that its shelves register all the possible combinations
> of the twenty-odd orthographical symbols (a number which, although vast, is
> not infinite): in other words, all that it is given to express, in all languages.
> Everything: the minutely detailed history of the future, the archangels'
> autobiographies, the faithful catalogue of the Library, thousands and
> thousands of false catalogues, the demonstration of the fallacy of those
> catalogues, the demonstration of the fallacy of the true catalogue, the
> Gnostic gospel of Basilides, the commentary on that gospel, the commentary
> on the commentary on that gospel, the true story of your death, the
> translation of all books in all languages, the interpolations of every book in
> all books. When it was proclaimed that the Library contained all books, the
> first impression was one of extravagant happiness.
>
> —Jorge Luis Borges[1]

WHEN IT WAS PROCLAIMED that the Library contained all books, the
first impression was extravagant happiness." The dream of a library (in a variety
of configurations) that would bring together all accumulated knowledge and all
the books ever written can be found throughout the history of Western civiliza-
tion. It underlay the constitution of great princely, ecclesiastical, and private
"libraries"; it justified a tenacious search for rare books, lost editions, and texts
that had disappeared; it commanded architectural projects to construct edifices
capable of welcoming the world's memory.

Bringing together the entire written patrimony of humanity in one place
proves an impossible task, though. When print produced a proliferation of titles
and editions, it ruined all hope for an exhaustive collection. Even for those who
hold that a library must be encyclopedic, selection is an absolute necessity. This
was true for Gabriel Naudé in his *Advis pour dresser une bibliothèque*, written in 1627
and addressed to Henri de Mesmes, *président* at the Parlement de Paris and a great
book collector.[2] Against the model of the *cabinet curieux* or the *cabinet choisi*
reserved for the delectation of their proprietor and gathering together a small
number of books distinguished for their rarity or their luxury, Naudé pleads for
a well-furnished library: "It is much more useful and necessary to have, for

example, a great quantity of books well bound in the ordinary fashion than to fill only some small, pale, gilded, and decorous room or cabinet enriched with all manner of little oddities [*mignardise*], luxuries, and superfluities."[3] A library is not built to satisfy egotistical enjoyments but because there is "no more honest and assured means for acquiring a great renown among the peoples than to erect handsome and magnificent Libraries in order then to dedicate and consecrate them to the use of the public."[4]

Ideally made up of an "infinity of good, singular, and remarkable" works, the library must nonetheless limit its ambitions and make choices:

Still, in order not to leave this quantity infinite by not defining it, and also in order not to throw the curious out of all hope of being able to accomplish and come to the end of this handsome enterprise, it seems to me that it is appropriate to do as the Physicians do, who order the quantity of drugs according to their quality, and to say that one cannot lack gathering all those [books] that have the qualities and conditions required for being put in a Library.[5]

Naudé's *Advis* thus functions to guide the collector as he makes necessary selections and takes the appropriate "precautions," since Naudé indicates the authors and the works absolutely indispensable for his library.

The division between the books that one absolutely must possess and those that might (or must) be left aside is only one of the ways to mitigate the problem of the impossibility of a universal library. There were other ways, which the language of the seventeenth and eighteenth centuries indicated with the very term defining the place in which the books were kept: *bibliothèque*. In the entry for that word in Furetière's *Dictionnaire* (1690) the first definition is the most traditional meaning: "*Bibliothèque*: Apartment or place destined for putting books; gallery, building full of books. Also said in general of the books that are placed in this vessel." Next comes a second meaning designating a book rather than a place: "*Bibliothèque* is also a Collection, a Compilation of several works of the same nature or of Authors who have compiled all that can be [compiled] on the same subject."

The Latin terms for a collection vary considerably in these titles: *thesaurus*, *corpus*, *catalogus*, *flores*, and so forth. In French the genre was usually qualified as a *bibliothèque*. Four years after the publication of Furetière's *Dictionnaire*, the *Dictionnaire* of the Académie Française bore witness to this preference: "One also calls *Bibliothèques* Collections and Compilations of works of like nature." Three examples follow the definition: "*La Bibliothèque des Pères, La Nouvelle Bibliothèque des Pères, La Bibliothèque du Droit François.*"

Eighteenth-century bookseller-publishers published great numbers of these multiple-volume collections gathering together published works in a given genre such as novels, tales, or travel accounts. Many collections, however, made use of both the formula and the term inaugurated by the Amsterdam periodicals of Jean Le Clerc, the *Bibliothèque universelle et historique* (1686–93), the *Bibliothèque choisie*

(1703–13), and the *Bibliothèque ancienne et moderne: Pour servir de suite aux Biblio-thèques universelle et choisie* (1714–27). In all, there were thirty-one periodical pub-lications in the French language, some of which lasted longer than others, that were offered under the title of *bibliothèque* between 1686 and 1789.[6] The term was used throughout the century, with seventeen titles published before 1750 and fourteen after. Several of these publications were not periodicals, properly speaking, but imposing collections of texts related by their genre or their targeted audience. One such was the *Bibliothèque universelle des romans* (1775–89, com-prising 224 volumes in duodecimo format), which was presented as a "periodical work in which is given the reasoned analysis of Novels ancient and modern, French or translated into our language," which published extracts and summa-ries, historical and critical notes, unabridged texts of novels, and tales both tra-ditional and original.[7] Another was the *Bibliothèque universelle des dames* (1785–97, comprising 156 octodecimo-sized volumes), which had encyclopedic ambitions, given that it contained travel narratives, novels, works of history, morality, math-ematics and astronomy, physics and natural history, and all the liberal arts.

These imposing "libraries," along with the encyclopedias and the dictionaries, constituted a major part of the great publishing ventures of the eighteenth cen-tury. As Louis-Sébastien Mercier noted, they guaranteed the diffusion of knowl-edge—or at least of literary pleasure—and they provided a living for a multitude of the people who were scornfully called *demi-littérateurs* or *écrivailleurs*.[8] The "libraries," which aimed at being exhaustive and universal in any given genre or domain, had a counterpoint in the eighteenth century in a vast number of equally popular small, concise, and easily handled volumes named *extraits*, *esprits*, *abrégés*, *analyses*, and so forth.[9]

The smaller, portable anthologies were another form of "library" produced by the book trade. Even if both genres offered extracts, their intention was not the same. The smaller works aimed at eliminating, selecting, and reducing rather than accumulating a multitude of separate and dispersed works in one collection, periodical or not. If the collections in a *bibliothèque* were constructed with the aim of accomplishing the impossible task of assembling for every reader all the books concerning a particular subject, an appeal to *analyse* and *esprit* implied that such a task was useless or harmful, and that the necessary knowledge—available in a small number of works—needed to be concentrated or distilled like a chemical substance. In that belief the compilers of portable anthologies agreed with the utopian writers of the century who rejected encyclopedic libraries as over-encumbered and superfluous and permitted only a very few books in their ideal library.

In his utopia (more accurately, his "uchronia") of 1771, *L'An 2440*, Louis-Sébastien Mercier pays a visit to the library of the king and finds it to be somewhat singular: "In place of those four galleries of immense length, which contained many thousands of volumes, I could only find one small cabinet, in which were

several books that seemed to me far from voluminous." Intrigued, Mercier asks the librarian what has happened, and the librarian answers that before burning all the books judged to be "either frivolous or useless or dangerous," the enlightened men of the twenty-fifth century saved the essential, which took up little room: "As we are neither unjust nor like the Saracens, who heated their baths with masterworks, we made a choice: wise men extracted the substance from a thousand in-folio volumes, all of which they transferred into a small duodecimo-sized volume, somewhat in the same way that the skilful chemists who extract the virtue from plants concentrate it in a flask and throw out the vulgar liquors."[10] The tension between the exhaustive and the essential thus ordered the complex and contradictory relations linking the library, in its usual spatial and architectural sense, to print genres (only some of which were called *bibliothèques*)—relations that assigned to the "library" as a book, be it one volume or one of a series, the functions of accumulation or selection attributed to the library as a place.[11]

But a library was not only a place or a collection. Furetière's *Dictionnaire* proposes a third definition of the term (not found in the more concise entry of the *Dictionnaire* of the Académie): "One also calls *Bibliothèque* the books that contain the Catalogs of the books in the *Bibliothèques*. Gesner, Possevin, Photius, have made *Bibliothèques*. . . . Father Labbé, a Jesuit, has made the *Bibliothèque des bibliothèques* in an octavo-sized book that contains only the catalogue of the names of those who have written *Bibliothèques*."[12] For anyone who might wish to design an open and universal library, the possession of such catalogs was a necessity. The sum of their titles defined an ideal library freed from the constraints imposed by any one actual collection and overflowing the limits inherent in anthologies and compilations by the immaterial construction of a sort of library of all libraries in which nothing, or almost nothing, was lacking. Thanks to the circulation of the catalogs, the closed world of individual libraries could be transformed into an infinite universe of books noted, reviewed, visited, consulted, and, eventually, borrowed.

Furetière's definition slips from catalogs of particular holdings toward another sort of work. A "library" is not only the inventory of the books assembled in a specific place; it can be an inventory of all the books ever written on a given subject or by all the authors of a given nation. Thus Furetière notes: "In France, there is not yet a general *Bibliothèque* of all the Authors. There are particular ones by the Sieur La Croix du Maine Manceau and Anthoine Du Verdier. Spain has one by Nicolas Anthonio. There is also a *Bibliothèque d'Espagne* of Peregrinus, and the [*Bibliothèque*] *Des Escrivains Espagnols* by André Schot in 1608."[13] Thus the genre that the *Dictionnaire* evokes and designates with the term *bibliothèque* is defined according to two criteria: it lists authors, and it respects the national (French or Spanish) framework.

At the end of the seventeenth century such "libraries" already had a long history.[14] Three such works had appeared before 1550, the *Cathalogus illustrium*

virorum Germaniae suis ingeniis et lucubrationibus omnifariam exornantium of Johann Tritheim (Mainz, 1495), the *Bibliotheca Universalis, sive Catalogus omnium scriptorum locupletissimus, in tribus linguis, Latina, Graeca, et Hebraica* of Conrad Gesner (Zurich, 1545), and the *Illustrium Maioris Britanniae Scriptorum* of John Bale (Ipswich, 1548). These three works have several traits in common: they are written in Latin, they list for the most part ancient authors, and they privilege works written in the classical languages. Gesner innovated by launching a new usage of *bibliotheca* that detaches the word from its material definition and invests the library without walls proposed in his book with universality. Finally, the three works differ in their organization: Tritheim and Bale chose a chronological structure (the latter specifying "in quasdam centurias divisum cum diversitate doctrinarum atque; annorum recta supputatione per omnes aetates a Iapheto sanctissimi Noah filio, ad annum domini M.D. XLVIII"), providing an alphabetical index to make the work easier to consult. Once again Gesner stands alone, opting for alphabetical order but in the medieval style (unlike Tritheim and Bale) and classifying his authors by their baptismal names—that is, their first names. The declared universality of his *Bibliotheca* presupposes an exhaustive survey that retains ancients and contemporaries, printed texts and manuscript texts, learned authors and less learned authors.[15]

When Anton Francesco Doni published his *Libraria . . . Nella quale sono scritti tutti gl'Autori vulgari con cento discorsi sopra quelli: Tutte le tradutioni fatte dell'altre lingue, nella nostra e una tavola generalmente come si costuma fra Librari* (Venice, 1550), he inaugurated a new mode of presentation in this genre.[16] He innovated in three ways: first, in language, since the *Libraria* reviewed only authors or translators in the vernacular and is itself written in the vulgar tongue. Furthermore, the intention of the book was new: it contains no inventory of all authors, no collection of judgments. Rather, it is primarily designed to provide information on titles available in the vernacular: "I have made this library only to give knowledge of all the books printed in the vulgar language so that people who like to read in our language may know how many works have been published and what [they are], not to judge which are good and which bad." The third novelty consisted in the work's format. Doni abandoned large formats (the quarto of Tritheim and Bale, the infolio of Gesner) to publish his *Libraria* in a more manageable duodecimo format that the reader who haunted bookshops in search of the titles suggested by this ideal library (again, without walls) could easily carry with him.

The small volume of the *Libraria* published in 1550 had 144 pages and listed 159 authors, arranged in alphabetical order by their first names (from Acarisio da Cento to Vincenzo Rinchiera). Doni plays learned games with the fourteen letters of the alphabet around which his nomenclature is organized. The initial of the given name of the authors listed in a section was also the initial of the given name of the dedicatee mentioned in a preamble heading the section, as well as the initial of the first word in that brief text (for example, the *A* section was

headed, "Abate Abati. Assai son l'opere . . ."). After this list of all the authors who had published in the vulgar tongue, Doni provides three other lists: a typology of vernacular genres, an inventory of texts translated from Latin into Italian, and a "Tavola Generale di tutti libri volgari" in the form of a bookseller's catalog but without bibliographic information on specific editions.

A year after this first book Doni published *La Seconda Libraria* listing texts that had not yet been printed. The principle in this work, an alphabetical inventory, was the same as in the first. As Amedeo Quondam has noted, the *Libraria* of manuscript works—"of Books that the Author has seen in manuscript and which are not yet printed"—is largely fictional, enumerating invented authors and imaginary titles. It provides something like a "paradoxical and ironic double" to the *Libraria* that surveys published works.[17] Doni's two *librarie* form a complex book. Their bibliographic definition ("they were not only the first Italian national bibliographies; they were also the first bibliographies in a vulgar tongue")[18] fails to do justice to their multiple significance. They proclaim the excellence and the dignity achieved by the vulgar language; they constitute a repertory of contemporary authors; they dismantle, in a parodic key, the recipes for literary invention.

Doni's work was known in France, where it gave direct inspiration to two "libraries," the one published in 1584 by François de La Croix du Maine and the other published in 1585 by Antoine du Verdier.[19] These two works share an interest in demonstrating the superiority of the French language over the Italian by citing the number of authors who wrote in the vernacular, by the fact that French had been used as a literary language longer than Italian, and by the scope of the learning of French expression. This intention is explicit in the *Premier volume de la Bibliothèque du Sieur de La Croix du Maine: Qui est un catalogue général de toutes sortes d'Autheurs, qui ont escrit en François depuis cinq cents ans et plus, jusques à ce jourd'huy* (Paris, 1584). La Croix du Maine compares, to the advantage of France, the "three thousand authors" (in fact 2,031) inventoried in his "catalog" and the three hundred (in fact 159) who figured in Doni's *Libraria*.

In *La Bibliothèque d'Antoine Du Verdier, Seigneur de Vauprivas: Contenant le Catalogue de tous ceux qui ont escrit, ou traduict in François, et autres Dialectes de ce Royaume* (Lyons, 1585) recognition of the superiority of France does not refer explicitly to Italy. The model from which Du Verdier took inspiration was not Doni but Gesner: "In our times Conrad Gesner has gathered together all Authors whatsoever in three languages, Hebraic, Greek, and Latin, to his great honor and the common benefit." It was in reference to that ancient knowledge and that great example that Du Verdier constructed the catalog by which he intended to prove the excellence of the moderns. Du Verdier simply surveys modern authors "from sixty or seventy years past," whom he finds sufficiently numerous and excellent to obviate any need to name older writers, since before that time "our [authors] were somewhat heavy in their writings."

There are obvious similarities between Doni's *Libraria* and La Croix du Maine's *Bibliothèque*. Both inventory books (printed and in manuscript) written or translated into the vulgar tongue; both offer brief biographies of some of the authors whose works they list; both classify authors in strict alphabetical order by author's given name.

There are nonetheless fundamental differences arising from their quite different ways of conceiving the library without walls. First, there is a physical and formal difference between the two works: far from being a manageable small-format book in the manner of the *Libraria*, La Croix du Maine's *Bibliothèque* was a majestic folio volume, a *libro da banco*, to use Armando Petrucci's terminology, not a *libro da bisaccia* (saddlebag book) or a *libretto da mano* (little handbook).[20] Anton Francesco Doni's *Libraria* was founded on the practice of literary novelties; La Croix du Maine's *Bibliothèque* was based on the scholastic tradition of commonplace books. A literate man without originality, but not without prolixity, La Croix du Maine scrupulously calculated his compilation activities. He states that he wrote three hours per day, figuring that if in one hour he filled one sheet of paper of over one hundred lines, his yearly production was some one thousand sheets. It is certain that his work was organized intellectually according to the principle of the notebook or the commonplace book and that it gathered under one heading extracts from various authors' works. Hence the central importance that La Croix du Maine gave to the instruments for putting order into this proliferating material.

La Croix du Maine's work also differed from Doni's in that the *Premier Volume* of his *Bibliothèque* was "dedicated and presented to the King," whose engraved portrait figured on the page facing the dedication addressed to him. In both the *Desseins, ou Projects* of 1583 and the *Premier Volume de la Bibliothèque* published the following year, La Croix du Maine pursued the same aim of obtaining the sovereign's protection, which had cash value in terms of gratifications and posts. The originality of this "notice to erect a library," which preceded Naudé's project by a half century, lay in La Croix du Maine's desire to embody the immaterial and universal library of *loci communes* in a real library, one of whose bookcases (one of the *cent Buffets*) is depicted in the work.

Thus it was on the basis of the practice of the commonplace book that the totally original system of classification proposed by La Croix du Maine should be understood.[21] The work was divided into seven "orders": "sacred things," "arts and sciences," "descriptions of the Universe both in general and in particular," "the human race," "famous men in War," "the works of God," and "miscellanies of various Memoirs," subdivided into a total of 108 "classes." Unlike the twenty-one categories in Gesner's *Pandectarum sive Partitionum universalium . . . libri XXI* (Zurich, 1548), this organization was not intended to construct a tree of knowledge that proceeded by successive divisions. In Gesner's work, the *artes et scientia*

that make up *philosophia* were divided into *substantiales* (subdivided into *physica* or *naturali philosophia*, *metaphysica et theologia gentilium*, *ethica* or *morali philosophia*, *oeco-nomica*, *politica*, *jurisprudentia*, *medicina*, *theologia christiana*) and *praeparantes*. The latter category was subdivided into *ornantes* (*historia*, *geographia*, *divinatio et magia*, and *artes illiteratae et mechanicae*) and *necessariae*. These latter are further divided into *mathematicae* (*arithmetica*, *geometria*, *musica*, *astronomia*, and *astrologia*), and *sermocinales*, which were *grammatica et philologia*, *dialectica*, *rhetorica*, and *poetica*. A "Tabula de singulis pandectarum libris" arranged the various bibliographical classes according to a systematic order—the order of the divisions of *philosophia*, understood as a trajectory of knowledge leading from the *trivium* and the *quadrivium* to Christian theology. Unlike Gesner's taxonomy, the one proposed by La Croix du Maine has no overall governing system, but simply juxtaposes convenient headings in view of gathering together extracts and commonplaces. The fourth "order," for example, includes the bookcases devoted to "Man and what is dependent on him," "Diseases of Men and their remedies," "Illustrious and other Women," "Worldly Wisdom, or Instruction for men," "Divers exercises of Nobles and Gentlemen," "Miscellaneous exercises for the mind or the body," "Divers traffics and commerce of men on sea and on land," "Divers customs and fashions of living everywhere in the universe," "Men of honest exercise," and "Officers of long robe, or of the Judiciary."

Because it was to be an example worthy of being imitated, the "perfect and accomplished" library set up by the king was to be "the means for rendering the less learned or the totally ignorant well informed and knowledgeable, and also to make the vice-ridden exercise virtue if they conform to their Prince." Similarly, only the approval of the king could give authority to the *Premier Volume de la Bibliothèque* published in 1584 and to all the other books that were supposed to follow it. At the end of his dedicatory epistle, signed "FRANÇOIS DE LA CROIX DV MAINE, the anagram for which is RACE DV MANS, SI FIDEL' A SON ROY," La Croix du Maine suggests a more concrete version of the connection with the sovereign: "If your Majesty should desire to know what are the other [volumes] that I have written and composed for the ornamentation and illustration of your so famous and flourishing Kingdom, I am ready to provide a reading (when it may please you to so command me) of the Discourse that I had printed five years ago touching the general catalog of my works." Doni's *Libraria* had multiple dedicatees (one for each letter of the alphabet) and was aimed at a broader audience. La Croix du Maine's *Bibliothèque* supposes an exclusive relationship, established in proximity by reading aloud, between an author in search of protection and the monarch whose patronage he seeks.

A final difference between Doni's work and that of La Croix du Maine is that the Florentine's work was solidly connected with publishing activities; it was "constructed in direct contact with (and probably backed by) two of the publishers of

greatest cultural importance in the mid-sixteenth century," the Venetians Gabriele Giolito de' Ferrari, the publisher of the first edition and of the complete edition of the work, and Francesco Marcolini, the publisher of the *Seconda Libraria*.[22] La Croix du Maine's work originated in the construction of his private library, begun in his university years. That was the collection of printed books and manuscript memoirs that La Croix du Maine had transported to Paris in 1582.

The library that La Croix du Maine gathered together and, in part, produced provided support for all his undertakings. The library published in 1584 was in fact little more than an *epitomé* of a more ambitious undertaking, the projected *Grande Bibliothèque Françoise* (and its twin, a *Bibliothèque Latine*).

Imitating Gesner, La Croix du Maine added to his *Bibliothèques* volumes of *Pandectes Latines et Françoises* ("to wit, a very ample Catalogue of all the Authors who have written in each art, science, or profession of studies, which I have divided according to the seven arts that we call liberal") and several volumes of what he called a *mentionnaire*, "which is like a book of commonplaces, or an Aggregation of authors who have made mention of particular things."

Three different principles of classification exist concurrently in La Croix du Maine's works. The first organizing criterion is the category of the author. The author function, as Foucault defines it, is already sketched out here.[23] In his only published volume, as in his *Grande Bibliothèque*, La Croix du Maine makes this the basic criterion for assigning discourses, which are organized alphabetically by their authors' given names. In announcing that he will provide authors' "lives" (written, according to La Croix du Maine, in imitation of Suetonius, Plutarch, and Paolo Giovio), he equates men of letters with military leaders, famous for their exploits, and with princes and grandees, masters of their deeds.

Nonetheless, this first scheme for assigning works did not neglect the power of patronage. La Croix du Maine demonstrates this when he promises to indicate, for all the works mentioned in his unpublished *Grande Bibliothèque*, "*above all* [emphasis mine] the name of those men and women to whom they were dedicated, without omitting their full and entire qualities." A work thus belongs as much to the person to whom it has been dedicated as it does to the person who has written it and, in the ideal library as on the title page, the two names of the author and the patron stood as proof of this.

A third criterion for classifying works eliminates assignment to an individual in favor of placing each work within an order or class of knowledge. It is the tension between a proper name and a commonplace category that underlies Gesner's dual enterprise, the *Bibliotheca universalis* of 1545 and the *Pandectarum . . . libri XXI* three years later—a work that was presented as "Secondus hic Bibliothecae nostrae Tomus est, totius philosophiae et omnium bonarum artium atque studiorum Locos communes et Ordines universales simul et particulares com-

plectens." That same tension is reflected in La Croix du Maine's bibliographic zeal, even though his grandiose projects were never realized.

The almost simultaneous publication of the two *Bibliothèques* (May 1584 for La Croix du Maine; 1585, with an end printing date of 15 December 1584, for Du Verdier) raises a problem. La Croix du Maine took the initiative and preempted any possible accusation that he had plagiarized a work as yet unpublished, but whose publication he knew was imminent, as shown by the entry under "Antoine du Verdier" in the *Premier Volume de la Bibliothèque*. Declaring that he had never known of the existence of Du Verdier's work, La Croix du Maine claimed anteriority for his own venture, begun more than fifteen years before. He stressed the great distance ("more than a hundred leagues") that separated their places of residence, Paris and Lyons, where Du Verdier had settled in 1580 and held the post of *contrôleur général des finances*. For good measure, La Croix du Maine stated his scorn of plagiarism, and he founded the authority of his own book on the resources of his library and on his own knowledge: "As for the authors I have mentioned in my work, I have seen or read them, and have them still before me for the most part without having borrowed them." As in the travel narrations of the age, *auto-psie*—the action of seeing with one's own eyes ("I have seen them") became the exclusive guarantee of truth. That certification of authenticity through direct experience is not without paradox in an author who compiled extracts and commonplaces in innumerable notebooks that he then presented as learning itself.

Du Verdier, who was first a financial officer in the election of Forez, then *contrôleur général des finances*,[24] weighed heavier in the social scales than La Croix du Maine, a simple provincial gentleman who had moved to Paris. Du Verdier's response was two-pronged: first, he mocked the erudite rodomontades of his rival and expressed doubts about the existence of the many works La Croix du Maine promised. Furthermore, after Du Verdier examined the work in question (which he lists as being currently printed in Paris in his entry "François de La Croix du Maine" in his own *Bibliothèque*), he questioned the accuracy of the information given by La Croix du Maine because the latter surveyed fictitious or unproductive authors, including in his work "several [authors] that never were in nature, or if they were, have written nothing, as he himself confesses."

In its format (a heavy folio volume) and in its form (organized alphabetically by name), Antoine Du Verdier's *Bibliothèque* is akin to La Croix du Maine's work, but it is constructed on a different principle. Du Verdier's immaterial library is not directly dependent on the constitution of the author's own collection but is rather a conceptual entity detached from any particular material presence. Du Verdier's catalog is indeed a "library," but it is an all-inclusive library. In this exhaustive inventory every reader must be able to find what he or she needs and use that information to construct a library made up of real books.

It was in order to facilitate that task that Antoine Du Verdier gave the bibliographic information that was lacking in the *epitomé* published by La Croix du Maine. There was thus no contradiction between the design of a "universal library of French books," which necessarily had no physical reality, and the making of a bibliographic instrument useful to all who might want to create a collection.

The various meanings given to the term *bibliothèque* thus clearly show one of the major tensions that inhabited literate persons of the early modern age and caused them anxiety. A universal library (or at least universal in one order of knowledge) cannot be other than immaterial, reduced to the dimensions of a catalog, a nomenclature, or a survey. Conversely, any library that is actually installed in a specific place and that is made up of real works available for consultation and reading, no matter how rich it might be, gives only a truncated image of all accumulable knowledge. The irreducible gap between ideally exhaustive inventories and necessarily incomplete collections was experienced with intense frustration. It led to extravagant ventures assembling—in spirit, if not in reality—all possible books, all discoverable titles, all works ever written. "When it was proclaimed that the Library contained all books, the first impression was one of extravagant happiness."

As the twentieth century wanes, our dream is to be able to surmount the contradiction that has long haunted Western Europeans' relationship with the book. The library of the future seems indeed to be in a sense a library without walls, as were the libraries that Gesner, Doni, and La Croix du Maine erected on paper. Unlike their catalogs, which furnished authors' names, the titles of works, and at times summaries of or extracts from the works, the library of the future is inscribed where all texts can be summoned, assembled, and read—on a screen. In the world of remote relays made possible by digital and electronic communications, texts are no longer prisoners of their original physical, material existence. Separated from objects, texts can be transmitted; there is no longer a necessary connection between the place in which they are conserved and the place in which they are read. The opposition, long held to be insurmountable, between the closed world of any finite collection and the infinite universe of all the texts ever written is thus theoretically annihilated: now the catalog of all catalogs, ideally listing the totality of written production, corresponds to electronic access to texts universally available for consultation.

This projection of the future, written here in the present tense, retains something of the basically contradictory utopias proposed by Louis-Sébastien Mercier and Etienne Boullée. Still, it is perhaps not too soon to reflect on the effects of the change that the projection promises and announces. If texts are emancipated from the form that has conveyed them since the first centuries of the Christian

era—the *codex*, the book composed of signatures from which all printed objects with which we are familiar derive—by the same token all intellectual technologies and all operations working to produce meaning become similarly modified. "Forms effect meanings," D. F. McKenzie reminds us,[25] and his lesson, which should be taken to heart, warns us to be on guard against the illusion that wrongly reduces texts to their semantic content. When it passes from the *codex* to the monitor screen the "same" text is no longer truly the same because the new formal mechanisms that deliver it to the reader modify the conditions of its reception and its comprehension.

When the text is transmitted by a new technique and embodied in a new physical form, it can be subjected to manipulation by a reader who is no longer limited, as with the printed book, to adding hand-written notes in the spaces left blank in typographic composition.[26] At the same time, the end of the *codex* will signify the loss of acts and representations indissolubly linked to the book as we now know it. In the form it has acquired in Western Europe since the beginning of the Christian era, the book has been one of the most powerful metaphors used for conceiving of the cosmos, nature, and the human body.[27] If the object that has furnished the matrix of this repertory of images (poetic, philosophical, scientific) should disappear, the references and the procedures that organize the "readability" of the physical world, equated with a book in *codex* form, would be profoundly upset as well.

To realize the dream of the Renaissance bibliographers of making the particular place in which the reader finds himself coincide perfectly with universal knowledge, thus putting that knowledge within his grasp, inevitably presupposes a new definition of the concept of the text, wrenched away from its immediate association (so evident to us) with the specific form of the book—the *codex*—that some seventeen or eighteen centuries ago replaced another form, the *volumen* or scroll.[28] The historian's musings presented here lead to a question essential for the present—not the overworked question of the supposed disappearance of writing, which is more resistant than has been thought, but the question of a possible revolution in the forms of its dissemination and appropriation.

—Translated by Lydia Cochrane

Notes

1. Jorge Luis Borges, "The Library of Babel," in *Labyrinths: Selected Stories and Other Writings*, ed. Donald A. Yates and James E. Irby (New York, 1964), 54–55.
2. Gabriel Naudé, *Advis pour dresser une bibliothèque*, reproduction of the 1644 edition, with preface by Claude Jolly, "L'*Advis*, manifeste de la bibliothèque érudite" (Paris,

1990). On Naudé's text, see Jean Viardot, "Livres rares et practiques bibliophiliques," in *Histoire de l'édition française*, ed. Henri-Jean Martin and Roger Chartier, 4 vols. (Paris, 1982–86), vol. 2, *Le livre triomphant: 1660–1830*, 446–67, esp. 448–50; Viardot, "Naissance de la bibliophilie: Les Cabinets de livres rares," in *Histoire des bibliothèques françaises*, 3 vols. (Paris, 1988–91), vol. 2, *Les Bibliothèques sous l'Ancien Régime, 1530–1789*, ed. Claude Jolly, 269–89, esp. 270–71.

3. Naudé, *Advis*, 104. 4. Ibid., 12. 5. Ibid., 37.

6. Jean Sgard, ed., *Dictionnaire des journaux, 1600–1789* (Paris, 1991), nos. 144–74.

7. Roger Poirier, *La Bibliothèque universelle des romans: Rédacteurs, textes, publics* (Geneva, 1977).

8. Louis-Sébastien Mercier, *Tableau de Paris: Nouvelle Édition revue et augmentée*, 12 vols. (Amsterdam, 1782–83), vol. 6, *Dictionnaires*, 294–95.

9. For example, see Hans-Jürgen Lüsebrink, "L'Histoire des Deux Indes' et ses 'extraits': Un Mode de dispersion textuelle au XVIIIe siècle," *Littérature* 69 (1988): 28–41 (special issue on "Intertextualité et Révolution").

10. Louis-Sébastien Mercier, *L'An 2440: Rêve s'il en fut jamais*, ed. Raymond Trousson (Bordeaux, 1971), chap. 28, "La Bibliothèque du roi," 247–71. For quotations, see 247–78 and 250–51.

11. Jean-Marie Goulemot, "En guise de conclusion: Les Bibliothèques imaginaires (fictions romanesques et utopies)," in *Histoire des bibliothèques françaises*, 2:500–511.

12. Furetière was alluding not only to the *Bibliotheca universalis* of Gesner but also to Antonio Possevino, S.J., *Bibliotheca selecta qua agitur de ratione studiorum* (Rome, 1593; Venice, 1603; Cologne, 1607); Photius, *Myriobiblion sive Bibliotheca librorum quos legit et censuit Photius . . . Graece edidit David Hoeschelius . . . et notis illustravit, latine vero reddidit et scholiis auxit Andreas Schottus* (Rouen, 1653, after the Greek and Latin eds. published in Augsburg in 1601 and 1606); Philippe Labbé, S.J., *Bibliotheca bibliothecarum curis secundis auctior* (Paris, 1664; Rouen, 1672).

13. The two Spanish "libraries" that Furetière mentions are Nicolás Antonio, *Bibliotheca hispana, sive Hispanorum qui . . . scripto aliquid consignaverunt notitia* (Rome, 1672; 1696); and Andreas Schott [or Andreas Schott Peregrinus], S.J., *Hispaniae bibliotheca, seu de academiciis ac bibliothecis; item elogia et nomenclator clarorum Hispaniae scriptorum* (Frankfurt, 1608).

14. Theodore Besterman, *The Beginnings of Systematic Bibliography* (Oxford, London, 1935); Luigi Balsamo, *La bibliografia: Storia di una tradizione* (Florence, 1984), available in English as *Bibliography: History of a Tradition*, trans. William A. Pettas (Berkeley, 1990). Helmut Zedelmaier, *Bibliotheca Universalis und Bibliotheca Selecta: Das Problem der Ordnung das gelehrten Wissens in der frühen Neuzeit* (Cologne, 1992), was published after this essay was written.

15. There is an abundant bibliography on Gesner as a bibliographer: see Jens Christian Bay, "Conrad Gesner (1516–1565), The Father of Bibliography: An Appreciation," *Papers of the Bibliographical Society of America* 10 (1916): 53–88, published separately as *Conrad Gesner, The Father of Bibliography: An Appreciation* (Chicago, 1916); Paul-Emile Schazmann, "Conrad Gesner et les débuts de la bibliographie universelle," *Libri*, 1952–53, 37–49; Josef Mayerhöfer, "Conrad Gesner als Bibliograph und Enzyklopädist," *Gesnerus* 3/4 (1965): 176–94; Hans Widman, "Nachwort," in Konrad Gesner, *Bibliotheca Universalis und Appendix* (Osnabrück, Germ., 1966), i–xii; Hans Fischer, "Conrad Gesner (1516–1565) as Bibliographer and Encyclopedist," *Library*, 5th ser., 21 (1966): 269–81; Hans H. Wellisch, "Conrad Gesner: A Bio-Bibliography," *Journal of the Society for the Bibliography of Natural History* (1975): 151–247, 2nd ed., rev. and

published under the same title (Zug, Switz., 1984); Luigi Balsamo, "Il canone bibliografico di Konrad Gesner e il concetto di biblioteca pubblica nel Cinquecento," in *Studi di biblioteconomia e storia del libro in onore di Francesco Barberi* (Rome, 1976), 77–96; Joseph Hejmic and Václav Bok, *Gesner europaïsche Bibliographie und ihre Beziehung zum Späthumanissmus in Böhmen und Mähren* (Prague, 1988); Alfredo Serrai, *Conrad Gesner*, ed. Maria Cochetti, with a bibliography of Gesner's works by Marco Menato (Rome, 1990).

16. For a reprint of this text, see Anton Francesco Doni, *La libraria*, ed. Vanni Bramanti (Milan, 1972). See also Cecilia Ricottini Marsili-Libelli, *Anton Francesco Doni, scrittore e stampatore* (Florence, 1960); Amedeo Quondam, "La letterature in tipografia," in *Letteratura italiana*, ed. Alberto Asor Rosa, 8 vols. (Turin, 1983), vol. 2, *Produzione e consumo*, 555–686, esp. 620–36.

17. Quondam, "La letteratura in tipografia," 628–29.

18. Besterman, *Beginnings of Systematic Bibliography*, 23.

19. I shall quote from Du Verdier's and La Croix du Maine's works from the copies in the Bibliothèque nationale de Paris. On these two *Bibliothèques*, see Claude Longeon, "Antoine Du Verdier et François de La Croix du Maine," *Actes du Colloque Renaissance-Classicisme du Maine* (Le Mans, 1971; Paris, 1975), 213–33.

20. Armando Petrucci, "Alle origini del libro moderno: Libri da banco, libro da bisaccia, libretti da mano," in *Libri, scrittura e pubblico nel Rinascimento: Guida storica e critica*, ed. Armando Petrucci (Laterza, 1979), 213–33.

21. On the history of classification, see the very dogmatic E. I. Samurin, *Geschichte der bibliothekarisch-bibliographischen Klassifikation*, 2 vols., originally published in Russian (Moscow, 1955; Leipzig, 1964); on La Croix du Maine, vol. 1, 106–9. Samurin's *Geschichte* is also available as a single volume (Munich, 1977). See also Henri-Jean Martin, "Classements et conjonctures," in *Histoire de l'édition française*, ed. Martin and Chartier, vol. 1, *Le Livre conquérant: Du Moyen Age au milieu du XVIIe siècle*, 429–41.

22. Quondam, "La letteratura in tipografia," 623.

23. Michel Foucault, "Qu'est-ce qu'un auteur?", *Bulletin de la Société Française de Philosophie* 44 (1969): 73–104, reprinted in *Littoral* 9 (1983): 3–32. Also available in English as "What Is an Author?" in *Textual Strategies: Perspectives in Post-Structural Criticism*, ed. Josué V. Harari (Ithaca, N.Y., 1979), 141–60.

24. Claude Longeon, "Antoine Du Verdier (11 novembre 1544–25 septembre 1600)," in *Les Écrivains foréziens du XVIe siècle: Répertoire bio-bibliographique* (Saint-Etienne, France, 1970), 288–316.

25. D. F. McKenzie, *Bibliography and the Sociology of Texts* (London, 1986), 4.

26. Roger E. Stoddard, *Marks in Books Illustrated and Explained* (Cambridge, Mass., 1985). As examples of studies that take handwritten entries presented in printed works as a fundamental source of a history of reading and interpretation, see Cathy N. Davidson, *Revolution and the Word: The Rise of the Novel in America* (Oxford, 1986), 75–79; Lisa Jardine and Anthony Grafton, "'Studied for Action': How Gabriel Harvey Read His Livy," *Past and Present* 129 (1990): 30–78.

27. The fundamental work on the various definitions of the metaphor of the book in the Western philosophical tradition is Hans Blumenberg, *Die Lesbarkeit der Welt* (Frankfurt, 1981; 2nd ed., 1983).

28. On the difficult and controversial question of the shift from the *volumen* to the *codex*, see Colin H. Roberts and T. C. Skeat, *The Birth of the Codex* (London, 1983; reprint ed., 1987); Alain Blanchard, ed., *Les Débuts du codex*, Actes de la Journée d'études organisée à Paris par l'Institut de Papyrologie de la Sorbonne et l'Institut de Recherche et

d'Histoire des Textes, 3–4 July 1985 (Turnhout, Belg., 1989); and the revision pro-posed in Guglielmo Cavallo, "Testo, Libro, Lettura," in *Lo spazio letterario di Roma antica*, ed. Guglielmo Cavallo, Paolo Fedeli, and Andrea Giardina, 5 vols. (Rome, 1989), vol. 2, *La circolazione del testo*, 307–41; Cavallo, "Libro e cultura scritta," in *Storia di Roma*, Arnaldo Momigliano and Aldo Schiavone, eds., 4 vols. (Turin, 1988–), vol. 4, *Caratteri e morfologie*, 693–734.

JANE C. GINSBURG

Copyright Without Walls?: Speculations on Literary Property in the Library of the Future

Introduction

THIS ESSAY CONSIDERS THE application and adaptation of copyright law to the library of the future.[1] In this "library without walls," works will be accessible by computer to users near and far. While a printed book usually is read by only one person at a time, that same book in digital format may be simultaneously consulted by as many users as have PCs linked by modem to the library. Where collecting quotations from printed sources today requires transcription or photocopying, in the library of the future it may be possible to download and print out excerpts, or even the entire work, through the user's personal computer.

All of these uses involve reproductions or transmissions of the accessed works. Unless the works are in the public domain, these uses, if unauthorized, may be copyright infringements—at least under today's doctrines. Are literary property rights as we have known them inimical to a networked environment? Or can there be copyright without walls? If copyright requires "walls," what will replace it, and will the replacement prove more satisfactory to libraries and their users? Although some librarians have lamented the restrictive effects of copyright, and perceived overreaching applications by publishers,[2] a world without copyright may prove even less user-friendly. The reason is simple: in such a world, the information supplier, relying on contract, forgoes the benefits of the copyright law, but also evades important limitations on the copyright monopoly, notably the fair use privilege. In such a world, librarian-users might look back on existing copyright law with wistful nostalgia.

To project the future of copyright in the library of tomorrow, it will be helpful first to set the stage by briefly reviewing the role of copyright in the operations of the library of today. In the library of tomorrow the past will long remain present: copyright issues are posed when the library scans printed documents and distributes them in digital format. I will therefore consider copyright issues that arise in the transition from hard copy to digital media.

The second part of this essay will posit an information world of tomorrow in which all documents are available from the outset in digital format—indeed,

some of them may be available *only* in that format. In this context, a variety of copyright questions presents itself to tomorrow's librarians. Some of these issues concern the library as a conduit for information originating elsewhere: How will the library obtain access to these documents, particularly if it is not a national deposit library? On what basis can the library make this access available to users? More broadly, does copyright have any remaining role in a digital environment in which information suppliers impose contractual conditions on access to works?

Other issues derive from the library's role as a generator of information, such as catalogs and summaries of documents both within and outside the library's own holdings. In this context, predictions of copyright's infirmity may well prove premature. The library may both create its own copyrighted works and infringe others'. The library may be a copyright proprietor of the bibliographic database if it extends even a modicum of creativity to its selection or organization of the information. But if its database substantially reproduces works contained in the catalog, the library may also be infringing literary property rights in the referenced works.

Copyright
and the Hard-copy Library

Copyright and the library of the recent past. Until the advent of the photocopier, a library's activities rarely, if ever, implicated copyright considerations. A library circulated books and other documents; it did not copy them. Copyright comprises the exclusive—incorporeal—rights to reproduce and publicly perform or transmit works;[3] it does not reach the physical object that embodies the work. Thus, once the copyright owner sold a copy of the work, that copy—in its physical manifestation—became the personal property of its new owner, who could resell, lend, or otherwise dispose of her chattel.[4] So long as the library simply rotated possession of the book, the library remained fully within its rights as a property owner.[5] Library patrons might, of course, manually copy or type out portions of the book for personal use, but these limited reproductions would have fallen within the "fair use" and "fair dealing" exemptions of U.S. and Commonwealth law, or under explicit private copying privileges found in continental copyright legislation.[6]

Once libraries began to avail themselves of the photocopier, however, they could no longer neglect copyright considerations. Photocopying could be used to preserve books and to fill gaps in collections when original formats were no longer available. Beyond these functions, photocopying could increase the library's ability to service users by multiplying the number of available copies or parts of copies. But once copies are being made, copyright issues are posed.[7]

To evaluate the severity of the copyright challenge, it is necessary to sketch

the contours of the U.S. "fair use" privilege, and its foreign-law analogs. Most, if not all, copyright laws afford certain exemptions from the author's or copyright owner's rights. One of the most widespread exceptions excuses copying that does not substitute for sale or licensing of the work.[8] In the U.S. "fair use" exception, the question of potential economic harm caused by copying is central, but the broader public-interest issue of access to knowledge weighs heavily in the balance as well, especially when the reproduction is made for nonprofit educational purposes.[9] In addition, in the 1976 Copyright Act Congress set forth special highly detailed rules under which libraries could engage in unauthorized copying.[10] These rules generally exempt archival copying[11] but would not permit a library to substitute photocopies for regular acquisitions.[12]

The U.S. Copyright Act also details circumstances in which libraries may make copies of works or portions of works for users for their private study or scholarship.[13] Because the statute circumscribes the instances in which libraries may supply copies of documents to patrons, an important copyright issue concerns the provision of photocopies to persons outside the scholarly and nonprofit communities. Many libraries, particularly legal, medical, and scientific libraries, have clients who pay for the library's services. If these clients are not nonprofit institutions, any "fair use" claim is likely to be questionable. These clients may be able to save time and money by using a library to deliver documents; however, there is no reason they should be able to save additional money at the expense of the copyright holder.[14] In these instances, libraries charge and remit royalties to the Copyright Clearance Center (CCC), a consortium of publishers that collectively licenses its repertory of works to various users, including university libraries. The collective licensing mechanism permits the library to copy any and all of the licensed works, without having to obtain separate permissions each time a copy is made.[15] If the copyright owner of the client-requested work is not a member of the CCC and has no other licensing program with the library, the library is supposed to seek permission to copy each work each time an outside request is made. Not surprisingly, this can be a burdensome process.

Organizations for the collective licensing of photocopy rights exist in many other countries as well. In some countries, collective licensing resembles the activities of the CCC: libraries may remit the monies, but the fees are actually paid by the libraries' users. In others, however, the government may negotiate with the collectives to pay a sum covering all photocopying in educational institutions, thus covering nonprofit end users, such as students and teachers, as well.[16]

Scanning the role of copyright in the transition to digital libraries. Many libraries are converting portions of their print collections to digital format. At the time they acquired the works they now intend to scan, the libraries may not have negotiated digital conversion rights. If the works thus to be converted are still protected by copyright, in what instances must permission to digitize be secured?

Putting the work into digital format is only the beginning, from both a copyright holder's and a user's point of view. Once the work has been converted, it can be accessed in several ways. It can be viewed on-screen, it can be printed out, and it can be downloaded. Under copyright law, all of these constitute reproductions.[17] Which, if any, modes of access might be considered "fair use" or benefit from another copyright exception? Analysis will require analogizing digital access to the kinds of reproductions that qualified for exemptions in the hard-copy world. Applying the rules of yesterday's library to regulate use of technologies that will radically transform tomorrow's library might seem like trying to use a phonograph designed for wax cylinders to play a CD. Nonetheless, this analysis may at least help identify those areas in which current copyright rules may require reshaping.

Conversion to digital format. Converting a hard-copy work to computer-readable form entails reproducing the work. If the work is scanned, it is first reproduced as an "image file," containing an electronic picture of the pages. If that file is then converted to ASCII form,[18] the resulting "text file" constitutes the creation of another reproduction. Because the copyright owner normally enjoys the exclusive right to reproduce the work, must the library therefore secure permission to perform the conversions? I would anticipate that, at least in the U.S., rules that today afford libraries exemptions for archival photocopying also apply to optical scanning and text-file creation for the same purposes. If the library is permitted to make the copy, it should not matter what technology was employed to generate the reproduction.[19]

Making the file available to reader-viewers raises a different problem. For a printed text, reading presents no copyright issues because copyright does not attach to the physical object. In the digital world, however, looking at the text does implicate copyright, because viewing the text on-screen entails making a reproduction of the text.[20] The question therefore arises whether the digital equivalent of "looking at a book" requires the copyright owner's permission. I suspect that, although this act of viewing is analytically prima facie copyright infringement, were the issue to be litigated a court would excuse the copying as fair use. Although the work's format is different, the library is providing the same service of making the work available to users. A policy favoring easy and inexpensive public access to works of authorship underlies the fair use exemption.[21] A court may therefore be unlikely to look sympathetically on a copyright holder's attempt to impose a pay-per-view requirement simply to access the work when no permanent copies are made.

The preceding discussion has addressed the access question as if the library would treat the digital copy like a hard copy, making it available only to one user at a time. In fact, however, digital copies, unlike hard copies, can be made available simultaneously to as many users as a network or online service permit. Establishment of a digital copy therefore can lead to a multiplication of user copies.

Creation of text files in order to multiply the number of copies in the library's collection would also, at least under today's rules, fall outside the free-copying boundary.[22] The practical effect of converting a text from hard copy to digital is the creation of digital copies in addition to—or in lieu of—hard copies; accordingly, unless it determined to forgo one of the signal benefits of digital technology—multiplicity of access—the library will have to confront the copyright consequences of multiple reproductions. Thus, copyright considerations necessarily influence a library's disposal of its digital files, even if no copyright was infringed when the file was initially established.

For example, suppose the library wished to preserve its copy of a work still protected by copyright, such as Herbert Howell's 1942 treatise on copyright law,[23] which we will assume was printed on acid paper and is slowly but surely burning itself up. We will further assume that the book is out of print, and unavailable at a reasonable price from other sources. In the U.S., these facts would entitle the library to convert the book to digital format. They would also permit the library to make the digital copy available to one user at a time. But they would not entitle the library to make the digital copy available to many users at a time. That kind of reproduction would require the authorization of the copyright holder.

By the same token, suppose that the library had multiple copies of certain high-demand, in-print books, such as Allan Farnsworth's treatise on contract law, and that the library wished to save shelf space by substituting digital copies for all but one hard copy. The first question is whether the library may establish the initial digital file without the copyright owner's permission. Because this work is currently available, the library cannot avail itself of an archival copying exception; it would, therefore, probably need permission to digitize in the first place.

How many copies may the library simultaneously generate from the Farnsworth digital file? Arguably, the library should be able, without permission, to create as many digital copies as it had hard copies. But this argument is weak; after all, if a library had four copies of a commercially available text, and loses three because borrowers fail to return them, the library is not entitled to free photocopies to restock its inventory.[24] Moreover, the library's privileges "extend to the isolated and unrelated reproduction . . . of a single copy"; they do not cover "concerted reproduction" of "multiple copies of the same material, whether made on one occasion or over a period of time."[25] Systematic substitution of digital for hard copies of particular works seems more like "concerted" than "isolated and unrelated" reproductions. As a practical matter, however, this question may not arise in this fashion: once the library must negotiate with the copyright owner to engage in the initial digitalization, it should also negotiate the number of copies, and the further reproductions that users make from them.

Copying from the digital copy. Let us assume that we are starting from a text file that the library created either within the bounds of the library's free-copying or fair use privileges, or with permission from the copyright owner. We already

know that making that file available to more than one user at a time means reproducing the work in a manner exceeding the traditional library prerogatives. The copyright owner will therefore assert legal control over the amount of and manner of access to the work. Similarly, the copyright owner will wish to regulate any further reproductions that libraries or users might make by printouts or downloading. Indeed, the owner might demand compensation for certain reproductions that would otherwise qualify for an exemption under the library copying or fair use provisions. Because the U.S. Copyright Act explicitly permits contractual override of the library copying privileges,[26] it is foreseeable that, once the library is required to negotiate with the copyright owner in order to obtain permission to digitize at all, or to make more than one simultaneous copy, the copyright owner will endeavor to impose a host of additional conditions on access to and further reproduction of the work.[27]

On the other hand, if the library enjoyed a privilege initially to digitize the work and it restricts availability to one user at a time, the copyright owner would have no claim to demand additional compensation unless any further reproductions made by the library or its users exceeded the statutory exemptions. It is important to consider the application of these exemptions in the digital environment. This examination requires not only transposing the copying media from photocopying to printouts and downloading, but also evaluating whether the transposition leads to results inconsistent with the policies underlying the current rules.

Reproductions that currently qualify for exemption under U.S. law include a user's printing out or downloading short excerpts for private study or scholarship[28] and a library's provision of a copy of even an entire work to a user for private study or scholarship when an original is no longer available at a fair price.[29] However, in the second case, one might anticipate that the library should make such a reproduction available only in hard copy. A digital copy too easily lends itself to further reproduction, thereby undermining the reprint or reissue markets for the work and exceeding international norms of exempted reproductions.[30]

For the same reason, in those countries that permit free "private copying" of entire works, the exemption should be tailored to exclude private copying by means of downloading. Even if the further digital copy is made for purely private purposes, the medium so enhances the copy's potential to be fruitful and multiply that temptation is best avoided. Similarly, the provision of the U.S. copyright law that exempts a library from liability for copies made by patrons if the copies were produced on equipment made available, but unsupervised by, the library, requires rethinking.[31] While the exemption might continue to apply for user-accessible printers attached to workstations, the library should be liable if, without the copyright owner's permission, it makes equipment available to users that enables them to download entire files.[32]

Interlibrary loan practices afford a further illustration of the potential incompatibility of the current library copying exemptions and the electronic environment. The U.S. Copyright Act permits libraries to "participat[e] in interlibrary arrangements that do not have, as their purpose or effect, that the library or archives receiving such copies or phonorecords for distribution does so in such aggregate quantities as to substitute for a subscription to or purchase of such work."[33] Sending digital copies on interlibrary loan could achieve precisely that effect—because once a library acquired a digital copy, absent further limitations, the library would no longer require hard copies (or publisher-authorized digital copies). Were digital-format works to be made available through interlibrary loan, the originating library should at least accompany any freestanding digital version, such as a floppy disk, with limitations as to the number of users and the kinds of further reproductions. Similar limitations should apply to copies sent via electronic mail. Alternatively, the originating library could restrict the requesting library to online access from the originating library while denying permission to download; authorized downloading would be subject to the requesting library's agreement to destroy the copy.

Several of the accommodations just proposed have in common the attempt to respond to the transition to "libraries without walls" by erecting walls wherever possible. Thus, in a model in which hard-copy copyright concepts continue to dominate, fair use will remain shaped by the model of the printed book. That means, for example, that the law imposes a wall between the first, free, digital onscreen copy and the subsequent multiple copies that can be viewed simultaneously. The law maintains walls between documents and users by obliging libraries to limit user access to onscreen views or short printouts, because access by downloading too easily lends itself to generation of uncontrollable user copies.

These accommodations, and the concepts underlying them, will require further evaluation and adjustment in the library of tomorrow in which the documents originate from publishers in digital form.[34]

Copyright and Contract
in the Digital Library

Copyright law has supplied protection to authors who could not otherwise control the exploitation of their works. It has traditionally presumed a world in which, but for copyright, unauthorized reproductions would be pervasive and unremediable. As Justice Holmes observed, "In copyright, property has reached a more abstract expression. The right to exclude is not directed to an object in possession or owned, but is now in vacuo, so to speak. It restrains the spontaneity of men where, but for it, there would be nothing of any kind to hinder their doing as they saw fit. It is a prohibition of conduct remote from

persons or tangibles of the party having the right. It may be infringed a thousand miles from the owner and without his ever becoming aware of the wrong."[35]

In the library of the future, these assumptions may no longer apply. Today, I will not know if a library user in Berkeley, in Boston, in Bonn, or in Brisbane is photocopying this article.[36] But tomorrow, when "we are all connected," and this article is available worldwide online, I will have the means to know who is reading the article onscreen, and who is downloading or printing out excerpts or complete copies. Here, as elsewhere, knowledge is power: I (or my digital publisher) can condition online access to my article on compliance with whatever restrictions I wish to impose.

Libraries as conduits for digital information: acquisitions and restrictions on use. In imagining a world in which most new works will be available in digital format, and in which many will be available only in digital format, I have suggested that one question is whether copyright retains any relevance. Another question is whether libraries retain any relevance. After all, if users may obtain the information by logging onto the publisher, or onto a third-party information provider such as Dialog or Prodigy, what use does a library serve? The user need no longer go to a place where works are gathered; assembly of works from many sources will be accomplished by modem. The library itself will be an electronic phenomenon, affording digital access to its own and to others' collections of works. Why should an information provider resort to the conduit of a library, when it can connect directly to the user? If the provider nonetheless gives libraries access to its information, how will the provider control the information so that the library does not displace the provider's customers?[37]

From the publisher's perspective, libraries may still afford valuable publicity for their works, and may reduce the transactions costs of dealing with individual users. Libraries may also become the repositories of digital files whose commercial value has ebbed; although library acquisitions of current material may pose conflicts with a publisher's program of dissemination, libraries may become storehouses of older works whose retention would be burdensome for the publisher, but which still have importance for scholars. From the user's perspective, tomorrow's library may resemble a full-service "help line"; the librarian of tomorrow will assist users in understanding and navigating the myriad available databases and other digital sources.

If digital publishers determine that it remains worthwhile to give libraries access to their works, they will almost certainly seek to condition that access upon compliance with a variety of restrictions. Publishers may wish to prevent certain kinds or quantities of user reproductions, or to charge for all uses over single viewings of the document. Publishers could enforce these limitations directly if the library is simply providing the user with a computer connection to the publisher. Publishers then could themselves limit initial access (onscreen viewing) to

certain categories of users; they could prescribe a maximum number of bytes to be reproduced by printing out or downloading; or they could completely prohibit downloading.

Digital documents that are distributed in freestanding format, such as CD-ROMs, may prove more susceptible to unlicensed copying than online sources. Once the document leaves the producer's control, the producer cannot know firsthand who is viewing, who is copying, and how many copies are being made. Nonetheless, technology affords the producer a variety of extra-copyright protections. For example, the library would not be permitted to make the CD-ROM directly accessible to users, but would be obliged to make it available through the library's local-area network (LAN). Such a network would respond to individual user-access codes, enabling the library either to screen out or to charge more for certain kinds of users identified by the publisher. The LAN could be programmed to limit or prohibit printing or downloading. Moreover, both CD-ROMs and online services could be "booby-trapped" to prevent unauthorized printing out or downloading, for example, by flashing warnings that the user's request may not be fulfilled; by "freezing" if the user attempts to make a further copy; or even by sending a virus to the user's disk if the user persists.

Contracting out of fair use. Some of the limitations sought by digital publishers might override rights of libraries and users under fair use and library copying privileges, even after these privileges have been adjusted to account for the greater potential of digital copies to supersede or compromise the publisher's market. The U.S. Copyright Act provides that the library's privileges in no way affect "any contractual obligations assumed at any time by the library or archives when it obtained a copy or phonorecord of a work in its collections."[38] It seems clear, therefore, that the policies underlying these exceptions to copyright protection are not violated if the library agrees to forgo its privileges.

The same provision of the U.S. Copyright Act also states that the library's special statutory privileges in no way affect "the right of fair use,"[39] and the legislative report accompanying the 1976 Act indicates that the special privileges accorded to libraries give them greater leeway to copy than they would enjoy by application of fair use alone.[40] Fair use in effect affords libraries and users some kind of free-copying "safety net." One should inquire, therefore, whether a library's agreement with a publisher to forgo whatever free-copying privilege might be available under fair use is permissible under the copyright law.

In addressing this question, one might first inquire why copyright law is at issue at all. In the world here posited, the publishers abandon copyright and seek to regulate all use by contract, on the premise that where copyright's protections have nothing more to offer them than do contract and technological controls, copyright taken together with its exceptions, particularly fair use, offers them less. In pressing a contract claim, the publisher is seeking to achieve copyright-

like protection, unencumbered by copyright's countervailing limitations. Do the Copyright Act and the federal policies underlying it permit enforcement under state contract law of what one might call the publisher's re-edition of copyright?

This question calls for application and analysis of federal preemption doctrine. The Copyright Act precludes state law claims when the subject matter to be protected is copyrightable, and when the rights asserted are equivalent to exclusive rights under copyright.[41] Since what the publisher purveys almost always constitutes "original works of authorship,"[42] the first prong of the preemption test will usually be met. The right asserted by the publisher is the right to prevent copying; this appears equivalent to the exclusive right under copyright to reproduce the work in copies.[43] However, substantial authority supports the proposition that rights under contract are not equivalent to rights under copyright. The nonequivalence derives from the difference between a contract and a property-right claim. A contract binds only those who are parties to it. A property right, such as a copyright, is good "against the world"; it is not based on any relationship between the party having the right and the party allegedly infringing the right. Hence Justice Holmes's statement that copyright "is a prohibition of conduct remote from persons or tangibles of the party having the right." A property right confers something in the nature of a monopoly in its object; a contract right governs relationships between persons, it does not regulate things.

Thus, in cases in which plaintiffs have invoked contracts granting them protection unavailable under copyright, courts have rejected preemption challenges. As one court stated: "A party by contract may agree to pay for ideas, even though such ideas could not be protected by copyright law. Rights under such an agreement are qualitatively different from copyright claims, and their recognition creates no monopoly in the ideas involved."[44]

Judicial enforcement of contracts barring one party from copying the other's ideas is particularly noteworthy, because the federal determination not to protect ideas under copyright is very clear. The Copyright Act explicitly provides "in no case does copyright protection for an original work of authorship extend to any idea."[45] One might argue that this implies that no legal protection should be available, whatever the source.[46] By upholding contracts that confer greater rights than copyright affords, these cases necessarily reject that proposition. As a general matter, moreover, U.S. intellectual property preemption decisions do not sustain the objection that limitations inherent to a formal intellectual property regime cannot be avoided by resort to a state law doctrine that dispenses with those constraints, at least when other constraints accompany the state law protection. The Supreme Court has, accordingly, declined to find state trade secret laws preempted by federal patent laws, even when they bear on the same subject matter.[47] While patent protection is of short duration (seventeen years), and requires the patent holder to disclose the invention, a trade secret lasts as long as it remains a secret and, by definition, carries no requirement of disclosure.

Though patent laws demonstrate a strong public policy in favor of making the invention available and understandable so that others may build on it, trade secrets advance none of those goals.

Nonetheless, the Supreme Court held that neither did trade secrets conflict with those goals, because trade secret protection was far more fragile than patent protection. Unlike patents, trade secrets do not protect against independent generation of the invention or against reverse engineering. In essence, trade secrets govern relations between the trade secret proprietor and those persons, such as employees, that she permits, in confidence, to learn the secret. Most trade secret cases concern a breach of that confidential relationship.[48] Trade secrets thus offer an illustration of the successful resistance of a state law information right to federal intellectual property preemption. What saves the state law right appears to be its contractual (and therefore relatively weak) nature, even though one must acknowledge that the party advancing the contract would endeavor to push that contract right as close to a property right as possible.

But what if the premise underlying the nonpreemption cases proved false? In the digital environment posited here, contract protection may not be the fragile creature presumed in prior intellectual property preemption decisions. If access to works could be obtained only through the information provider (directly or through an authorized online distributor), and if copying could be electronically tracked or prevented, no "third parties" to the contract would exist. When "we're all connected," no functional difference may exist between a contract and a property right. At that point, it becomes necessary to consider whether limitations incorporated in the copyright law should be imported to its contractual substitute. With respect to libraries and their users, one should inquire whether some kind of fair use exception is appropriate. This might take the form of a judge-made right of "fair breach," or legislatively imposed mandatory library-user rights.[49]

Such exceptions could be appropriate if they salvaged important copyright policies that would otherwise be frustrated in the move from copyright to contract. But the policies underlying fair use can be variously described, and not all characterizations conflict with the contract regime here imagined. Under one approach, fair use is a response to market failure: when the copyright owner cannot efficiently license the kind of copying in which the defendant is engaged, the use may proceed unlicensed.[50] If, by contrast, there exist "reasonably priced, administratively tolerable licensing procedures,"[51] no gap exists for fair use to fill, and there is no need for the exemption. The contractual regime discussed here is consistent with this characterization, because the publisher can charge for every kind of use, and the electronic media can keep track of it all.

Nevertheless, fair use can also be described as an exception to the copyright owner's prerogatives, or even as a subsidy from the copyright owner, in favor of uses that benefit the public. This interpretation emphasizes the constitutional

purpose of copyright to "promote the progress of science (knowledge)." If, in certain instances, the law upheld the copyright owner's refusal to license the kind of copying in which a defendant seeks to engage, we would be permitting copyright to hinder rather than promote the progress of knowledge.[52] The progress of knowledge would be impeded because a defendant would have incorporated copied material into a new endeavor, such as a work of criticism or scholarship, that would have contributed to public enlightenment.[53]

That the "public benefit" rationale for fair use would mandate grafting a fair use exception onto our imagined contract regime is not clear. This rationale has traditionally focused on "productive use" of the copied material in the creation of new works, for which copying from old works may be necessary; it does not necessarily supply a justification for "intrinsic" copying—copying of a work to make "ordinary" use of it.[54] Yet under the 1976 Act, libraries have enjoyed some degree of fair use copying, even though that copying would seem to be for "intrinsic" purposes. Library copying remains consistent with the public benefit rationale, if one contends that access to the works is either the predicate for a subsequent productive use of them, or, more abstractly, promotes the progress of knowledge, because researchers will be enriched by what they read.[55]

A role for "fair use breach" or mandatory user rights could be imagined if publishers imposed conditions on libraries that denied meaningful access to their works. More likely, however, publishers will not deny such access; they will want to charge for it in ways they did not charge, and could not have charged, in the hard-copy world. Today, the effect of declaring a use "fair" is to make it free of charge. Perhaps in a digital world, fair use would not be an all-or-nothing matter; a court might uphold the copying at issue, but require the copyist to pay for it. The price the user would pay would be less than the price the information-provider would have charged. In effect, a compulsory license regime might split the difference between user claims to free access and publisher initiatives to charge for all uses.[56]

But a compulsory license would be justified only if the publisher's rates were "unreasonable" according to criteria yet to be articulated. In the digital world, it remains to be examined if publishers will in fact make libraries pay "too much" for any access to documents. In a digital world, libraries could avoid the sunk costs of building and maintaining a paper collection. Online subscription would have to cost more on a yearly basis than hard-copy libraries cost, before the price-gouging objection would be borne out. Digital publishers might make libraries pay for simultaneous access beyond the first user, but this may still cost less than investing in additional hard copies. Moreover, competition among digital publishers should keep prices down. A more reasonable fear may be rooted in monopoly concerns: no competition exists because some publishers are the sole source of certain documents; these publishers, if unhappy in their negotiations with libraries, will someday pull the plug on the online system. In the hard-copy

world, the library always is in possession of the books; in the digital world, if the online publishers cut the supply, the library is left with inert workstations.

This examination has shown that digital media, by enabling publishers to keep track of all the uses being made of their works, also give publishers the opportunity to charge for all uses, including those that would have been free in a hard-copy world. One may therefore fear that publishers will be sorely tempted to "overcharge" for access to and copying of their works, especially if there is no longer a fair use doctrine to hold them in check. However, we do not now know whether, even accounting for new publisher charges, digital media will also enable libraries to save money overall. Let us assume that library savings do not offset publisher increases when contract replaces copyright regulation of library acquisition and use of digital works. A need may nonetheless exist to impose a fair use exception or other means of price control. If so, the law regulating book-sellers will have come full circle from the 1710 English Statute of Anne, the pre-cursor to our copyright law. While that statute was the first copyright act, it was not limited to granting authors exclusive literary property rights. Knowing that copyright-vested authors would assign their rights to printers and booksellers (antecedents of modern publishers), and suspicious of the booksellers, the English Parliament included a mechanism for review and reduction of book prices. Should books be sold "at such a Price or Rate as shall be Conceived by any Person or Persons to be High and Unreasonable," that person could complain to a variety of authorities who were empowered to summon the publisher "to Examine and Enquire of the reason of the Dearness and Inhauncement of the Price or Value of such Book or Books." If the price were deemed unreasonable, the inquiring official enjoyed "full Power and Authority to Reform and Redress the same, and to Limit and Settle the Price of every such Printed Book and Books, from time to time, according to the best of their Judgments, and as to them shall seem Just and Reasonable."[57] However, the history of this provision of the Act of Anne does not bode well for price regulation: the section was repealed because it proved unenforceable.[58]

Libraries as information generators. Finally, one should address the copyright role of libraries as originators of digital information. Digital libraries will compile online or disk-stored catalogs of their own and perhaps others' holdings. These catalogs may also include search programs to help users identify sources they seek from the mass of digital data. Having compiled the catalog or devised the search program, the library may be the holder of copyright in an "original work of authorship." The copyright laws would protect the library's exploitation of these works. However, if the catalog includes substantial portions of the listed works, the library may also be infringing third parties' copyrights.

Copyright in library catalogs. A catalog is a "compilation"; it is "formed by the collection and assembling of preexisting materials or of data that are selected, coordinated, or arranged."[59] If the selection, coordination, or arrangement man-

ifests a minimal degree of creativity, the catalog will be copyrightable.[60] The U.S. Supreme Court recently denied copyright protection to a white-pages telephone directory.[61] While the copyright threshold was very low, the Court believed that the phone book failed to meet it: its creation entailed no selection (the book listed all telephone subscribers in the locality), and no originality of arrangement (alphabetical). How would a library's digital catalog fare under the Court's analysis?

The selection criterion may not favor the library, at least not if the catalog covers the library's entire collection. While valuable for researchers, comprehensiveness may be counterproductive to asserting a copyright. Even so, if the catalog satisfies the arrangement criterion, that alone would support a copyright. The arrangement may be standard to the genre; for example, books might be retrieved according to author, title, or subject listings. Nonetheless, if the catalog includes some nonstandard features, it might manifest sufficient selection or arrangement of information to be considered minimally "original." These features might include atypical combinations of listings,[62] or supplemental information, such as bibliographic references concerning some (but not all) other libraries' collections, or online services.

If the catalog is "original," copyright would protect it against unauthorized copying, but only to the extent that "original" material is copied. Thus, at least under current U.S. copyright law, downloading all the listings would infringe, but extracting standard information would not.[63]

Copyright infringement by libraries of works referenced in the catalogs and search programs. Imagine the following online catalog of a library's collection:

Level 1: Author, title, and subject listings
Level 2: Publisher-prepared abstract(s) of the chosen work(s)
Level 3: Excerpts from the chosen work(s), displayed in response to search terms selected by the researcher
Level 4: Full text of the chosen work(s)

This kind of catalog could be a very effective research tool, but portions of it also implicate rights in the referenced works. Level 1 does not raise a copyright issue, because this information is basic and involves minimal, if any, copying from the work. Level 2 is unlikely to offend the copyright laws, because the abstract contains the bare information necessary to identify the major ideas of the work.[64] As such, either it is an uncopyrightable collection of "ideas," or copying it would be considered *de minimis.*

Level 3 becomes more troublesome, because the excerpts may be substantial. If so, they pose a prima facie case of infringement, which might be overcome by a fair use defense. Similarly, including full-text works might constitute either infringement or fair use. In both cases, the catalog and its search program, as imagined, would make it possible for the user to call up onscreen all or substantial

parts of the digital work. If the catalog and search program do no more, these acts seem analogous to simply reading a hard-copy book and should not implicate copyright interests in the work viewed. However, if it is also possible for many users at one time to access the work in whole or in part, then the catalog is generating multiple copies of the referenced work, and this may exceed fair use bounds. By the same token, a "level 5" that enabled users to download the works would provoke copyright conflicts, although one that permitted printouts of excerpts might not.

In many instances, the library's catalog will not be able to act independently of the laws covering the works it lists. The catalog might be viewed as a search tool that interacts with text files. But if the text files originate from a digital publisher, the library's agreement with the publisher will govern incorporation of the works in the catalog. Copyright in the listed works remains an issue for digital works generated by the library (for example, by scanning its hard-copy collection) and for which the library did not previously obtain permission to make these kinds of reproductions.

Conclusion

Legal analysis of copyright or contract rights in the library of tomorrow depends heavily on conditions that one can try to predict today, but that are likely to prove quite different tomorrow. Extrapolating from today's laws, and experiences in the transition to digital media, affords some guidance, but also highlights the shortcomings of analyses grounded in past presumptions derived from the capacities of print media. Existing copyright may be inadequate for the "library without walls." But substituting a contract regime may become far too burdensome, at least from the library's perspective. If the copyright doctrine of fair use survives the rise of contract in the digital world, it must be a different kind of fair use, one consciously adapted to the expanded capacities of digital communications. But its contours—never precise, even in the hard-copy world—cannot be articulated without a clearer picture of the kinds of contracts and communications the library of tomorrow will call into being.

Notes

Many thanks to Jim Hoover, Professor of Law and Law Librarian, Columbia University School of Law, and to Paul Smith, Columbia University School of Law, Class of 1993.
1. Although this essay primarily concerns U.S. copyright law, I will endeavor to point out parallels or contrasts with general principles of other Western copyright systems.

In addition, although the law governing the relationship of copyright and libraries in the U.S. is rather detailed and technical, I will attempt to avoid entanglement in the minutiae of our domestic regime. This essay therefore should not be considered a primer on copyright and libraries in the U.S. For a fuller and more precise treatment of that topic, see, e.g., Randall Coyne, "Rights of Reproduction and the Provision of Library Services," *Arkansas Little Rock Law Journal* 13 (1991):485; Laurie C. Tepper, "Copyright Law and Library Photocopying: An Historical Survey," *Law Library Journal* 84 (1992):341

2. E.g., generally, Anne Okerson, "With Feathers: Effects of Copyright and Ownership on Scholarly Publishing," *College and Research Libraries* 52 (1991): 425–40; Nancy Marshall, "Copyright and the Scholarly Community: The Library's Responsibility to Guarantee User's Rights," Paper delivered at the Fifth U.S.-Japan Conference on Libraries and Information Sciences in Higher Education, October 1992. See also Steven Gilbert and Peter Lyman, "Intellectual Property in the Information Age," *Change* 21 (1989): 22–30: "If higher education cannot effectively deal with these issues, vendors and funders will be less receptive to doing business with . . . colleges and universities."

3. See 17 U.S.C. § 106 (1988) (rights under copyright).

4. See 17 U.S.C. §§ 109(a), 202 (1988) (distinguishing ownership of incorporeal copyright from ownership of the physical object).

5. In some countries, however, the owner is compensated each time a book is lent from a library to a user. Such a system is commonly called the "public lending right" (PLR), and, as of 1988, was in place in twelve countries. Jennifer M. Schneck, "Closing the Book on the Public Lending Right," *New York University Law Review* 63 (1988): 878, 880–81 and n. 29. All but Germany have enacted the PLR as a regime separate from the country's copyright system (ibid., 897). In the U.K., the purpose of such differentiation is based on the notion that PLR is merely a payment to the author for a "service" rendered; Brigid Brophy, *A Guide to the Public Lending Right* (Aldeshot, Eng., 1983), 53. Others have suggested a less objective purpose: that a country adopting the PLR and incorporating it into the copyright regime would have to recompense foreign authors under the Berne and Universal Copyright Conventions. See Schneck, "*Closing the Book,*" 898.

6. For U.S. law see, e.g., Paul Goldstein, *Copyright: Principles, Law, and Practice* (Boston, 1987), § 10.2.2.1 (a noncommercial, nonprofit activity "would support a presumption that the use is fair"). For U.K. law see, e.g., E. P. Skone James et al., *Copinger and Skone James on Copyright*, 12th ed. (London, 1980), § 513 (need for fair dealing arises only after a substantial portion of the work has been taken). For French law, see France, Code of Intellectual Property, art. 122-25, 2o (permitting copying for private use).

7. For a helpful general review, see generally Tepper, "Copyright Law and Library Photocopying."

8. See, e.g., Berne Convention for the Protection of Literary and Artistic Works, art. 9.2, September 1886, 828 U.N.T.S. 221 (hereinafter Berne Convention): "It shall be a matter for legislation in the countries of the Union to permit the reproduction of such works in certain special cases, provided that such reproduction does not conflict with a normal exploitation of the work and does not unreasonably prejudice the legitimate interests of the author."

9. See 17 U.S.C. § 107 (1988), setting forth four factors that courts shall take into account: "(1) the purpose and character of the use, including whether such use is of a commercial nature, or is not nonprofit educational purposes; (2) the nature of the copyrighted work; (3) the amount and substantiality of the portion used in relation to

the copyright work as a whole; and (4) the effect of the use upon the potential market for or value of the copyrighted work." The Supreme Court has stated that the fourth factor (economic harm) "is undoubtedly the single most important factor," Harper & Row v. Nation Enters., 471 U.S. 539, 566 (1985). Compare *Meeropol v. Nizer*, 417 F.Supp. 1201, 1205–6 (S.D.N.Y. 1976), aff'd in part, rev'd in part 560 F.2nd 1061 (2nd Cir. 1977): "Courts in recent years have come to recognize that there are occasionally situations in which the copyright holder's interest in a maximum financial return must occasionally be subordinated to the greater public interest in the development of arts, science, and industry."

10. See 17 U.S.C. § 108 (1988).

11. By "archival copying," I mean copying to preserve a document from degradation or destruction, when a replacement is not available. See 17 U.S.C. § 108(c).

12. For example, § 108(d) and (e) of the 1976 Copyright Act authorize copying for interlibrary loan, but only so long as the copy goes to the user; the requesting library may not retain the copy.

13. See 17 U.S.C. § 108(d) and (e). Section 108(f)(1) of the Act also exempts libraries from liability for copies made by patrons engaged in "unsupervised use of reproducing equipment located on [library] premises," without limitation as to the patrons' purposes for making the copies.

 Under many foreign copyright laws, the kind of copying § 108(f)(1) addresses would most likely be considered "private copying," and therefore exempt. By contrast, copies made by third parties, even for the user's private enjoyment, might not qualify for the private copying exemption. See, e.g., Cass. civ. lre, Decision of 7 March 1984, 1985 (Juris-Classeur Periodique) II 20351, note R. Plaisant (Fr.) ["affaire Rannou-Graphie"] (for private copying exemption to apply, the user must make the copies). The World Intellectual Property Organization has proposed permitting certain kinds of library provision of reproductions to patrons, but only if no collective licensing arrangement is available for the territory concerned. The WIPO proposal would permit libraries to make free copies for purposes of replacement or conservation. See WIPO, Committee of Experts on a Possible Protocol to the Berne Convention for the Protection of Literary and Artistic Works, § 88(a) and (b), reprinted in *Copyright* 28 (1992): *March*, 70–71.

14. Particularly when they can pass along the copying costs to their own clients, see *American Geophysical Union v. Texaco, Inc.*, 802 F. Supp. 1, 26 n. 24 (S.D.N.Y. 1992).

15. On the CCC and its work with university libraries, see, e.g., Jane C. Ginsburg, "Reproduction of Protected Works for University Research or Teaching," *Journal of the Copyright Society* 39 (1992): 181, 208–11, 216 and works cited therein. See also Tepper, "Copyright Law and Library Photocopying," 357–58, and Coyne, 485, n. 5, and 499–50 (discussing role of CCC in photocopying liability cases). Compare William Patry, *The Fair Use Privilege in Copyright Law* (Washington, D.C., 1985), 320–32 (discussing library photocopying and fair use in light of legislative history of § 108).

16. On collective licensing societies in other countries, see Stanley Besen and Sheila N. Kirby, *Compensating Creators of Intellectual Property: Collectives That Collect* (Santa Monica, Calif., 1989); Stanley Besen et al., "An Economic Analysis of Copyright Collectives," *Virginia Law Review* 78 (1992): 383, 388, n. 23, and 408, n. 95; Gunnar Karnell, "The Legal Situation Concerning Reprography in the Nordic Countries," *International Review of Industrial Property and Copyright Law* 15 (1984): 685; Jon Rudolph, "Licensing, Collecting, and Clearing for Reprographic Rights," *Copyright* 23 (1987): 148.

17. A printout is a traditional form of reproduction. Storage on a disk or in the computer's

fixed memory is also a reproduction, even though the copy is not directly perceptible. Viewing the work onscreen requires storage of the work in the computer's volatile memory. Although the work will be erased from that memory once the machine is turned off, both U.S. and European Community copyright law have determined that the temporary storage nonetheless constitutes a reproduction. See, e.g., the 1978 Commission on New Technological Uses of Copyrighted Works (CONTU) final report, "The Input Issue," excerpted in Alan Latman, Robert A. Gorman, and Jane C. Ginsburg, *Copyright for the Nineties*, 3rd ed. (Charlottesville, Va., 1989), 166–68, concluding that inputting into a computer's random, erasable memory, constitutes a reproduction. CONTU's recommendations were codified in 1980 at 17 U.S.C. §§ 101, 117 (1988). See also European Council Directive on the Legal Protection of Computer Programs, 91/250 1991 O.J. (L 122), art. 4(a) (hereinafter EC Directive). "Restricted acts" include inputting.

18. ASCII stands for "American Standard Code for Information Interpretation," and is the most unadorned machine readable text form, consisting only of characters without formatting information (such as "bold face" or "underline"). ASCII files can be transferred between machines operating on incompatible formats, such as IBM and Macintosh.

19. Arguably, the library should be entitled to make a free copy only of the image file, and not of the text file, because the latter is a second reproduction, and is not strictly necessary to preserving the document. On the other hand, the text file enhances access to the work, and the purpose of preserving the work would be not only to possess it, but to be able to make it available to readers. Conversion of the image file to a text file is probably consistent with the policies underlying library copying exemptions; the tensions with copyright are more likely to arise over the exploitation of the text file, rather than over its creation.

20. See note 17 above. In addition, sending the text from the library's files to the user's workstation is a "public performance" by means of transmission; see 17 U.S.C. § 101 (1988). Cf. *On Command Video v. Columbia Pics.*, 777 F.Supp. 787, 789–90 (N.D. Cal. 1991) (hotel's transmission of video cassettes of motion pictures to guest rooms constituted public performance, even though no more than one guest room could access a particular film at any time).

21. See L. Ray Patterson, *The Nature of Copyright: A User's Guide* (Athens, Ga., 1991), 218, discussing library access in a fair use analysis. All copyright limitations, including fair use, are grounded in the purpose of advancing knowledge and promoting welfare; Patterson, 2. Patterson, "Understanding Fair Use," *Law & Contemporary Problems* 29 (1992):265 ("Fair use ceases to be viewed as taking advantage of the copyright owner and becomes, instead, a recognized right of the user.").

22. Cf. House Conference Report no. 94-1733, 94th Cong., 2nd sess. 72–73, reprinted in U.S.C.C.A.N. 5810, 5813-14 (under CONTU guidelines, interlibrary loan requests within one calendar year of more than six copies from one periodical—entire serial, not merely a single issue—constitute a "substitution of subscription," and exceed the scope of free copying under § 108[g][2]).

23. Herbert Howell, *Howell's Copyright Law* (Washington, D.C., 1942) (currently William Patry, *Latman's The Copyright Law*, 6th ed.; [Washington, D.C., 1986]).

24. However, if an "unused replacement" is not available at a "fair price," the library may make a replacement copy. See 17 U.S.C. § 108(c)(1988). On the other hand, § 108(a) limits the library's reproduction to "no more than one copy."

25. 17 U.S.C. § 108(g)(1)(1988).

26. See 17 U.S.C. § 108(g)(4) (1988). Whether libraries can "contract out of" their and their users' fair use privileges will be discussed below.

27. In fact, this is already happening in the dissemination of works on CD-ROM. Publishers are distributing these works to libraries subject to "site licenses" that exclude certain acts, such as interlibrary loan, or dissemination to users in sections of the university outside the library's normal users, as is permissible under the statutory library copying exemptions.

28. In U.S. law, this kind of copying would probably be considered a fair use under 17 U.S.C. § 107; in many other copyright laws, this copying would be considered "private," and therefore exempt, or would qualify for exemption because of its brevity.

29. See 17 U.S.C. § 108(e) (1988).

30. See Berne Convention, art. 9.2.

31. See 17 U.S.C. § 108 (f)(1) (1988).

32. The distinction drawn here between hard copy and digital copying assumes that the former does not pose a threat of multiple and multigenerational copying. This distinction may lose significance as optical scanning technology improves and comes within the reach of the average consumer. At that point, the user will be able quickly and easily to convert the hard-copy reproduction to digital format.

33. 17 U.S.C. § 108(g)(2) (1988).

34. For convenience, I am defining "tomorrow's" library to include digital media to which the library subscribes, even though some of today's libraries already obtain many documents in CD-ROM or online form.

35. *White-Smith Music Pub. Co. v. Apollo Co.*, 209 U.S. 1, 19 (Holmes, J. concurring) (1908).

36. Although, I may ultimately find out, if the library is making the copy and has a license with a collective licensing authority that requires the library to track its copying.

37. Some libraries, such as the Library of Congress and the Bibliothèque de France, are national deposit libraries. Domestic copyright or other law requires deposit of copies of the work in the national library. See, e.g., 17 U.S.C. § 407 (1988) (Deposit to the Library of Congress); France, J.O. 1 July 1943, pp. 1778–79, D.C.L. Loi no. 341, 21 June 1943.

But deposit does not of itself entitle the library to copy the work. Having secured the copy by legal compulsion, the library may be able to avail itself of applicable library copying or fair use exemptions in copyright law to engage in limited disclosure of the work. Wider dissemination, however, will require permission.

Libraries that are not national deposit institutions may have difficulty making acquisitions from digital publishers. Similarly, digital publishers may be reluctant to authorize a national library to permit access to and copying of the work to any greater extent than the limited amount to which it is entitled under applicable copyright laws' free copying privileges—as adjusted to take account of digital media.

38. 17 U.S.C. § 108(f)(4) (1988). As indicated earlier, libraries are in fact being asked to forgo some of their copying privileges in return for "site licenses" from publishers of digital media. One might inquire why publishers of hard-copy media did not seek to contract out of library copying privileges. The answer may be that, even if the thought of doing so had occurred, it is too difficult to control the copying of hard-copy media, especially when the document is available from sources other than directly from the publisher.

39. Ibid.

40. See H.R. Rep. no. 94-1476, 94th Cong., 2nd Sess. at 74, reprinted at 1976 U.S.C.C.A.N. 5659, 5687-88 (hereinafter "House Report" citing to U.S.C.C.A.N.):

"The doctrine of fair use applies to library photocopying, and nothing contained in section 108 . . . is intended to take away rights existing under the fair use doctrine. To the contrary, section 108 authorizes certain photocopying practices which may not qualify as fair use."

41. See 17 U.S.C. § 301 (1988).

42. Copyright protects "original works of authorship," 17 U.S.C. § 102(a) (1988), but the standard of originality is very low. See, e.g, *Feist Pubs. v. Rural Tel. Serv.*, 111 S.Ct. 1282, 1288 (1991); *Atari v. Oman*, 979 F.2nd 242, 244–45 (D.C. Cir. 1992).

43. 17 U.S.C. § 106(1) (1988). Arguably, the right sought to be enforced by contract is not "equivalent" because it is not freighted with the limitations that attend rights under copyright (section 106 makes its grant of rights "subject to sections 107 [fair use] through 120"). However, Congress intended to preempt state laws granting greater protection as well as state laws granting identical protection. See House Report, above note 40, at 5746: "The preemption of rights under State law is complete with respect to any work coming within the scope of the bill, even though the scope of exclusive rights given the work under the bill is narrower than the scope of common law rights in the work would have been."

44. *Smith v. Weinstein*, 578 F.Supp. 1297, 1307 (S.D.N.Y.), aff'd without opinion, 738 F.2nd 419 (2nd Cir. 1984). *Accord, Acorn Structures, Inc. v. Swantz*, 846 F.2nd 923, 925 (4th Cir. 1988); Gorman, "Fact or Fancy?: The Implications for Copyright," *Journal of the Copyright Society* 29 (1982): 560, 605–10. See also House Report, above note 40, at 5747: "Nothing in this bill derogates from the rights of parties to contract with each other and sue for breaches of contract." This quotation taken from the House Report accompanying the bill that became the 1976 Copyright Act does not end the analysis, because the quote describes a portion of the bill that was subsequently deleted.

45. 17 U.S.C. § 102(b) (1988).

46. Cf. *Bonito Boats, Inc. v. Thunder Craft Boats, Inc.*, 489 U.S. 118, 151 (1989) (holding a state law forbidding copying of unpatented boat hulls preempted by federal patent law; the Supreme Court declared that the patent laws "embody a congressional understanding, implicit in the Patent Clause itself, that free exploitation of ideas will be the rule, to which the protection of a federal patent is the exception. . . . The federal patent laws must determine what is protected, but also what is free for all to use."

47. See *Kewanee v. Bicron*, 416 U.S. 470, 479 (1974).

48. See Restatement of Unfair Competition §§ 40–43. Other trade secret cases involve acquisition of the information through other wrongful means, such as fraud or trespass. Rarely does a successful trade secret claim protect the information itself, when there is no conduct that is otherwise wrongful. But see ibid. § 43, ill. 5 (flying over a factory and taking photographs to discover a trade secret, while not trespass, nonetheless violates the trade secret).

49. Cf. EC Directive, above note 17, at arts. 5.3, 6, and 9 (establishing mandatory software user rights to analyze and decompile the program).

50. See generally, Wendy Gordon, "Fair Use as Market Failure: A Structural Analysis of the *Betamax* Case and Its Predecessors," *Columbia Law Review* 82 (1982): 1600; Goldstein, above note 6, at §§ 10.1.1–10.1.3. See also *American Geophysical Union*, 802 F.Supp. 1, 24–26 (S.D.N.Y. 1992) (rejecting fair use claim by for-profit corporation whose researchers photocopied from scientific journals). The *American Geophysical* court distinguished *Williams & Wilkins Co. v. U.S.*, 487 F.2nd 1345 (Ct. Cl. 1973), aff'd by an equally divided court, 420 U.S. 376 (1975)—which had found photocopying by the National Institutes of Health to be fair use—on the ground that at that time, no

"convenient, reasonable licensing system" was available, while such licenses were available (from the CCC) today (at 25).

51. *American Geophysical Union*, 802 F.Supp. at 250.
52. See, e.g., *Rosemont Enters. v. Random House*, 366 F.2nd 303, 307 (2nd Cir. 1966): "The [fair use] practice is permitted . . . so that the world may not be deprived of improvements, or the progress of the arts retarded") (quoting *Sayre v. Moore*, 102 Eng. Rep. 138, 139 [K.B. 1801]). See also L. Ray Patterson, *User's Guide*, 102, noting that fair use is central to balancing author's rights in furthering goal of learning: "Access to copyrighted materials is necessary if that fundamental goal is to be fulfilled."
53. See generally Pierre Leval, "Toward a Fair Use Standard," *Harvard Law Review* 103 (1990): 1105, 1111–16 (stressing the claims of "transformative uses" to the fair use exemption).
54. See Leon Seltzer, *Exemptions and Fair Use in Copyright* (Cambridge, Mass., 1978), 24 (rejecting application of fair use privilege to "intrinsic uses").
55. Cf. *Sony Corp. of America v. Universal City Studios*, 464 U.S. 417, 455 n. 40 (1984) (stating that copying for "personal enrichment" can qualify as a fair use).
56. An alternative is to permit the publishers to set their own rates, subject to judicial review for reasonableness. See *In Re Turner*, 1991 WL 331491 (Aug. 8, 1991 S.D.N.Y.) at *1 (challenge, pursuant to terms of antitrust decree governing ASCAP's activities, to ASCAP's rates for blanket license to cable operators).
57. 8 Anne c. 19, sec. IV. On this provision, see generally, Harry Ransom, *The First Copyright Statute* (Austin, Tx., 1956), 96, 101–2.
58. See Act of 12 George II (1739); Ransom, *First Copyright Statute*, 107 n. 13. See also John Feather, *A Dictionary of Book History* (New York, 1986), 79–80 (discussing history of Act).
59. 17 U.S.C. § 101 (1988).
60. See *Feist Pubs. v. Rural Tel. Serv.*, 111 S.Ct. 1288, 1294 (1991).
61. Ibid. at 1295–97.
62. See, e.g., *Key Pubs., Inc. v. Chinatown Today Pub. Enters.*, 945 F. 2nd 509, 512, 515–16 (2nd Cir. 1991) (unusual listings in plaintiff's Yellow Pages of Chinese businesses met originality standard).
63. The EC Commission has proposed a Directive on the Legal Protection of Databases that would afford not only copyright protection to original electronic compilations, but a new "right to prevent unfair extraction" of nonoriginal material; COM (92) 24 Final at arts. 2.5, 8.
64. Or because the publisher-supplied abstract comes with permission to make this kind of use.

DOMINIQUE JAMET AND HÉLÈNE WAYSBORD

History, Philosophy, and Ambitions
of the Bibliothèque de France

As is to be expected, any project as conceptually innovative and architecturally ambitious as the Bibliothèque de France has elicited passionate controversy over its contents and even its meaning right from the start. But the free play of the imagination, enriched by confrontation and the exchange of ideas, is at present hobbled by time constraints. Construction of the Bibliothèque de France began on 23 March 1992; in its present phase, certain priorities having to do with what the building will contain have to be fixed and irreversibly set into motion.

For the Bibliothèque de France, the time for action has come.

The architect has put the finishing touches on his project. The administrative and political infrastructure for the completion of the project has been created. The minister of culture and the secretary of state for public works have conferred upon André Miquel, president of the Board of Directors of French Libraries, the task of organizing a commission responsible for determining, together with the Etablissement public de la Bibliothèque de France, guiding principles for the future library's intellectual organization.

We will, then, call to mind first the history of this colossal undertaking before presenting its founding philosophy, a philosophy that confers upon the Bibliothèque de France a unique and original character.

History

On 14 July 1988 President François Mitterrand proclaimed, and thus launched, the project of a new national library—a "très grande bibliothèque" known today as the Bibliothèque de France (fig. 1). President Mitterrand has not ceased since that moment to follow closely the progress of this the largest of the large public works projects of his two seven-year terms. In so doing, he continues a long French tradition of great public works, which may be royal or republican, but which has always had a centralizing thrust, as can be seen in the examples stretching from the Louvre to the Pompidou Center. Yet President Mitterrand,

having laid the basic framework for the future library, has not tried to play the role of a great architect, head engineer, or supreme librarian. To effect the plan, a professional work group, the Etablissement public de la Bibliothèque de France, was created, as has been the case in other projects of this scale. Such a procedure is aimed at insuring the most dynamic and efficient integration of the diverse aspects of the project. Once the future library comes into being, the Etablissement public will give way to the permanent corporation of the Bibliothèque de France, according to the statutes which will have been enacted along the way.

Where the modalities of work and of decision-making are concerned, the conception and the construction of the Bibliothèque de France has been a collective endeavor in which a panopoly of experts—specialists, professionals, and researchers in and around the winning architect—have participated. Beginning with the overall orientation laid out by President Mitterrand, the basic features of the project have been produced through consultation with the scientific community, with future users, and especially with professionals at the Bibliothèque nationale. The plans were approved by the Scientific Board of Advisers of the Etablissement public de la Bibliothèque de France, headed by Roger Chartier, and confirmed by the board that oversees French libraries.

One has heard a lot about the short time required for the construction of the Bibliothèque de France—"only" seven years. One year for organizing and judging the architectural contest on the basis of a prospectus of the project; three

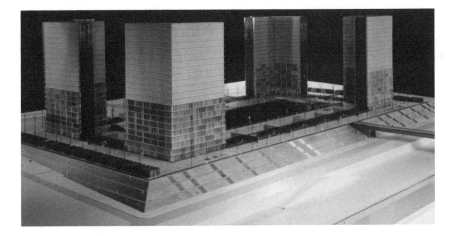

FIGURE 1. Dominique Perrault, Bibliothèque de France, maquette. Photo: Etablissement public de la Bibliothèque de France (EPBF).

years of constant back and forth between the architect's offices, the technical and library management services of the Etablissement public, and experts belonging to various work groups; three more years for construction. This is all, to be sure, a tight schedule, but one that nonetheless leaves time for reflection, consultation, protestation, reconciliation, and reorientation.

An initial consensus on the design provided the various planning teams with a year's grace period and offered no hint of the intense polemic that would shake the project during 1991. However, the lesson was there to be learned in connection with the other large public works projects throughout French history. These have often elicited a violent outcry at the outset before eventually enjoying glory and consecration. In this connection we must not forget the Eiffel Tower or, more recently, the pyramids of the Louvre.

It has been necessary to clarify our original plan and to satisfy those who have raised objections. And to this end the governing authorities have organized a special committee composed of competent and impartial specialists responsible for studying the question. Their report, delivered in January 1992, affirmed the soundness of the original proposals and of the teams assembled to organize the project. It confirmed the overall credibility of the project as we had conceived it despite a certain number of criticisms of which the most important had to do with the spread-out design of the buildings and the reduced ratio of usable to actually constructed space. President Mitterrand responded to the report by reducing the height of each tower by two stories (seven meters) and increasing the storage space in the foundation and in the actual library portion of the Bibliothèque de France. Now that work has begun at the actual site, the work crews continue to make progress in keeping with the original spirit of the project and its ambitions.

Ambitions:
Toward a Philosophy of Openness

The Bibliothèque de France can be situated, first and foremost, in the best tradition of the Bibliothèque nationale, which continues to accomplish the great work incumbent upon all national libraries—that of keeper of the national patrimony. Nonetheless, the role of the former, as President Mitterrand has defined it, is that of an entirely new type of library. Embracing all fields of knowledge, the Bibliothèque de France will welcome readers from all walks of life and will put at their disposal the most modern computer technology. It will also constitute the very heart of a national bibliographic and documentary network, which future Administrators of the Bibiothèque de France will be able to link up with other comparable networks elsewhere in Europe and the rest of the world.

One of the founding principles of the project is to make accessible to

researchers and readers information and documentation covering every branch of knowledge. This means the creation of new departments such as those relating to law, economics, political science, hard sciences, and technology. These new departments will complete and complement the strong holdings of the Bibliothèque nationale in literature, history, and, more generally, in the humanities.

In order to accomplish these objectives the Etablissement public de la Bibliothèque de France is pursuing an active acquisitions policy, especially in the areas of science and technology, but also in those of law, economics, and political science. We have also stressed the purchase of foreign publications. By the time the Bibliothèque de France opens in 1995, it will have acquired approximately 400,000 volumes, accessible to more specialized researchers as well as the public at large. Thus the Bibliothèque de France will have become a pluridisciplinary library without having sought a specific and illusory concentration in any particular field, especially in the sciences. It will be for scientific researchers a reference library for fields other than their specialties. And in this way it will better be able to contribute to furthering one of the dominant characteristics of contemporary science, that is, its interdisciplinary nature.

But the expansion of fields of knowledge will not, and cannot, where such an innovative project is concerned, be limited only to written material. The Bibliothèque de France will also integrate image and sound. Sound already plays a large role in the Bibliothèque nationale through its Phonothèque and the copies of records and CDs which it acquires through copyright. Henceforth, however, research in all disciplines will be based increasingly on the study of new territories of image and of sound, which, alongside of books, constitute objects of knowledge and of memory in their own right.

Pictures and sounds in their diverse fixed, moving, recorded, and digitalized forms constitute a documentary stratum which will be integrated in the new library across the range of specific departments. One department, for example, will assimilate the collections presently housed in the Phonothèque of the Bibliothèque nationale and will henceforth be responsible for the copyright deposit of audio material. This department has already undertaken a new program of acquisitions. By 1995 its holdings will include approximately 5,000 hours of radio recording, 5,000 hours of animated images, and more than a million stills. The Bibliothèque de France will thus consummate the marriage of the universe of Gutenberg with that of McLuhan.

The question still remains, Who will have access to this immense treasure of books, periodicals, images, and sounds?

Municipal libraries in France currently welcome a wide public of general readers who seek classic works as well as recent publications. Just as these libraries do not attempt to serve the needs of university researchers and students, university and research libraries, or the libraries connected to other centers of docu-

mentation are not equipped to receive the public at large. In the case of the Bibliothèque nationale, its mission of collecting and conserving the national patrimony renders access to its holdings more difficult—even though this has changed in recent years. The situation for all great archival, scientific, or artistic institutions is one of a progressive gap between conservation and diffusion.

The founding principle of the Bibliothèque de France, proclaimed by the President of the Republic and inspired by democratic ideals, is the opening of the future library to as wide a public as possible, a principle not without its special challenge, but which has nonetheless been reaffirmed in the report of the National Governing Board of Libraries. Such a principle situates the project of the Bibliothèque de France at the center of a seemingly paradoxical set of competing claims. An entirely new kind of library, conceived in global terms, it is required to fulfill its divergent missions in order to satisfy the various expectations of a widely diverse clientele: researchers as well as the general public. If successful, the Bibliothèque de France will become a great archival depository while at the same time serving as an agent of culture, stimulating the desire to read in the widest possible public.

At a moment in history when the new wealth of nations—Japan, North America, Europe—is based upon their capacity to create complex systems for the processing and communication of information, could one possibly conceive of a library for the twenty-first century that would not include from the beginning the most up-to-date technologies, especially those of the computer age? The Bibliothèque de France will carry out its mission of preserving and organizing the national heritage, of making it available to the widest public, by recourse to computer technology.

The automatic transfer of documents, online catalogs (a top priority that President Mitterrand has defined as the "common landscape of all the libraries of France"), computer workstations—these are all new means of access favoring rapid and easy delivery of the material contained in various collections. In addition, the digitalization of 150,000 to 200,000 works to be completed by the library's opening in 1995 will facilitate both the rapid circulation of documents and computer-assisted research; it will also encourage the preservation of original documentary material, which will not necessarily need to leave the stacks in order to be utilized.

Thus the Bibliothèque de France envisages the computerized management of the life cycle of the book. It will permit librarians and archivists to control the diverse stages of its acquisition, classification, and handling, just as if its catalog card—indeed, its identity card—were its complete medical record. The transfer of books will also be automated according to the system currently used in the municipal library of Bordeaux.

Endowed with the most efficient tools for the consultation and communica-

tion of information, the Bibliothèque de France, henceforth the legal depository (*dépôt légal*) of copyright, has assumed the task of maintaining the collective catalog of France, and can hardly remain a major institution isolated from the rest of the universe of books, images, and sound. Its creation has already shaken France, the world of books, and it has benefited all types of libraries and centers of documentation; for this reason the Bibliothèque de France will necessarily lie at the center of a network composed of the major municipal, university, and research libraries to which it will eventually be connected.

The Etablissement public de la Bibliothèque de France, in collaboration with the government agency responsible for the Management of the Book and of Reading (Direction du livre et de la lecture) and with the office of libraries of the Ministry of National Education, has already set out a program of technical and financial assistance for the computerization of holdings dated prior to 1810 or for special collections. This plan, covering the period from 1991 to 1995, includes 22 municipal libraries and 31 university libraries. A study group has also defined, within a wider context, a concept of a regional documentary pole that will be associated with the Bibliothèque de France. In this way a true partnership has been created between a single institution and other libraries and centers of documentation throughout France as a preliminary step toward the establishment of network links with foreign libraries, including the great libraries of the United States—a fascinating preview of the twenty-first century.

In conclusion, we have sought in this brief outline of the history, philosophy, and ambitions of the Bibliothèque de France to make a simple point. It is in the process of coming into being, it will be open, democratic, innovative, but all of these things within a perspective ensuring the greatest respect for the past. Welcoming to both researchers, open to the wider public, a pure form, transparent, monumental, yet intimate, the Bibliothèque de France offers a symbolic contrast to the dark, disturbing labyrinth over which presides, until the final catastrophe, Jorge, the old blind monk, crazy about books and thirsting for hidden knowledge (Borges of course) in the beautiful parodic novel of Umberto Eco.

Beyond our everyday practices and experience, it is necessary to turn our vision toward the coming decades. In 1995 the library will be opened to its diverse constituencies, but the project will not be complete, because the Bibliothèque de France, like all great endeavors of the spirit, can only be imagined as a process of constant coming into being and renewal.

GÉRALD GRUNBERG AND ALAIN GIFFARD
New Orders of Knowledge,
New Technologies of Reading

He is misinformed who would declare himself his own contemporary.
—Stéphane Mallarmé

To national libraries falls the task of preserving for any given society the record of its past. The question of remembering (and thus of forgetting) is the fundamental and eternal mission of a national library, the symbolic meeting place of memory and knowledge. Beyond such a permanent condition, the extremely rapid development, on the one hand, of the social, economic, and cultural context in which this mission is carried out and, on the other hand, of the technologies deployed toward that end make conjecture about the future extremely risky. All the more so since libraries for the most part have more impact upon their cultural surroundings than they do upon the evolution of technology. Representing, in effect, a market that is too narrow to do otherwise than adopt technologies created in the industrial sector for the purpose of mass marketing, libraries are essentially a place for the absorption of existing technologies rather than a place where new technologies develop. They can only expose and perhaps extend certain changes in reading practices, which also on occasion have a determining effect upon the nature of knowledge itself.

This is not one of the primary objectives of the Bibliothèque de France, but it will certainly be one of its major effects. Yet we will not indulge here in such speculation. The project of the Bibliothèque de France is not a futuristic one, but one which seeks to develop, here and now, all aspects of reading—particularly scholarly reading—as the chief goal of the library.

Reading is already in and of itself a highly complex practice to which any national library is especially devoted. More than other libraries, a national library is supposed to contain considerable holdings of primary sources. This is what makes the British Library, the Library of Congress, or the Bibliothèque nationale so special. But even the best collection of holdings remains a dead letter if it is not accompanied by a technological apparatus that permits access to it. No matter how compelling the fantasy of the perfect preservation of the past may be, a library only becomes an active site of memory and of knowledge when it enables the meeting between its holdings and its readers. And just as there is no collection whose choice of contents, mode of organization, and means of access do not determine the perception and reaction that each reader has of and to it, there is also no such thing as an innocent reader. The interaction between the two is, in fact, a relatively recent and largely unexplored phenomenon, one to which the new technologies contribute by the very practices that they encourage. Such inter-

action is, in any case, an active principle that lies at the heart of the project of the Bibliothèque de France.

The New Encyclopedism

One of the most widespread clichés in France as well as in other industrialized countries is that reading is in a state of crisis. It is worth asking if there is not a relation, an institutional rapport, between this crisis of reading and the more effaced crisis called the information explosion that is shaking the soundest assumptions of library management.

Reading, contrary to popular opinion, is not taken for granted so much as the contents of reading, i.e., the canon—in the humanist tradition, a series of texts constituted over time and forming a coherent body of references. This is what Gabriel Naudé, the librarian at the Mazarin, refers to in 1627 in his *Advis pour dresser une bibliothèque*: "The first rule that one must observe is to furnish above all a complete collection of the best and most important authors, ancient or modern, selected from the best editions, whole or in part, and accompanied by the most learned and best interpreters and commentators." Though the classics were the foundation of the library's collection, this in no way meant that the fields covered were limited. Gabriel Naudé adds: "One should not omit all those who have innovated or changed something in the sciences, for to do so would be to encourage the enslavement and the weakness of our mind, to cover up the lack of knowledge we have of such authors by the scorn we have of them due to the fact they are opposed to the ancients." For this reason Naudé specifies that a library should include among its holdings Copernicus and Galileo alongside of Aristotle.

The realization of this encyclopedic ideal has become increasingly difficult today for the following reasons. The appearance of industrial printing in the course of the nineteenth century and especially in the twentieth has brought with it a prodigious production at the same time that new disciplines in all fields of knowledge have multiplied. The identification of the "best and most important authors" has become extremely complicated. Furthermore, the book is in competition with other means of communication, while the industrial production and diffusion of information itself competes with the traditional economy of libraries. Finally, the "end of master narratives" (Marc Augé) characteristic of our own "fin de siècle" is probably not without its effect upon the disappearance of the notion of a stable canon.

The Bibliothèque de France, which inherits the Bibliothèque nationale along with its missions, cannot escape these questions. But beyond acquiring the present collections of the Bibliothèque nationale (which will benefit from better means of preservation in the future building than in the present one), just what will the

future library offer by way of reading matter? In addition to the legal deposit of all copyright material and its efficient preservation and communication, what "politics of documentation" should we adopt in order to serve the needs of the users of a great research library? No matter how essential to the constitution of the national memory, the "dépôt légal" does not by itself permit the creation of a first-rate scientific collection or even of a true library in the sense that Gabriel Naudé understood it. A library is not only a collection but also an ensemble of scientifically sophisticated intellectual tools.

Preserving the Past
and Drifting

The national collections of the Bibliothèque nationale reflect an encyclopedic acquisition policy that remained in effect until the end of the nineteenth century. The richness of these older holdings in French and foreign sources attracts scholars from all over the world. In spite of the creation of the "dépôt légal" in 1537, requiring the deposition of copies of all published books, the royal library was rich especially in exceptional acquisitions and in humanist works, due to the policy of certain ministers of state and scholarly ambassadors of acquiring throughout Europe the holdings of sumptuous humanist libraries. The library was at that time truly encyclopedic, encompassing the domains of science, history, and philosophy. These collections are the fruit of a more voluntarist spirit than that prevailing under the rather inefficient system of "dépôt légal."

The French Revolution did not bring a radical break with the former voluntarist system, but it did permit a considerable supplementation of existing collections through the confiscation of the goods—in particular the books—of the nobility and the clergy. The nineteenth century, especially its second half, saw an improvement in the system of legal deposit according to the laws of copyright. Constant attention was paid to the principle of integrating the encyclopedic tradition with the contemporaneous growth of scientific publications. Foreign acquisitions from that period are also quite significant.

After the First World War the situation began to decline. The Bibliothèque nationale concentrated on the *national* tradition in the strictest sense, in part because of a lack of resources, but also because of the difficulty of perceiving and defining a coherent ensemble of disciplines. Scholarship had become both more autonomous and dispersed and so more inaccessible both to researchers and to librarians. The Bibliothèque nationale was no longer able to keep up and stopped buying foreign publications; the collection slowly grew out of balance as it passed from being a humanist library to being a library for the humanities. The Bibliothèque de France project seeks to reverse this trend in order that the principal national library of France may once again become an encyclopedic library able to serve the researchers of today.

Reorientation

At stake here is a renewal of the original encyclopedic character of the collections of the Bibliothèque nationale. The sciences, including the social sciences, economics, and law, will occupy as important a place in the Bibliothèque de France as that of literature and the humanities. This is all the more important since the development of contemporary research shows a growing interdisciplinary trend. The most promising contemporary work seems to emanate from the assumption of the connectedness of disciplines and procedures once taken to be quite separate. The links between linguistics and the cognitive sciences, between sociology and law or economics, between history and science are increasingly important, and pose, as we shall see below, formidable problems where the classification of such works is concerned.

Encyclopedism, yes—but by what means? It is not a question of having everything about everything; that would clearly be impossible. Indeed, it is necessary to break with the old ideal of exhaustiveness and in so doing to opt for choices that would supplement the "dépôt légal."

The Bibliothèque de France will seek to supply and to organize basic research tools, French and foreign reference works in all fields, that will be made generally accessible in the reading rooms. This will permit the maximal use of the encyclopedic holdings from the Bibliothèque nationale and at the same time will offer a panoramic view of the current state and the problematics of research in the principal disciplines. We will also seek to enrich current collections by the purchase of foreign books.

But this is not enough. A study under way for three years now in concert with the Bibliothèque nationale and numerous scholars is aimed at telling us in which disciplines the Bibliothèque de France should continue the tradition of excellence of the Bibliothèque nationale. One thinks naturally of the field of history.

Such a return to encyclopedism when it comes to reference works, along with the reinforcement of the areas of excellence of the Bibliothèque nationale in the humanities, both coupled with a consideration of the needs of working scholars, has led us to a system of organization of the "documentary spaces," and to a lesser degree the collections, of the Bibliothèque de France which is quite different from that of the Bibliothèque nationale.

Organizational Principles

Politics of document and thematic organization. Whether it is a question of the development of the encyclopedic dimension or a strengthening of areas of excellence, as in the fields of history and the humanities, one cannot sufficiently stress the necessity for the future library of working within a network and of

cooperating with other great research libraries. The principle of plenitude, of exhaustiveness of holdings, has been replaced by the principle of shared acquisitions and joint collective catalogs.

Following the work of numerous university professors and a study done in 1990 of documentation in France, three themes have emerged as essential for the organization of holdings and thus for the organization of services within the new library: to reinforce the areas of excellence of the Bibliothèque nationale; to develop the holdings in management, law, and economics; and to create a collection of reference works in the sciences and technology and to stress the history of science.

The general encyclopedic holdings should be made readily accessible, particularly by technical means. Whence the importance accorded to freely accessible collections, formed by specific acquisitions for the future library. One million works will be readily available in the reading rooms, encouraging the cross-fertilization of different domains; this in contrast to the 30,000 reference works currently within easy reach of the reader in the Bibliothèque nationale.

At the same time each reader should be able to easily find grouped together the documents, services, and references for his or her specialty. The current system—separated into a department of printed books and a periodicals department—of the Bibliothèque nationale responds inefficiently to this need: it does not facilitate the development of the heuristic practices specific to each discipline and encourages the hegemony of certain disciplines over others, all to the detriment of encyclopedism.

The new project will respond to a double demand. First, it will solve the problem of spatial organization by creating a series of reading rooms with a more human dimension; each room will contain a collection of freely accessible works belonging to a single discipline. Second, it will offer the user a means of rapidly identifying the location of such special collections. Teams of librarians specializing in every field will be available for consultation. This last element is particularly important since the future library has as its goal providing top-quality service, no matter what the field of the researcher. For disciplines are not all alike, and the means of research varies from one to the other. Thus, to take only the example of the sciences and technology, one sees that making available databases, unpublished findings, and research reports plays a much greater role than in the humanities where bibliographies and primary sources are the order of the day.

The Bibliothèque de France will be divided thematically into four departments: 1) philosophy, history, and social sciences; 2) management, law, and economics; 3) science and technology; 4) literature and art. To these will be added a bibliographic research service, a rare books section, and an audio-visual department. As with any system of classification, this one clearly poses certain boundary problems that no amount of epistemological reflection has yet satisfactorily

resolved. But it has the advantage of being simple and allows a good deal of flexibility within a whole whose coherence is assured by the unity of a single catalog with different means of access and an interdepartmental system for conveying documents automatically throughout the building.

Organization of collections. The collections are organized differently according to whether they belong to archival holdings kept in storage or freely accessible collections housed in reading rooms.

The printed archival holdings of the Bibliothèque nationale are housed according to a classification system developed in the seventeenth century by Nicholas Clément and modified several times since then. This plan provides for a division into 29 thematic categories centered on the disciplines of history and religious studies. Here intellectual classification also serves as the basis for a material arrangement of works, a system justified at the time by the relatively small number of volumes and the absence of viable catalogs.

These collections, containing some ten million volumes, will be shelved according to the same principle of classification in the new library, the call numbers being simply distributed among the stacks of the four thematically defined departments mentioned above. This collection will be closed in 1994, when a new system of classification will be put into effect to accommodate future acquisitions coming mostly from the "dépôt légal." New works will henceforth be housed in the stacks of the four departments; each work will receive a call number representing its address rather than its intellectual contents. The whole system will be managed by the library's computerized systems. Researchers will have access to the catalog according to the usual categories—the system will find the address of books requested using the traditional rubrics of author, subject, and title.

For the *freely accessible collections* it is necessary to envisage an intellectual classification system that will permit users to find works according to discipline. Universal classification systems presently in use include that of the Library of Congress, the universal decimal system, and the Dewey decimal system, to cite only the best known. These systems are old and respond imperfectly to the needs of contemporary classification within the sciences. Nonetheless, because of pragmatic concerns, the French have opted for the system most frequently used in Europe, the Dewey.

To be sure, there will be contradictions between the division of disciplines into four departments and the Dewey decimal system. The choices to be made reflect particular epistemological positions, which are always somewhat delicate. For example, the field of psychology is divided between the human sciences (the 100s) and the medical sciences (the 600s); where the auxiliary fields of history are concerned, we find that epigraphs belong to the 400s, numismatics to the 700s, while history itself is classified in the 900s. Beyond necessary overlappings, like that between philosophy and the sciences, documents will benefit from a double

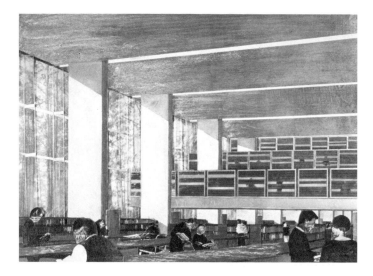

entry in the catalog despite having a single location in the stacks. Thus archae-
ology, which in France is heavily oriented toward art history, will deliberately be
housed in the Bibliothèque de France with history. (There will exist, moreover, a
great library for art history and archaeology on the rue de Richelieu and on the
site of the current Bibliothèque nationale.)

The organization of documentary spaces. The Bibliothèque de France is the future
Bibliothèque nationale. It will continue to fulfill the mission of the present Biblio-
thèque nationale, but in such a way as to become a library "open to all," in the
phrase of President Mitterrand. The democratic ideal of greater access is justified
by the goal of raising the general cultural level and serving a population desirous
of greater knowledge of the national past. How will we reconcile this ideal with
the archival mission of a national library?

From the beginning we envisaged the integration and complementary rela-
tion of two differently functioning collections: 1) A research level enabling access
to the archival collections contained in the stacks, augmented by the large refer-
ence collections with free access. This level is reserved for researchers in posses-
sion of a card to be issued upon presentation of the necessary qualifications. 2) A
level of study open to all, composed of high level reference books, all readily
accessible, and conceived as a beginning general research library serving both as
an introduction to the activity of research and as a protective cushion for the
spaces and collections of more advanced research.

There is no question, contrary to what one reads here and there, of a forced

cohabitation in the same building of a national archival library and a new public reading library. Instead, we are planning a study and research library with two tiers: one for precise short-term projects such as reference checking, the other for long-term scholarly undertakings.

The structuring principle of the two levels is the thematic organization of library departments. Each department will manage its own research and general-access reading rooms. The two levels will be intellectually integrated but physically separated within the building. There will be 1,870 research spaces, of which 300 will be individual carrels, and 1,570 seats in the reading rooms; in addition, 1,550 spaces will be open to the general public (fig. 2). The same levels of comfort, calm, and facilities will be maintained in both the research rooms and the general-access rooms. The latter will also benefit from exactly the same services as the research facility: numerous workstations from which to consult the catalog, large complementary collections accessible to both levels, microfilm and CD-ROM readers, access to databases, and assistance by trained librarians.

The research rooms are organized differently according to their function and the diverse disciplines they serve. For example, in the department of management, law, and economics, a special service is geared to furnishing continually updated information about the economy and business law. This project is one of the innovations developed in response to the complex problem that every great library now faces: Given its mission to manage permanent holdings—the basis of research in the humanities—how will it cope with the incessant flux of new information that is increasingly important to a variety of disciplines?

Research rooms and the general reading rooms will differ in another way, in that the research rooms will offer services aimed at facilitating new modes of reading, including computerized reading posts.

New Technologies of Reading

New technologies are a reality for libraries possessing computerized systems for the management of highly formalized bibliographic information. And they have an ideal model, an imaginary exemplar: the electronic library as network. Each new library project offers a new opportunity to judge the extent to which the mission and the services of libraries, the calling of the librarian, and the needs of users are facilitated or hindered by computer technology.

The technological organization of the Bibliothèque de France can best be characterized as a "high-level compromise." Serving up to a point as the benchmark for other projects, it contains three components: a system of global information, computer-assisted reading, and networking.

A system of global information. The catalog, the classification system, the architecture, and the mode of operation form the basic structure of the library system,

which encapsulates and mediates between librarians' perception of its holdings and the needs of those who use it. What is expected from computer technology is nothing more than the application of that perception. The archival services of a bank or of an insurance company could handle the management of the offerings of an editor or the organization of a large bookstore through the adoption of similar techniques, but their "system" would be fundamentally different from the informational system of a library, whose essence is to provide self-knowledge in order to acquire and conserve its holdings better, and in order to inform and to communicate better with its public.

In keeping with the adage "a library is a catalog," the production of bibliographical information takes pride of place. The organization of bibliographical information, as in a thesaurus or in catalog formats, is the task of the Bibliothèque nationale. But this information will be considerably expanded, and the retrofitting of the catalog currently under way at the Bibliothèque nationale will culminate in a computerized cataloging of over six million entries. At the opening of the Bibliothèque de France these entries will be augmented by the addition of "significant extracts" (tables of contents, for example). At last, the possibility of accessing referential components in a natural language will have been put to the test.

Although the catalog contains the basic information, it does not represent all the information of a library, all that a library "knows." The computerized system will also assist librarians in choosing, acquiring, and handling documents, in preserving them and circulating them.

Preservation. Each document will be assigned a "medical chart" (*fiche santé*) that will be filled out at the time of the regular check-ups of the holdings. The results of periodic soundings of collections can be utilized in a methodical way. The completion of the inventory of the Bibliothèque nationale currently under way is a necessary condition of such an ambitious politics of conservation.

Circulation. The full range of documents will be transportable to the research rooms within a period of time not to exceed thirty minutes. The system will channel requests to the various storage areas; it will "know" the status of each document, not only in the stacks, but also at every stage of transfer. In principle, it should know where a document is to be found at any given moment. The documents will be automatically conveyed from the storage to the research areas. The use of bar codes is planned in order to keep track of the documents' location.

In sum, the old representation of the library as a document-processing chain remains valid. But another representation is called for, according to which different categories of information constitute as many images, as many aspects, of the library: scientific activity (lists of acquisitions), bibliographic activity (the catalog), maintenance of collections (inventory, the "medical chart"), circulation management (localizations, in the widest sense, of the document). The information system of the Bibliothèque de France will coordinate these various activities

and permit the user programs (twenty are planned) to communicate among themselves.

Such a system will facilitate an increasingly precise management of the library. Because of the size of collections—in the case of the Bibliothèque de France, the volume of use increases this risk—the management of the great national libraries tends to escape the control of those responsible for running them. The state of collections ends up being poorly accounted for; the infrastructure is not in place to rationalize and systematize communication. However, the information system of the Bibliothèque de France should permit us to know better what resources and services exist and to modify them regularly. It is, of course, from the point of view of the library user that the efficiency of such a system will be judged.

We will summarize the "information track" a potential researcher at the Bibliothèque de France will follow. In a single series of operations the user will be able to be recognized as a valid registered reader, get information about services offered, consult the catalog, request a document, a seat, or a particular service. These are, then, the four different operations at his or her disposal, and which can be accomplished via the same program and, if he or she wishes, all at once. Seats and documents can be reserved either at the library or from home, a feature that will be of particular interest to foreign or non-Parisian readers. The essential character of this system is the quick and easy passage from consulting the catalog to ordering the document.

Computer-assisted reading. The aforementioned series of operations will improve the services offered to the library user, but one cannot pretend that they will modify the reader's basic activity. It is true that libraries and more generally the world of writing itself are the scene of a major technological transformation sometimes characterized imprecisely in terms of the "electronic book," the electronic or "virtual" library, multimedia, etc. (fig. 3). Electronic publications are increasingly popular at present, and libraries are acquiring more of them. The great computer companies have invested massively in the hardware that makes possible electronic reading techniques. The personal computer has become a multimedia device. Information science has moved closer to the disciplines of textual and linguistic analysis, having abandoned the naïveté or arrogance of its original assumptions concerning, say, the possibility of automatic translation.

All that's left is to understand what is going on! Does the electronic revolution imply the adaptation of certain preexisting givens, linked to the automation of older practices that simply opens up new possibilities, like, for example, the rapid transfer of documents? Or, on the contrary, should we take seriously the hypothesis according to which we are witnessing the advent of a completely new medium comparable to the invention of printing?

In the former case, the library will serve merely to welcome these new products and techniques. As the repository of knowledge in all its forms and its means,

the library will reflect generalized technical developments of our times—which means, in concrete terms, the making available CD-ROM, interactive CDs, interactive video discs, online databases, and multimedia services, etc. This is in a way the "minimum program," for the notion of the "electronic library" can mean nothing else.

In the latter case, if we are witnessing at present the arrival of a new technology of knowledge and of memory, how can the library, the institution of reading and of writing, the place where books are read and written, how can the library stand by and simply contemplate what is going on around it? A passive response to this question implies the end of the very idea of the library, or of the library that does not simply react to the political will of a government. A library is not simply a collection, but an institution where reading professionals participate in the definition of what we now call the "media." This definition is what occurred with Alexander and the establishment of texts, with scriptoria and the invention of the book, with the classical library and its "order of books."

Within such a perspective, the ambitions of the Bibliothèque de France are rather modest. We seek only to permit both researchers and the general public to have their say about the future of reading, while at the same time permitting the library to benefit in its everyday functioning from the most recent technological advances.

These claims will be put into practice through two complementary projects: a program for the digitalization of texts, and computer-assisted reader workstations. The digitalization program will include 100,000 books by the opening date of the Bibliothèque de France in 1995 and will eventually comprise 300,000 volumes. Such a digitalized collection will consist of the major reference works in every discipline, particularly those which have become relatively rare or inaccessible. From the point of view of library management, digitalization presents several advantages. First, the preservation of works through reduced pressure on the collections, whether the book is circulated in electronic form or on paper, having been downloaded electronically and reprinted after downloading). Second, circulation of works will be enhanced, since the same work can be read simultaneously by as many readers as request it. Finally, the transfer of texts will be possible over distances that until now have made circulation by more mechanical means cumbersome or impossible.

We are not proposing simply substituting an electronic copy for the original. The mission of the Bibliothèque de France remains that of conserving and placing at the disposal of readers publications in the form originally envisaged by authors and publishers. In no way can the library be insensitive to the material form of documents.

The electronic holdings, thus constituted, will be accessible at computer-assisted reader workstations. The overall goal of the project being to match electronic reproduction and storage techniques with the reality of a working tool for

FIGURE 3. Terminal display, reading station, Bibliothèque de France. Photo: EPBF.

reading, especially for scholarly reading. Which means, above all, reading by trained specialists. The reader knows his or her field; s/he is motivated by hypotheses which are more or less explicit. The type of questions he or she asks are not obvious to any third party, whether an expert in the handling of documents, or a computer system. Theirs is a reading activity that goes hand-in-hand with the long periods of time required for genuine intellectual endeavor and not the quick fix of merely getting a piece of information. Scholars read with the goal of producing a work: a monograph, a thesis, or an article. Their reading is organized incrementally; with, of course, numerous putting downs and taking ups that will require a system for memory notes, and for the classification of notes in order that electronic reading produce that which traditional reading now produces—that is, a piece of writing. Technically speaking, the computer-assisted reader workstation is nothing more than a microcomputer endowed with a huge memory and connected to the vast system of the Bibliothèque de France.

All of this places a great deal of responsibility on the shoulders of the reader. An electronic text is not a database but a weakly structured series of digitalized printed materials. The reader must select his or her corpus of texts via the catalog; s/he receives these texts at his or her workstation and must then work out the necessary program, organize the material received, and carry out the appropriate analysis.

The software at each workstation features a self-help menu to see documents, move around within them, identify secondary sources, load into memory a procedure for reading, and take notes—note-taking being useful in this first reading, but also serving the purpose of "structuring" the document for future readings. Other workstation software includes a guidance system for custom digitalization and for the optical scanning of characters, a system for the analysis and compar-

ison of lexicons tailored to particular research projects, a function that will search entire texts, and a system of memory to store research findings as an individualized database.

This conception of the reader's workstation has been in the process of development since the beginning of 1990, thanks to a group of researchers from various disciplines who have tested equipment and software programs and actually worked on clusters of digitalized texts. A prototype of the system presently exists, as does the ensemble of its programs within the Bibliothèque de France. The installation of the overall computer system should begin in the second half of 1993.

We have taken particular care to make the functions of the computer-assisted reader workstation as general and as broad as possible. The Bibliothèque de France does not seek to develop a unique or highly specialized program. On the contrary, we want to encourage those who use it to become part of the broader technological movement of the times. In this respect, the computer-assisted workstation is simply a particular example of a multimedia device.

We have, then, made a compromise. The structural logic of the library is still based upon its catalog; it is only at a secondary phase that the construction of a truly electronic library will be possible. Only then will the reader be able to move freely from the catalog to dictionaries, from dictionaries to various indexes, from indexes to this or that section of a particular work, etc. The reader will then be able not only to read and work in front of the screen but to find within the information system the richness and order of the library itself. Many other conditions must be fulfilled before even the possibility of the transfer of documents by electronic means can become a reality. It is only reasonable, then, that users, once situated within their new technological context, experiment with these new reading practices and articulate their experiences with them.

The network. Where the notion of the electronic library stands, that of the "ubiquitous" library cannot be far behind. But is this library without walls, this collection that will be universally accessible through telecommunication, anything more than a pious wish on the part of the great national libraries? Libraries are already working together in networks, and are doing so more and more in France. Thus, one day librarians will be able to rely upon the information systems of the Bibliothèque de France and on its various connections to select and consult different catalogs and online databases, to gather bibliographic information from extant bibliographic reserves, and to transfer information produced by the Bibliothèque de France to other libraries.

The Bibliothèque de France will be linked to the principal research networks, RENATER in France, other European networks, and Internet in the United States. Connections will also be offered to users who will be able to consult the catalogs of other large foreign libraries. Along with university, specialized research, and public libraries, the Etablissement public de la Bibliothèque de

France has undertaken a collective catalog for the whole of France. This catalog will enable not only the location of documents in the main French libraries, but it will also facilitate loans between libraries. Where the Bibliothèque de France is concerned, for example, such a loan might take the form of an electronic transfer of a digitalized document over telephone lines. Networks imply cooperation. The Bibliothèque de France seeks to strengthen the national system of document handling, to increase exchanges with foreign libraries and with the academic world. A little seed of ubiquitousness has thus been planted.

In his "American Lessons" Italo Calvino suggests that six qualities will dominate the next millennium: lightness, speed, precision, visibility, multiplicity, coherence. We are working toward integrating some of these qualities to the project of the Bibliothèque de France.

—Translated by R. Howard Bloch

ROBERT C. BERRING

Future Librarians

THE PARADIGM OF INFORMATION is changing. Western culture is shifting from a paradigm built around the icon of the book to one built around digital information. As one change breeds another, with the change in the source of information comes a change in the paradigm of libraries and the functions of librarians, who have long fulfilled the role of being the primary custodians of information.

While any librarian's experience is limited by the specialty in which they work, I have had the opportunity to view the profession from a variety of perspectives. For three years I served as Dean of the School of Library and Information Studies at the University of California, Berkeley, a position that offered insight into the nature of professional training in library education. During 1986 and 1987 I served as President of the American Association of Law Libraries, which allowed me to see professional organizations and the role such bodies have played in helping librarians react to the changes in the information environment. Nevertheless, because I hold a position as a law professor as well as that of a law librarian, my views may be skewed.

The Paradigm Change

This essay is premised on the idea that the advent of digital information is bringing about a shift in the paradigm of information. While it may take a generation for all of the implications of this change to work themselves out, the battle is largely over. The paradigm has shifted.

Whenever a paradigm changes, there are prices to be paid. Paradigm shifts occur when patterns that sorted the old world into recognizable, manageable categories become obstacles preventing an understanding of the new world. The new pattern is difficult to perceive, and the irony is that the tools that aided in understanding the old pattern may obstruct the new. There may be considerable groping toward understanding the nature of the change, which can bring about dislocation, unrest, and fear. Librarians are no different than any other group caught in the midst of such change. The foundations of librarianship are shaken by the current shift in the information environment, and, indeed, the change is revolutionary. It is not a matter of new forces taking over an existing power structure; this is a real revolution in which the entire structure is rebuilt.

Revolutions often produce predictable varieties of reactions as different camps rise to meet the challenges produced by the advent of a new paradigm. Regardless of the type of revolution, the camps can be classified into three groups—conservatives, reformers, and radicals—and librarians' reactions to the change of the information paradigm is no exception.

In revolutionary times it is the conservatives who plead the truth and beauty of the old system. They see in the old way a power that will be lost in the face of change. In the change of the information paradigm, the conservatives are the book people, the people who see digital information as part of a general decline in intellectual culture. Information not contained in a book is somehow at best middlebrow, the stuff of mechanics and popular culture. Librarians who are conservatives see themselves as identified with the book, so deeply enmeshed in the world of the book that leaving it destroys the very core of what they do. They resist change in the profession and cling to old explanations of the world. The conservatives view the exponents of change as barbarians pounding upon the gates of the sacred keep.

The reformers, who are often caught in the cross fire of the conservatives and the radicals, are those who believe that some of the old can sensibly be blended with some of the new to reach the best end. Reformers often share the conservatives' belief that there is some precious kernel in the old way, some style or value that can and must be saved. Yet the reformer also recognizes that the paradigm is changing and that while it is important to save the crucial parts of the heritage, it is also necessary to improve upon it with tools drawn from the changing pattern. In the information revolution these reformers put forth what Geoffrey Nunberg calls "reassuring ecumenism." Specifically, they feel that society will use both books and digital information in the future.[1]

Among librarians, the reformers are the people who are attempting to evolve the profession into a new role. They advocate changing the names of Library Schools to Schools of Library and Information Science or Library and Information Studies.[2] They believe that the precious kernel for librarianship lies in the ideals of the profession and its traditional concern with the equitable distribution of information. For them the new technology can and must be used to enhance the old model. They see a gradual change, an evolution, taking place.

The radicals are the true believers in total change. They see the old system as a problem in and of itself. For them it is time to shed the skin of the old system and charge forward into the new. They see the reformers as especially feckless; for the radical, half measures have no place. In the shifting paradigm of information, Raymond Kurzweil predicts the end of the culture of the book in his *Library Journal* article. His views can stand as a fair statement of the radical creed.[3] In the radical's view, every element of the old system must change and conciliatory maneuvers are not feasible. Attempting to cling to a "kernel," a radical would say,

will doom the enterprise. For librarians, the radicals are represented by those who feel that the entire template of librarianship must be discarded, the old stereotypes being too encrusted with the detritus of the old system to ever be changed. Indeed, radicals may see themselves as no longer associated with librarianship at all as they attempt to create a new reality for the profession.

The profession of librarianship is at a crucial juncture. The facts of the crisis are clear enough, including the closure of quality library schools. Within the last decade the two symbolic flagship institutions of library education have been closed by their universities: the Graduate School of Library Science at Columbia, the first library school founded by Melvyl Dewey, and the Graduate School of the University of Chicago, which was long viewed as the most rigorous of library schools. When this essay was written, in 1993, the School of Library and Information Studies at Berkeley was no longer accepting students, and the School of Library and Information Science at UCLA is in the process of losing its independence and being merged into the School of Education. Both of these schools were listed among the premier library schools until the very end. In a speech in New York City in October 1993 Richard Budd, the dean of Rutgers's library school, contended that librarianship should no longer be taught in a professional school but rather offered as an undergraduate major.[4] Revolutionary change is afoot.

As information is becoming a more central topic in society, the profession of librarianship, the information profession, is in decline. At the very moment when librarianship should be striding forward it is in full retreat. What has happened?

Some of the causes of this professional crisis may not relate to digitalization per se. They may relate to the internal problems that face the profession of librarianship, or to the elitism inherent in academic communities where the professors are the aristocracy, the graduate students are the knights and the librarians are loyal retainers. In a time of dwindling resources, budget cuts are first dealt to the loyal staff. Librarianship has always been a service profession, and great librarians have been devoted to the institutions that they served. This identification is shown by the fact that librarians designate their profession by the names of the institutions in which they labor. It is the American Library Association, not the American Librarians Associations, the American Association of Law Libraries, not the American Association of Law Librarians. Librarians have always viewed themselves as part of a larger entity. In these days of bottom lines and downsizing, such an attitude can be fatal.

But for all this, it is digitalization that has occasioned the largest changes. In 1986, when the Provost of Professional Schools of the University of California called me and asked me to serve as Dean of the School of Library and Information Studies at Berkeley, she told me that the Library School had toddled along quite adequately, safe in its relatively quiet niche for many years, but that now it was coming upon some valuable turf. This turf promised great opportunity but also

brought great danger. Others would want it, and they would fight for it. The Business School might want to fill this role, the Computer Sciences Department might try to claim this turf. The Library School, she assured me, would be in for a battle and they needed a dean. She was right. The change in the nature of information created opportunity and danger, and the result is being played out today, at places like Berkeley and elsewhere across the country.

Many librarians have written concerning the crisis and the paradigm change. But by looking at what librarians do, and how the move to digital information will change what librarians do, we may be able to gain insight without a dogmatic battle. While such a functional approach may not resolve the larger arguments among the conservatives, reformers, and radicals, it may offer a glimpse into the future.

Throughout history, librarians have carried out three basic functions.[5] First, they have gathered and protected data; second, they have organized and stored that data according to some system; third, they have distributed that data to users. Each of these functions deserves to be addressed, both as the function has been performed until now and as digital information might change it.

The Functions of Librarians Under the Book Paradigm

Gathering and Protecting Data

Gathering and protecting data was the greatest challenge to librarians until the modern era. The word "data" may sound prejudicially modern, but it is meant to encompass books, papers, manuscripts, really any artifact. The physical act of gathering these items was once an inordinate challenge. Books and manuscripts were relatively rare and precious. Such items represented power and wealth, and they might be perceived as a threat by those who did not have or use them.[6] Books and manuscripts allowed for the growth and spread of ideas, representing an almost magical power in a largely illiterate world.[7] When I taught "Introduction to Information," a course then required of all graduate students in the School of Library and Information Studies at Berkeley, I assigned my students a short story by T. Corraghesen Boyle, "We Are Norsemen." Boyle writes this story in first person as a Viking poet, someone from the oral tradition who is accompanying a group of Vikings on a raid. In the final act this band of almost subhuman specimens attacks a monastery. After destroying everything in sight they head for the last stronghold. At the top of the last stairway, behind the last door, they find the library. The Vikings confront the monk librarian who attempts to protect his books. In the words of the narrator:

The book. What in Frigg's name was a book anyway? Scratchings on a sheet of cowhide. Could you fasten a cloak with it, carry mead in it, impress women with it, wear it in your hair? There was gold and silver scattered round the room, and yet he sat over the book as if it could glow or talk or something. The idiot. The pale, puny, unhardy unbold idiot. A rage came over me at the thought of it—I shoved him aside and snatched up the book, thick pages, dark characters, the mystery and the magic. Snatched it up and watched the old monk's suffering features as I fed it, page by filthy page, into the fire. Ha![8]

I told my students to keep in mind that though things may look bleak—their budgets might be cut and their salaries might seem low—it is unlikely that a ship of Vikings would attack them. But at one time it *could* have been that bad. Boyle's fiction reveals the visceral hatred that the book can inspire. The emotions that Boyle shows us are sparked by an earlier paradigm shift, when the oral culture, "natural" and "real," was changing to a threatening written tradition. Boyle's Viking skald provides a glimpse of the deep antipathy of the old for the new, and it may serve us well to recall this scene as we sail into an age where we may be taking books off the shelves.[9]

The culture of the book won out over the forces that despised it, but the book is still a powerful symbol, representing culture and power in the current paradigm. Bookishness is a symbol of intellectual attainment, a library a place of calm and learning. Individuals may collect their own small libraries in their homes and take the often bulky collections with them when they move from place to place. The book is a powerful force in most traditional religions, often symbolizing divine knowledge. How better to empower a means of communicating information than to conceptualize it as divine utterance made tangible?

Books can also inspire fear, perhaps akin to that felt by Boyle's Viking. The book is still subject to frequent attack. In today's world it is still a criminal act in some societies to retain heterodox or offensive books, with the nature of heterodoxy being defined by those in power. Repressive authority fears the power of the book. On the opposite side of the language of censorship is the language of books. People use the phrase "book burning" as an emotional description of any form of censorship, whether or not it involves books. There is repression of other media—movies are banned, pictures are condemned—but books are still special. The American legal system accords decidedly different standards to books; compared to other media, books receive special protection.[10] The welter of issues surrounding these questions thus remains vital, and librarians continue to be on the front line of the battle. Courageous librarians continue to fight to keep certain titles on the shelf.

But the challenge of just *getting* the information is now largely gone. Modern industrial printing has changed this. Books appear in great numbers and voluminous editions. What cannot be bought can be photocopied or microfilmed. The great explorer librarians who traveled the world searching out rare collections

and finding odd titles are now a tiny band indeed. Each year there is a river of new books. No library can own it all. The function of gathering has been transformed into the challenge of choosing. Given the development of interlibrary loan, the photocopier, and, in recent years, the fax machine, one can still gain relatively easy access to information one chooses not to obtain in its original form. Information is pouring down upon us. Even specialists are hard-pressed to keep up with everything published in their area, let alone read it all. The problem is no longer finding information, but sorting it, filtering it.

Preserving and protecting information is an important aspect of this function. A book is a physical object; it occupies a particular space. Once obtained it has to be protected. Formerly librarians assumed the roles of guardians of books, first gathering the books together, then protecting them by controlling both the books and access to them. This issue of *control* has been key for librarians throughout the ages. There were always physical threats to books. William Blades, in his charming series *The Enemies of Books*, listed the whole catalog of challenges to books: vermin, fire, water, even librarians. The great Zen koan of librarianship was the drive to find and protect material and the inevitable need to give people access to it.

The American system of open-stack libraries in part answered this challenge by declaring that the user's need to access materials was more important than the need to protect the books. Such a decision leads to wonderful freedom for the library user but exacts an inevitable toll from the books. Despite innovations like open stacks, librarians came to be identified with the guardian function. The stereotype of the librarian standing ferocious guard over materials that she would rather not see touched is etched in popular consciousness.

There is another element to the preservation function. The dirty secret of anyone who works with the collections of books in great research libraries is that the books are rotting on the shelves. While we know how to preserve them, we cannot afford to do so. The acid content of most paper produced in the last 150 years has doomed the books printed on it to slow, inevitable deterioration.

Lastly, it is worth noting that the sheer number of books now held by research libraries has become a problem in and of itself. Libraries are warehouses of information, but the inventory is out of control. Most great research libraries have been forced to consign parts of their collections to remote storage, sometimes to places where retrieval presents a major challenge. But under the old paradigm, the guardian librarian had a duty to hold onto the books. Discarding the books was not an option.

Each of these aspects of the old prototype of the librarian is based on the function of guarding and protecting. But today's librarian is actually someone who is filtering a flood of information, most likely with no real ability to control or preserve what they already have. The modern librarian may still be called upon

to show courage to retain certain titles in the face of political pressure, but they will face the problem of finding the necessary resources to purchase all the information desired, not the problem of finding the information itself.

Organizing Information

The modern profession of librarianship has emphasized developing methods for organizing information. As the problem of gathering data waned, the problem of organizing the data grew. The way in which this challenge was met can be split into two parts: physically organizing the data and cataloging it.

The first is the most basic: how should one organize the data? The data here was largely books. As physical objects, the books needed to be put somewhere. What methods should be used to shelve them? Of course one could simply shelve them in the order in which they arrived. This system, constructed around an "accessions book" recording each arrival, might serve in certain situations. In a closed-stack library, where a library employee retrieved each book as it was requested by inventory number, the system worked fine. In a small collection the librarian might not even need a record of what had arrived; she might know where each book resided, and with a small enough collection and the right set of users, each user might know as well.

But even small collections soon developed classification systems. Systems could be quite basic, perhaps an alphabetic arrangement of titles, or the books could be grouped into large categories. Recall, for example, the important role classification systems play in Umberto Eco's *The Name of the Rose*.[11] In the novel, the solution to the murder, indeed the crucial piece in the whole puzzle, lies in the organization of the books in the monastery library. Primitive classification systems soon gave way to the pressure of growing numbers of books. As more and more books on more and more subjects appeared, libraries that collected general materials were forced to turn to universal systems of classification. The large libraries were holding first hundreds of thousands and then millions of books. More precise means for classifying the books were needed so that the books could be reshelved after each use in a predictable manner.

This need led to the development of the pre-coordinated index, an index designed before having access to the information. It is the opposite, for example, of indexing a book, where the information is already there for the indexer to describe. A pre-coordinated index provides a systematic description of every possible topic into which books will be grouped.

The challenge of creating a system that provides a topical universe covering every possibility is not trivial. Melvyl Dewey supplied his Dewey Decimal System, a broadly based but comprehensive system that worked well enough with fairly general collections, and one still used in some smaller collections. But

the size of many libraries outstripped the organizational specificity of the Dewey system. As the great libraries grew, more precision was needed. Smaller specialized libraries too needed more depth of description for the collections they housed. It was useless to a library to have all its books carry the same classification designation. Some libraries opted to create their own classification systems, each of which represented the intellectual effort of a librarian grappling with information.

In the U.S. the Library of Congress undertook the challenge of developing a system that was precise enough to allow meaningful classification of large numbers of books while also providing the depth of description needed by small specialty collections. The Library of Congress has been in the process of constructing such a system over the course of recent decades—indeed is still being constructed—that, when complete, will offer a universal system for putting books on the shelf in the most effective order. The Library of Congress's collection dwarfs all others in the country, so its needs were the most pressing. The system created to serve the purposes of this enormous number of books had to be universal—no book can be denied a place—and the attempt is made not just to shelve the books into a universal system, but in fact to place them in a compelling arrangement. Debates have long raged as to how to divide up the world of ideas into the most useful arrangement. A professional librarian is always amused to hear a researcher talk about how they often work based on serendipity, going to the library shelf looking for one book and then, incredibly, find an even better one by miraculous chance. Of course, legions of librarians have spent their lives trying to create arrangements that would allow just this kind of miracle to take place. Think of it as prearranged serendipity.

This is not the place to retell the stories of the development of these kinds of classification systems, but it is important to recognize that it was the fact that each book within the library had one unique location that compelled librarians to create the system. Many books cover more than one topic, but the book could only be put in one place. The library user needed a way to find a book without having to puzzle out the classification system. It was to meet this need that the other great intellectual effort of descriptive cataloging and subject analysis was undertaken.

Subject and descriptive cataloging is the process of precisely describing each book and creating a separate set of records reflecting those descriptions. These records describe the books according to a standard protocol, thus enabling the library user to find a specific book by any one of a number of access routes.

Card catalogs were an enormous improvement in organizing information. They allowed the librarian to describe a single book in several distinct ways. Unlike the shelving of the book, where the book had to be placed in one specific location, a whole set of catalog cards could be made. While the description

of the book might be the same on each card in the set, each card could also carry a designation reflecting a different element of its description. For example, one might first create a catalog card that reflected the "main entry" for the book. (Main entry represents the primary access to the book by the user. At its most effective, main entry is the way to find a book by its most logical access point.)

The beauty of the card catalog was that it provided multiple points of entry to a static set of books. But it too possessed some of the problematic traits inherent in any tangible representation of information. It was bulky, and as collections grew, card catalogs grew to be huge. Also, since most cards were filed in alphabetical order, there was a limited range of options for organizing the information. As the numbers of cards swelled, new algorithms for organizing the cards had to be devised. Librarians responded by developing increasingly intricate schemes for putting the cards in order, schemes that were often difficult for library employees to understand and almost completely inpenetrable to the average library user.

Another inherent limitation was that each card still existed in only one place. Thus, one could search by author, but not by author and by subject at the same time. Furthermore, since the cards were not cross-filed against each other, even a skilled searcher had to shuttle back and forth between cards. There was also the inevitable problem of how to manipulate such a large number of physical objects. To allow for the filing rules to be served, very precise forms of description were developed. These guidelines were created for professional catalogers, and even among this group, the rules were and are a constant matter of debate. The old chestnut that the same cataloger would describe a book differently if they did it twice on consecutive days was probably correct; with such complicated rule systems, it could hardly be otherwise.

These systems of classifying and cataloging information were necessitated by the physical nature of the book. Librarians devoted themselves to perfecting these systems. As the database of books grew larger and larger, the systems became more and more stressed. Librarians developed increasingly detailed rules for filing catalog cards and describing books. Indeed, these rules became so complex that many librarians had trouble following them. Great research libraries took enormous pride in the specificity and precision of the descriptions in their catalogs. Of course, as the complexity of such systems grew, their opacity to the user grew apace. The typical user had no chance of understanding the algorithm that guided the construction of the catalog.

Librarians took on the stereotype of cataloger and classifier. The image of the librarian laboring to describe a book in painstaking detail and creating drawers of catalog cards, which were zealously guarded as the written record of the library's holdings, is one that is a part of many a person's consciousness. The

librarian as organizer, as creator of precise systems of control, is intertwined with the paradigm of the book.

Distributing Information

This third function of librarians has been increasingly emphasized in recent years. At the most basic level, distributing information in the form of books is simply a matter of allowing physical access to them. This is the flip side of protecting the books. The American movement toward open-stack libraries in which the user is allowed to walk directly to the shelves to retrieve their own book rather than asking to have it paged was the first major step. Paging a book involved having the library employee retrieve the book while the patron waited. This system afforded librarians great control over the books, indeed, it allowed shelving arrangements to be based on nothing more than convenience, but it made the users completely dependent on the library's finding tools. As library collections grew and the variety of materials grew more complex, such restricted access was hardly sufficient. Library users were puzzled by the size of the collection, or incapable of using the finding tools provided. Indeed, some users had problems understanding how to use the books once they found them.

Librarians created two solutions for this problem. One was an increased level of reference assistance. This concept included more aggressive forms of outreach to the library patrons and the development of pathfinders, handouts, library guides, and other reference tools. Reference librarians debated the ethics of how much to involve themselves in the library patrons' reference questions. The dynamics of the reference interview and the best strategies for helping the user find what they needed were explored in professional literature and in the library schools as librarianship became increasingly concerned with issues of communication.

A second solution to the problem was called bibliographic instruction. Librarians were cast as teachers whose mission was to guide the users by teaching them research skills. This form of instruction placed the librarian in a proactive position. Rather than serving only as a guardian and organizer of information, the librarian became one to assist in its interpretation and use. This is not to say that a librarian had not previously played a role as adviser and helper, but the role of teacher grew in importance.

As the image of librarians shifted toward one of distributing information, new challenges were posed. How far could and should librarians go? In some ways the librarian's legacy as guardian data gatherer and supremely precise information organizer made it hard to think about these issues creatively. Straying too far toward training the user led one right out of the profession of librarianship. The logical extension of this movement is the involvement of public librarians in

literacy training. The librarian actually assists the user in learning to read. No longer is it enough to get the books, organize them, and hold them open for use; now the librarian must teach the user to read them as well.

It is important to note that each of these distributive functions, with the exception of literacy training, is driven by the physical nature of books. The dilemma of whether to allow the public access to them relates to the properties of the unique physical object that is the book. If it is stolen, or its pages torn, it is removed from the information base. The problem of finding the book on the shelf, as well as many of the issues related to using the book once found, is tied to the limitations of the book as a physical object.

A Word on the User

There are many types of library users. For the purposes of this essay it is especially vital to note two large divisions. The first is the average user. This person, in whatever library setting they might be found, is a non-expert user of the information systems. They may know how to perform some basic searching functions, but they do not really understand the larger systems. They may be completely intimidated and incompetent, or they may be able to stumble along, but their most important characteristic is that of being a non-expert. They are not capable of fully exploiting the traditional tools of information organization and categorization. They have neither the time nor the interest even to try. They simply want the data they seek.

The second kind of library user is the expert. This is a person who grasps the operative principles of the library's organization. They understand precisely what the librarians are doing, and, indeed, since so much of what librarians do is subjective, they may well disagree with the way the librarians work. I will always recall the late Professor Richard Baxter of Harvard Law School. When I was Acting Director of the Law Library there he would leave notes attached to books telling me how the cataloging and classification of each volume could be improved. To Professor Baxter, a book assigned to the wrong classification or given an improper subject heading was an intellectual affront. Such an expert user is both the joy and the bane of librarians.

Traditional research libraries were designed to be used by experts. The intricacies of the great organizational schemes—indeed, the depth of data gathered in the great research collections—were only truly appreciated by a knowledgeable few. As the user population expanded and the number of books increased into the millions, reference librarians embarked on rehabilitative projects designed to assist the average user in gaining some measure of expertise, but the library systems continued to be designed for the expert user, and the systems continued to

become more filigreed. However, with the digital revolution, this set of traditional functions has been changed completely.

The Functions of Librarians under the New Digital Paradigm

The paradigm for the use of information has changed. Barring some worldwide economic catastrophe, the change to the widespread use of digital information is inevitable. This fact, so apparent to those willing to look and so incredible to those entrenched in the old book paradigm, will be assumed for the purposes of this essay. In light of this change, what will happen to the traditional functions of librarians? Will they be preserved, reformed, or destroyed?

Gathering Data

The old model of the library was based on a conception deeply rooted in the idea of the book. Indeed, librarians, the profession that served the information needs of society, named itself after the buildings that housed the books. Librarians went forth into the world to gather information and bring it back to the library, where they guarded it. If it was a rare item, because it was scarce or had a special quality of binding or illustration, it was placed in special storage. But every item that was brought back to the library was *owned* in a physical sense by the library. It might be borrowed by a user, but when it was taken, careful records were maintained of who had it and where. Each physical entity, no matter how banal its information, was physically unique. Once again, many of the common stereotypes of librarians grew out of this monitoring function. The library card was one's ticket to privilege, allowing a person to use the books, to remove them. The systems for monitoring the book's use, especially the systems of enforcement like the library fine, became a fixture in comedic literature. Librarians were seen as the book police.

Some materials were so costly, so large, or so likely to be needed by large numbers of people that they could never be allowed to leave the library building. These items were not necessarily rare, but they were valuable and thus had to be controlled. Once again, it is the physical nature of the book that makes this action necessary. The book can only exist in one place at a time, and only one user at a time can comfortably use a single volume.

The new paradigm of digital information completely changes this set of relationships. Digital information does not exist in one tangible place. It cannot be stored in an edifice, nor can it be owned and controlled like a book. It lacks all of the attributes of physicality. The data is stored in electronic form and may be scattered throughout the memory of the storage vehicle. When one wishes to use

it one can take a copy away while leaving the original in place. Use by one patron in no way precludes use by others. Nor does the information have to be returned; it can be retained by the user. There is no need for guarding it and monitoring its use, at least no need related to the librarian's function.[12] The digital information beginning to flood the information marketplace is infinitely elastic and uncontrollable. The entire concept of ownership will have to be rethought. But regardless of the shape that the new conceptualization takes, it will not replicate the library model.

If individuals who need information can gain access to it via a home computer and a modem, they will not have to come to the library at all. While some information may continue to be restricted due to its content, or have its access limited by being priced on a per-use basis, there will be no rationale for screening users from information since the information no longer possesses physical attributes. If a library user wants to use an electronic reference work over a modem on their home computer, there is no need to move an object to them or them to the object. She can use, perhaps even copy, the object without prejudicing the ability of others to use it as well. Whereas one user hunched over the unabridged dictionary excluded all others by their ownership of the physical aspects of the book, in the digital paradigm it will be possible for a number of users to all have access to the electronic version of the same dictionary at the same time.

For librarianship this will be most unsettling. No longer will librarians be curators or caretakers of information. There will be no need. Librarians will have to choose what data to purchase or lease and how to structure its availability, but most of the rest of the basic tenets of the old paradigm are gone. At the Research Libraries Group Symposium on Electronic Libraries held in Menlo Park in August 1993, Douglas Van Howeeling of the University of Michigan stated that librarians must realize that in the new information age they are retailers of information, discount retailers, in fact.[13] In the old world of information warehouses, librarians guarded the information and protected it from a sometimes hostile world (remember the Boyle quotation). In the new world librarians will be facilitating patrons' use of information: moving information out, packaging it, marketing it.

This is a deep and serious shift in the profession's image and role. There is a great danger facing librarians if they do not perceive the change and become retailers of the information they own. The database vendors may decide to distribute information directly to the users without using librarians, or even libraries, as intermediaries. The full-text databases LEXIS and WESTLAW, that are now so important in law, have already effectively achieved this end. When LEXIS and WESTLAW were first introduced the systems were made available through the use of dedicated terminals, each terminal having a unique number. The user went to the appointed terminal to conduct their search. Law students came to the school law library because that's where these terminals were located.

Lawyers went to the law firm library for the same reason. The terminal was physical, like a book, and subject to all of the custodial and guardian functions that defined the relationship between librarians and books.

But as the technology advanced and user sophistication and demand shifted, LEXIS and WESTLAW moved to a new system that did not require dedicated terminals. Under the new arrangement, each user received an identification number. This number could be used on any standard terminal equipped with a modem, thus freeing the user to work at their desk, home, or other location of their choice; they no longer had to come to the library to access LEXIS and WESTLAW. LEXIS and WESTLAW developed a large number of support tools, designed to make the systems easy to use (they even offer a toll-free 800 number to assist beleaguered researchers). When the user entered the LEXIS system, they found all of the databases ready for use, and theoretically needed no librarian at all. As the change to digital materials continues, with more information originating in digital format, the appeal of using these systems will increase. For law students—and there are 120,000 students currently enrolled in accredited law schools—the shift is easy. As law schools move into the digital age, there will be less and less need for the law student, or the lawyer, to go to the physical place called the library at all.[14]

If such a scenario, or any variant of it, spins out in the future, there will be no place for the librarian as gatherer and guardian. There is nothing to defend. If the conservatives do choose to defend this turf, they will die upon it. Nor can the reformers do much here, except to serve as discount retailers of information through public libraries, the least well-funded sector of the profession. In the digital shift, the gatherer and guardian functions are going to be vestigial at best.

Organizing Information

It was the tangible nature of the book, its property of occupying one particular space, that led to all the efforts to describe it and categorize it. Once the book was assigned to a location, no matter how well thought-out that location, systems had to be designed to lead users to the book from various starting points. It was never apparent that the physical nature of the book dictated these decisions until digital information demonstrated that the tangible form of the book was inherently limiting. Such limited vision is natural in any paradigm because one cannot see beyond one's environment—indeed, it is hard to see one's environment as an environment at all. The essence of a paradigm is that one sees it as a reality. And digital information allows us to see just how limiting the book's physical form was.

Digital information does not occupy a physical space in the same sense that a book does. The electrons that make up a body of digital information do not sit on a shelf; they may be scattered throughout the storage mechanism used and

only reconfigured as needed. In a full-text digital on-line system, the finding tool does not lead one to the single specific location of a physical manifestation of information; instead the tools recreate the information. In other words, one formulates the parameters of the search for information and is then given appropriate results. In a very real sense, full-text on-line systems create a customized result for each search. This obviates the need for classification systems since one does not use the results of the search to go somewhere else. Now instead of the user going to a shelf, the information is recreated according to the needs of the user and brought directly to them, almost instantaneously.

Since the information is not limited to one location, and since it does not have to be "found" in the old sense, it does not have to be classified. But does it have to be described and cataloged? Naturally the proper paths for finding information have to be embedded within it to allow for its retrieval for later use. But this function of creating pathways for retrieval is usually the work of the database creator, not the librarian. Just as librarians do not prepare the index or table of contents in books, they do not prepare the search engines for most databases. But where the patron had to find the book to use the index, the index can now leap out at their command. All of the indexes can become one enormous index, made manageable by the search engines replacing the old organizational systems. Once again the mediating function of the information-gatherer librarian is rendered unnecessary by the nature of digital information and by electronic publishers' development of their own user-friendly search systems.

These search engines, which allow the user to search databases by hooks embedded in the data, or by Boolean search connectors,[15] and to penetrate the full text of documents, are rendering any form of catalog less and less useful for most users. The original LEXIS and WESTLAW systems were touted as paragons of Boolean searching, in which the user can search the whole document for particular words or phrases, even specifying the joint occurrence or proximity of terms in the document. Since the legal databases included each word of each document, this offered enormous power. Unfortunately Boolean searching is hard to do.[16] Although it is very good at locating unique terms (one can quickly and easily find every case where the word "Twinkie" was used), there are searches where Boolean techniques do not work well, such as subject searches, where conceptual thinking is involved.

But Boolean searching was not the final step. The search engines for LEXIS and WESTLAW continue to improve. Research and development departments are working on front-end systems designed to assist the user in finding what they need. These are systems that will transform the user's inept search into a dynamic effort. The first big step was taken when WESTLAW introduced the WIN system. The WIN system allows a user to type a sentence in natural language into the computer, relying on the computer to parse it out, interpret it, and retrieve

results. The user doesn't need to know any protocols at all. WIN is still far from perfect, and at the time this essay was written, LEXIS was rolling out a competing system. These systems are only the first step—the search engines will get better and better, but they are a far cry from the old methods librarians used to organize information.

Librarians have long known that most people had trouble using card catalogs. Most library users are just not good subject searchers. Being precise and complete in describing each book called for a level of detail and a complexity of organization that rendered the systems of information location produced counterproductive for everyone but the expert. When I instructed graduate students in Library and Information Studies at Berkeley, I would spend two full classes teaching them how to use the Library of Congress subject headings for finding books. It struck me as odd that nascent experts, graduate students, were struggling to master systems that librarians asked the average patron to use successfully.

Now the point is moot. If one can search for information through a modem on-line bibliographic system using a "words in title" search that does not require precision or the use of protocols, one seldom will resort to any subject system that, by its nature, requires protocols and hierarchical judgments. The next step is to turn to a full-text system and, using the embedded search hooks and the power of full-text Boolean searching, go straight to the information itself. Such systems already exist in the field of law. The commercial databases offered by LEXIS and WESTLAW, which compete for the soul of legal researchers in a ferocious marketplace, have the full text of American primary legal materials: cases, statutes, administrative rules and regulations, and constitutions. They also contain legal periodicals, loose-leaf services, and other tools. Each also offers access to stunning reservoirs of non-legal information. And all of this is in full text. When the American law student, equipped with a free home-use LEXIS or WESTLAW identification number, signs on via their home-computer modem, they have full-text access to more information than any law library contains. And they need no library catalog to search it. All of the necessary tools are built in, and the system is designed for simplicity, not for the appreciation of expert users.

These legal systems are the Rolls Royces of research, and it is fair to contend that the average person could never hope to afford to use them. But the systems are proof that the idea works. The price will come down as the market grows. Other vendors will learn.

As such systems develop, they will be applied to the information that exists in digital form. Thus, as more and more information is converted to that form, these systems will replace any intermediary engine developed by librarians. One could debate at length the speed with which existing information will be put in digital form via imaging or some related technology, but one must assume that

where there is a market for such conversion, it will occur. As it does, the role of librarians and the systems of organizing and classifying information that they have so carefully developed will grow less and less relevant.

The intangible nature of digital information, and the systems to format and retrieve it that are coming to the fore, have potential that cannot be matched by any traditional system. Those trained in the old ways may remain more comfortable using them, may in fact regard the new systems with the same visceral hatred that Boyle's Viking felt for the printed word, but it will be the comfort of familiarity and emotional attachment, not logic, that maintains them.

Distributing Information

The most puzzling part of the paradigm shift is its impact on the distribution of information by librarians. Digital information raises a host of distribution-related questions that are moving to the center of the stage of societal debate. Federal policy on information is now getting increased coverage, and the related intellectual property issues are rising to the fore.[17] Jane Ginsburg's article in this volume outlines many of these concerns in arresting detail. But legal issues aside, what will be the role of librarians in the new systems of information distribution?

The conservatives see the librarians as attached to the old tradition: librarians as the protectors of the book. The book stands as an icon in need of defense from the computer-hacker barbarians who pound upon the gate. There will be a new entry in William Blades's *The Enemies of Books* series: Digital Information. In part this defense will relate to the essence of the function that librarians have performed for millennia. It is hard to abandon the old ways. But the defense also partly relates to the deep cultural association between intellectual legitimacy and books. Someone who grew up in the old paradigm might use a computer if it can provide some especially useful or efficient service, but it will still lead them to a print source in the end. Information received on a screen is inevitably regarded as second-class or lowbrow. It can never be viewed as substantive.

There is a marvelous example of this in the world of legal research. Although law schools have been turning out ardent users of on-line systems for the past few years, most senior legal professionals were trained in one of the most book-intensive environments possible. They remain skeptical of the usefulness of on-line systems and view LEXIS and WESTLAW as gimmicks or expensive toys, or, at best, as case finding tools that point one toward the right book. Some would resist viewing a case printed out from one of the databases as valid information, preferring to wait until a "real" version of the case appeared.

Someone at WESTLAW realized that it helped to format WESTLAW printers to make them produce printed pages that looked just like the pages in

printed case reporters, complete with double columns of type. It was a marvelous triumph in recognizing the importance of form over content in information consumption. Senior faculty members who had scorned the printouts looked at the new pages, nodded approvingly, and said, "Well, this is real." They accepted it because the format was close to what they will always view as legitimate information—books.

The conservatives in the library profession will side with these book people. In doing so they will define the purpose of librarianship as guarding and distributing books. They may suffer the introduction of computer terminals into the library, but it is permitted with tolerance at best. The computers are not really a part of the "library," but rather something alien introduced into it. They will never abandon the book distribution paradigm; indeed, they will fight to defend it. There will be enough demand by other members of the book generation, users who wish to remain in the old paradigm, to sustain some functioning of the old model for years to come, but it will be an increasingly small business. Younger users and users who must be conscious of economics will abandon them. If librarianship allies itself with these conservatives, it will become a vestigial profession. Of course, to the true conservative, it will be more fitting, more glorious, to perish than to convert.

The radicals in the library world are already abandoning the profession. The world is in the midst of an information obsession. When Jay McInerny, a symbol of everything trendy in American letters, began a recent essay in the *New Yorker*, that citadel of the old literate culture, with an account of "infosurfing" on the Internet, no one could any longer deny that digital thinking had truly arrived.[18] The potential of the Internet and the information superhighway are everywhere among us. The fiction of William Gibson paints a picture of a new world,[19] and the radicals wish to be a part of it. They see the traditional library paradigm as wrongheaded. Indeed, to the radicals the game of distributing information, at least premium information, is lost to librarianship already. For them the mergers of telephone companies and cable television operations have more to say about the use of information than anything associated with the concept of shelving books.

Business schools are training management information systems specialists, computer science departments are training database managers, and undergraduate programs are beginning to offer majors in information. These people see information as a commodity. It is the new preferred product and its distribution will become the business at which the U.S. excels. The new corporate heroes are figures like Bill Gates at Microsoft, the symbol of information manipulation and the new paradigm.

This puts librarianship's old model for the distribution of information in jeopardy. The radicals within the profession do not want to be called librarians;

they want to cut loose the old heritage and move on. They can point to the fact that the two most prestigious library schools in the country have closed and that those at both Berkeley and UCLA are severely threatened. They can contend that, in any case, the life and energy of information is not found in the halls of any library school. Those halls are filled with librarians; the wrong horses are in place. There may continue to be library schools, but they will train information workers who will be clerical and who will never hope to aspire to the humanitarian goal of public enlightenment.

There is a bundle of complex issues present here, issues that relate to the long-term undervaluing of librarianship as a women's profession and the service ideal of librarianship and its relation to entrepreneurship. Without disentangling those issues, it is nonetheless important to recognize that what has brought about this particular crisis, and what needs to be addressed now, is a problem created by the changing paradigm of information distribution. Each of the old challenges that the profession faced pales in comparison to the magnitude of this crisis. The radicals are correct: librarians cannot distribute information the old way without limiting themselves. But the radicals' solution is to abandon the profession of librarianship and move on to new careers. In doing this, they may find answers for themselves, but they offer no rescue to the profession in its crisis.

There are still the reformers. The reformers see several roles for a revitalized librarianship. They see a place for those who want librarianship to help users committed to or trapped in the old paradigm move to the new, or at least to understand the new. They also wish to transfer the values of service and integrity, which have been the defining virtues of librarianship, to the new paradigm of information. The reformers understand that information has become a commodity and that the world demands bottom-line accounting of every action, but they remain committed to the fact that people need information and that a librarian's role is to help them find it.

The central dilemma is caused by the fact that librarianship has retained its ideals, its commitment to service. Other professions, like law and medicine, long ago opted for systems designed to yield hefty remuneration for their members, but librarianship has retained a sense of service at its core. This central ethos is part of what the reformers want to save, and they seek a way to protect it while keeping the profession vital.

The reformers also recognize that librarians have always understood how people use information and that librarians have always served as the medium for introducing new information vehicles. Librarians are the people who understand how information works, how it fits together. The reformers see the power of this strength but they also realize they have no natural allies. The conservatives have a visceral dislike of any change—temporizing does not help—so they scorn the reformers. The radicals see the reformers as pathetic accommodationists. Worse still for the reformers, there is little in the way of resources to support them. The

organizations in which librarians work, whether academic, public, or private, are currently caught in a dangerously shortsighted cycle of cost centering. It is more likely that an organization will cut the library's budget to realize short-term savings than support the reformers' efforts to bring about logical change for long-term gains. Through bitter experience librarians have learned that the organizations they serve will not be of help. The only path available is to work with vendors.

Vendors of information are also caught in the paradigm switch. They too are unsure how to manage the change. For vendors, just as for librarians, there is danger in the air. To refuse to change is fatal, but to change too quickly is equally deadly. Many information vendors have recognized the need for the understanding of information and its use that is exactly what librarians can provide.

In the field of law librarianship one can currently observe a fascinating phenomenon. The annual meeting of the American Association of Law Libraries is now attended by the presidents and chief executives of the major publishers. These decision-makers come seeking advice. They know that librarians still have contact with the patrons, and they believe that librarians can see which configuration of information works and which does not. Librarians can help train people in using the new systems. They have credibility with the users.

These executives are asking for help. Some traditional librarians view such overtures as illegitimate. For them the idea of dealing with the vendors as partners smacks of selling one's soul to the devil of commercial enterprise. Librarians have always viewed the distribution of information as a neutral activity, one where information producers were to be held at arm's length. The vendors, with their focus on profit, were always the enemy. But now, with information being organized by information producers and the old warehousing function gone, the librarians must see that their best hope is to work with vendors to structure tools for distributing information. Librarians can help design and implement the new systems. Librarians can be the intermediaries. The information producers are the librarians' natural allies. Librarianship must become entrepreneurial. It must help put together systems and introduce them into organizations.

Yet it remains crucial to remember the role of the user. Expert users of the new information, the techno-cowboys of the new generation, will need little help. But the vast majority of users in any library will be average and they will need to be taught how to navigate the increasingly digitized library. Some believed that as digital systems proliferated, typical users would grow more and more sophisticated until they no longer needed librarians. This theory is demonstrably wrong. As the systems have developed, users have grown used to icon-based, menu-driven systems that are extremely easy to use. The average user today expects to be prompted by systems that call for no training and operate intuitively. Large-scale database systems have yet to meet these expectations, so, in fact, users need more help than ever. The librarian's role can be to provide that help.

Librarians must recognize that the modern distribution function consists of holding the digital hand of a database user, serving as the neutral expert who can credibly advise users on what they are using. To do this librarians must insert themselves in the process of creating, organizing, and introducing these databases. This is new and it is intimidating, but it is the profession's last hope.

Someone will have to fill the helping function. Librarians would be the best choice since the profession is already in place, but it will have to show that it is ready and it will have to move quickly. In four or five years the executives of the large database companies will not be coming to library meetings asking for help. They either will have received help from librarians or they will have gone elsewhere, but whatever the source, the boat will have sailed. Librarianship should do everything that it can to be on that boat.

Will the reformers be capable of capitalizing on this new opportunity? Will they be able to retain the ideals of service that have been part of the library profession while also forging alliances with the private sector? It will not take long to discover an answer. This scenario will spin out over the next few years. If librarianship cannot change dramatically and quickly, it will become a vestigial profession. Such apocryphal statements are safely made. Librarians will wither away as the functions they filled for so long become unnecessary in an age when digital information is plentiful, self-sorted, distributed directly to the user. But if librarians can recognize the change and work with vendors to become the mediators of the digital revolution for the average user, there is hope.

Notes

1. See Geoffrey Nunberg's essay in this volume.
2. The evolution of the University of California's School of Librarianship to the School of Library and Information Studies and then to the School of Information Studies is instructive.
3. Raymond Kurzweil, "The Future of Libraries, Part 2: The End of Books," *Library Journal*, 15 February 1992.
4. This speech was recorded on audio tape and will be available in the near future, though I do not yet have publication information.
5. This particular functional breakdown is my own, although many have produced similar and dissimilar categorizations.
6. Book burning and censorship have been part of many regimes. This pattern is not limited to Western culture. The famous "Burning of the Books" in which the Emperor Chin Shih Huang Di attempted to destroy all heterodox writings in 212 B.C. is one of the most famous events in Chinese history. It was repeated in the destruction of all non-Maoist literature during the Cultural Revolution of 1966–76.
7. It is interesting to note that as the paradigm moves away from printed information

toward digital information, scholarship on the change from the manuscript and oral traditions to the paradigm of the book is blossoming.

8. T. Coraghessan Boyle, *Descent of Man: Stories* (Boston, 1979).

9. It is worth noting that Boyle chooses a skald, a poet of the oral tradition, as narrator. Who would find books more threatening?

10. Books are treated differently than other forms of expression with the doctrine of prior restraint, which prevents the banning of books coming into play.

11. Umberto Eco, *The Name of the Rose*, trans. William Weaver (San Diego, 1983).

12. Jane Ginsburg's essay in this volume discusses some of the ways in which the ownership of information and its distribution may change. Monitoring use of materials for some future compensation system may introduce a new kind of control function for librarians.

13. These proceedings are in the process of being published, though no publication information is currently available.

14. The recent report issued by the University of Dayton Law School is an interesting and balanced projection of how this transformation may take place. (Interim Report of the University of Dayton School of Law and the Mead Data Central Joint Committee to Study Computer Technology, Mead Data Central, Dayton, 1993.)

15. If one is unfamiliar with Boolean searching, see Robert Berring, "Full-text Databases and Legal Research: Backing into the Future," *High Technology Law Journal* 1 (spring 1986), especially note 31.

16. The best summary of the problems of full-text Boolean searching is still Daniel Dabney, "The Curse of Thamus: An Analysis of Full-Text Legal Document Retrieval," *Law Library Journal* 78 (winter 1986): 5–40. It also explains indexing theory with startling clarity.

17. The questions of federal information policy, especially given Vice President Al Gore's interest in the information superhighway and the recent pressures brought to bear on the Government Printing Office, will be complex. It is difficult to predict how important the federal government's role will be, but it is safe to assume that it will be a key factor.

18. Jay McInerney, "The Way of All Text," *The New Yorker*, September 20, 1993, 128.

19. If one wishes an introduction to the culture of information, try William Gibson's *Neuromancer* or *Count Zero*, which were foundation stones of the culture and literature known as cyberpunk. Gibson introduced terms and phrases that are now found throughout popular culture.

DOCUMENT

EMMANUEL LE ROY LADURIE
My Everydays

MY DESTINY AT THE Bibliothèque nationale (BN) began in late October 1987, despite the fact that, as long ago as 1971, Edgar Faure bragged: "I can make Le Roy Ladurie administrator of the BN." This was, of course, mere table talk, and I have no regrets that such a prophecy came true only some sixteen years later. After my very close friend André Miquel decided to leave the post of general administrator of the Bibliothèque nationale, I learned that M. Léotard, then minister of culture, wanted to give the job to me. I was called to the Ministry of Culture by a member of the bureau responsible for libraries, M. Brossolet, and then by the directeur du cabinet, M. Boillon. It's difficult to explain to North Americans the significance of a ministerial cabinet in France. Suffice it to say simply that the director of such a cabinet was at the time the equivalent of a vice-minister.

My first reaction—after, of course, all kinds of oscillation and hesitation—was to refuse the job. I was happy at the Collège de France, where for fifteen years I had led the life of a gentleman scholar. Whatever might possess me to shoulder the burden of this institution, the BN, which I loved dearly, but which I had seen shaken by so many shocks, this seemingly dysfunctional family . . . ? My friends, as always, advised me both ways—some for acceptance and others against. Those against won the day. Though M. Léotard summoned me in order to explain his intentions, I had decided to "stand him up," excusing myself politely on the grounds that I was obliged to leave for England, where Peter Burke had invited me to give a lecture. And I immediately took flight.

To no avail! As soon as I got off the plane, I was informed that "Monsieur le Ministre" had already telephoned twenty times. The twenty-first time, I spoke with M. Léotard, who warned, "You cannot do this to me. It's going tomorrow before the Conseil des ministres. Mitterrand and Chirac are agreed. I would look ridiculous." So I accepted, and became general director of the Bibliothèque nationale. Chaban-Delmas, who loves sporting metaphors, asked me at one of the cocktail parties which I am required to attend from time to time, "Do you like climbing up the north face of Mt. Everest with big strides?" Some exaggeration, of course . . .

What has been my tactic, or rather, my operational plan?

It has seemed to me absolutely essential always to be there. One doesn't take

on the BN half-heartedly. Of course, there is my research, the all-precious research, of which I have done more than my share. But it was also of utmost importance to give the impression (a true one in fact) to patrons of the BN that someone was piloting the plane. I resolved to be in my office every morning at 7:45 A.M. and to spend my entire day there, which isn't such a long one, ending at six or seven o'clock. If sometimes there are meetings, receptions, or social occasions geared toward the interests of the BN, my workday does not end until eleven o'clock at night.

Does this mean that I work all day for the BN?

Not exactly. I reserve for my own research the after-dinner hour, weekends, short vacations, and trips, etc. One cannot, of course, undertake just any kind of research under such conditions. The books I have published while serving as administrator—the two volumes of a *Histoire de France*, for example, or the volume on the sixteenth century I am writing at present—lend themselves well to a kind of piecemeal approach, enhanced by the fabulous resources of the BN.

But let's return to my work as administrator. I am conscious, of course, that I am not a professional librarian but an enlightened amateur. For this reason I seek above all to impose a human presence—my own—beginning officially at nine in the morning, the opening hour of the main reading room. I have the greatest respect for my fellow workers in the various departments of the BN, some of whom are, moreover, also friends since I am a former library user. Here lies, in fact, the uniqueness of my position. There has never been a "reader"—in the fullest sense of a "professional" reader—as head of the Bibliothèque nationale before me; and there will not be one after me, barring the unforeseen. My appointment from this point of view has been, I think, a fortunate one. I knew from my long experience as a reader what many of my predecessors did not necessarily know—that the BN is judged primarily on how well the general reading room functions. It is here that the "company image" is created, even if other departments work well, or occasionally, which is inevitable, less well.

The problem I faced was, then, how to improve the workings of the main reading room, this famous salle Labrouste, and thus to improve the image of the BN, especially in the eyes of the Americans, these demanding readers (and one can understand them, given the high level of their libraries) who are sometimes a little too demanding or even arrogant. But whether or not one does or does not like Americans, and personally I like them a lot, having lived over two years in the United States, one must recognize that through the power of their press and their language they dispose of an incomparable strike force. An article hostile to the BN in the *Spiegel* is only half bad. A hostile article in the *New York Times* or the *New York Review of Books* is catastrophic, since it is circulated throughout the world. It thus happened once that we were compared to the Gestapo in one of these Anglo-Saxon newspapers. Our American friends who protested to the *New York Times* did so in vain. The insult stuck.

But why this insult? It may have happened the American in question was greeted coldly by a young and inexperienced employee of the department that issues library cards. One of my (somewhat vain) intellectual masters, in fact, never pardoned the same department of the BN for having required him to write out and pronounce his last name and profession (which he changed with vengeful intent to *sociologist*) in front of a novice employee; many years after his death his widow reminded me of the incident, though actually I had no part in it.

Before the militant leftist period of my youth, I grew up in a conservative village as the son of a gentleman farmer who belonged to the rural gentry— although that gentry was bourgeois and not noble. I enjoyed that village life, and I still nostalgically recall meeting different people in the workplaces and gathering places of the village. I found at the BN an urban version of this same sense of community: I love to meet and to greet both the staff members and the readers.

The BN is not a business enterprise, it is a public administration. We do not have complete control over the assignments, appointments, and departures of our staff. This fact affects the overall efficiency of the system, yet at the same time it encourages, given the right circumstances, a more convivial atmosphere, to which I have devoted myself.

How then can one contribute to making this institution work, an institution that works well enough without me in any case, thanks to a highly competent and motivated staff? The question brings us closer to those issues of everyday life and of conviviality just mentioned. After I assumed my duties I was summoned to a radio or TV station along with one of our great media show men, what you refer to as an "anchorman" in English. This gentleman asked me: what measures will you undertake to reform the BN in the next fifteen days? As if I were Mendès-France obliged to end the war in Indochina in three weeks . . . Let's just say that, given that I have marvelous colleagues who carry out with great efficiency the essential functions of the BN (budget, etc.), I can devote myself to user and staff relations, considering this a good way to create a climate that will benefit both.

So, a bit before nine o'clock when I am in Paris, which is most of the time (since, if I travel for a day or two in France, I no longer make long trips to the United States, it being impossible to leave such a big operation for longer than that; I still can remember my teacher Braudel, director of the Ecole pratique des hautes études, called back in an emergency from Chicago to face a crisis) . . . So, just before nine o'clock, I am stationed at the main reading room entrance to chat with readers. And while I do not identify completely with those department store owners who arrange to be there for the opening and to throw open wide the main doors of their vast establishments for the day's first clients, there is, finally, something of that in it . . .

Incidentally, if I insist upon the bewitching hour of nine o'clock in the morning, it is because one always reproaches bureaucrats blindly without rhyme or reason. Yet, one forgets that when there is public pressure one must be there

at nine and not at 9:30 or ten o'clock as is often the case in more relaxed segments of government service. Of course, in America too the rhythm of work is intense; and we hold up the United States as a model. Still, à propos of the space of the main reading room, let me once again insist upon a fact that emanates from my positive experience in America: that is, the presence in libraries of numerous working telephones. At the BN of years gone by, and certainly before my administration, in the 1960s, the public telephones were sometimes out of order because someone had forgotten to pay the telephone bill. Now, however, I have the reading-room telephones tested every morning by an employee. Library users have taken a long time to realize that our telephones are always in working order. Today they use them without thanking me; this is normal, after all. M. Dupuit, my deputy administrator, makes sure the bills are paid on time. Delay is one of the plagues of the French bureaucracy, which behaves sometimes like the Don Juan of Molière—a great lord who does not pay his debts, preferring instead to humiliate his creditor, M. Dimanche.

To return to the BN, I consider it my duty to pass through its large reading spaces, the main and the periodical rooms, at least twice a day. In truth, I do this with pleasure, with an intense friendly feeling toward the readers, stack employees, curators, and librarians, many of whom I know personally. I take especially good care of foreign users, particularly the Americans whose importance to us I have already stressed. They are often extremely engaging, and I count many friends among them. Sometimes, however, in extreme cases, certain of them are very demanding and arrogant. I remember the time one asked for a free library card, and, upon my refusal, he treated me as a member of the Gestapo. Another, who accused the BN of not having acquired his thesis, lacked the minimal decency to apologize when I demonstrated his error to him over the phone. I mention these incidents to show that I take it upon myself to enter into the details of library users' problems. God is in details, as the French proverb holds, and amoebas ingest many a protozoa . . .

Another area in which I have resolved to improve services to users is the famous call-number system, in which I am, again, assisted by numerous capable colleagues. Certain among you, "old" or perhaps "less old" patrons of the BN, remember the sad spectacle of the "inaccessible" call numbers—Z unavailable one day, Y the next day, A or B yet another day—because of insufficient staff or some other reason. The librarian who had invented this method imagined that the French government, once made conscious of the service interruptions at the BN, would grant us more resources, more money. As if our government ministers cared about anything that went on for better or worse in the main reading room of the BN, our beautiful salle Labrouste with its iron architecture so redolent of the Second Empire! As an experienced library user, I was conscious of the foolishness of closing off certain call numbers. In particular, the practice inconvenienced foreigners who had travelled all the way to France, perhaps renting a

summer apartment in the neighborhood of the rue Richelieu, and who beat their heads against the wall of unavailable call numbers. As soon as I took over at the BN I ordered somewhat imperially that a stop be put to the practice of closing off certain stack areas and ordered that all call numbers, no matter what the cost, be kept available. The library official responsible obeyed reluctantly, even somewhat bitterly. Mme. Sanson, who replaced her some years ago, has had no difficulty in supporting my position and even surpassing it, so that now all call numbers are delivered every day. Library users understandably consider this service as a basic right.

Speaking of rights, I will present another example from my everyday routine: the computerization of the library catalog. I consider computerization to be a case of good administrative procedure. Begun under my predecessor Le Rider in 1981, continued under Gourdon and Miquel, and intensified under my administration, library computerization, as a function of technological progress in general, takes place independently of any single BN administrator's policies. One must nonetheless note in passing the small hitch that occurred in 1983 because the government refused to order products from IBM, considered to be too "American," only to decide finally upon the highly competent Anglo-Canadian firm GEAC. This kind of little ideological glitch would not occur today, Gaullist positions being—thank God—much more flexible than even a decade ago; and indeed GEAC has turned out to be an excellent partner.

My own contribution has been to place this computerized catalog at the disposition of readers, and not only of librarians, on screens in the catalog room; to accelerate the development of the BN Opale database, which now comprises 1,500,000 entries, reflecting the entire catalog since 1970 (computerized catalogs of this size are common in the United States, and soon will be in France); and to undertake the retrospective conversion of our entire card catalog since Gutenberg, that is, from 1452 to 1993. The conversion project includes seven million items, of which 900,000 have already been encoded, though the information is not yet available online. This will eventually make the BN comparable to the British Library or even, all things being equal, to the Library of Congress. And while I am on the topic, let me give my thanks to the Bibliothèque de France for contributing ten million francs toward the conversion project.

We at the BN have been maligned for being dinosaurs, an insult that is not really one at all, since dinosaurs are very appealing animals whose disappearance we all regret. Yet we are at least computerized dinosaurs. The computerization of our catalog, rendered accessible to the user, proves the Bibliothèque nationale is truly an up-to-date, world-class library, even though we have not surpassed the Americans who have been involved in such a technological transformation for a long time now. We are at present within a reasonable striking distance of their performance.

I used to take pleasure in listening to users sing the praises of the comput-

erized catalog, until one day I experienced real disappointment when I asked an English-speaking woman what she thought of our bibliographic database. Whether good or bad, I wanted to know her views. She replied simply, "Too slow." And, in fact, our computer's capacity is too small for the traffic of readers, librarians, and catalogers using it around eleven o'clock in the morning, so that responses are sometimes a little slow in coming—"too slow." My sins were remitted for the shame.

There are other topics relating to the everyday life of the administrator of the Bibliothèque nationale I could mention: the search for outside support, for example, which is a less important factor for us than for certain American libraries like the New York Public. Nonetheless, when it is a matter of purchasing a beautiful medieval manuscript, I often go knocking on the doors of my friends in the financial world, and I obtain results. Then there is the question of maintaining good relations with politicians, whether they are in power or out . . . I also strive to make the activities of the BN known outside of Paris in such places as Lille, Toulouse, Auxerre, Metz, Epinal—or Washington—through loans of major objects, manuscripts for example, which make for an event in the everyday life of these cities, thereby attracting the attention of the local media and improving our image in the "regions" of France that used to be called the "provinces," and elsewhere.

The four or five great projects under way in connection with the Bibliothèque de France—the computerization already mentioned, the checking of holdings, various acquisition programs, the microfilming of 300,000 volumes, preparations for moving—also take up a lot of my time. And there are other activities worthy of note, like the administrative commissions of the staff, for example.

Suffice it to say that though I still am willing to teach and to publish within moderate limits, I have for the time being relinquished the publish or perish of the professor in favor of an ideal of public service in administration. One work has appeared in the last four years—*L'Ancien Régime*—comprising, it is true, 450 pages; I am required to teach only 26 hours per year at the Collège de France.

In a few years I will without doubt return, as Louis Philippe said of Adolphe Thiers, "to my dear studies."

—Translated by R. Howard Bloch

DOCUMENT

PROSSER GIFFORD

The Libraries of Eastern Europe:
Information and Democracy

Rather than treating developments in a single library or library system, I will describe the initial efforts in using technology to enhance both the resources available to and the usefulness of Eastern European library systems, and the related effort to change prevailing attitudes toward information. Two aspects of this story give it wider interest and perhaps some relevance to our discussion of the future of national libraries generally. The first is that technology may indeed provide some shortcuts for Eastern European libraries, enabling them to learn from and avoid the mistakes of others' earlier experience. The second is that a proposed system of interlibrary communication attracts quickly the possibility of other users—a widening circle of institutional purposes to be served.

The Bibliographic Blackout

The origins of the present project lie in the condition of Eastern Europe between 1948 and 1988. During those years, North American, Western European, and even Soviet scholarship on Eastern European countries was scarcely available in Eastern Europe. In fact, the countries of Eastern Europe had great difficulty in getting scholarly publications from each other's countries, not to mention *samizdat* material that was circulated clandestinely or smuggled to the West. During those years scholars and scholarly associations in North America and Western Europe decided that an aggregated cumulative bibliography, published on an annual basis, would be a service to those studying Eastern Europe.

The three bibliographies systematically compiled beginning in the 1970s are the *American Bibliography of Slavic and East European Studies*, *The European Bibliography of Slavic and East European Studies*, and those parts of the Soviet Academy of Sciences' bibliographic records dealing with Eastern Europe and the former Soviet Union. Starting in the mid 1980s all three bibliographies were created in machine-readable formats; by 1990 bibliographers were contemplating how to consolidate the three bibliographies in a single format and to locate them *within* Eastern Europe to mitigate the lack of knowledge there about publications avail-

able since 1948. To fulfill this ambition required the integration of the three bibliographies—which, as machine-readable files, aggregate about 54,000 records per year—in a common electronic form and the provision of online access to users in Europe, including many Eastern European countries. This would clearly be a service to Western and Eastern scholars alike. Once the work of integrating the three large bibliographic databases is accomplished, the possibility of issuing CD-ROMs for those unable to access the material online can be considered.

In February 1992 Marianna Choldin and I co-chaired a conference, held at the Rockefeller Conference Center in Bellagio, Italy, on the desirability of creating a common bibliographic database covering Eastern European scholarship in Western and Slavic languages. We brought together twenty-four participants from the United States, Western Europe, Eastern Europe, and Russia to wrestle with both general desiderata and some of the specific language and encoding difficulties of pursuing such a project. Our discussions documented that an integrated database obtainable online would be a significant service to the national libraries of the Eastern European countries.

Electronic Accessibility

Providing the national libraries with online access to such a database, wherever it might be located, is a formidable task. With the exception of the National Széchényi Library in Budapest, none of the national libraries have converted more than a tiny fraction of their own catalogs to machine-readable form. The conversion effort is receiving high priority in Prague, Warsaw, and Sophia—often with funds provided by American philanthropic foundations (e.g., the Andrew W. Mellon Foundation, the John D. and Catherine T. MacArthur Foundation, the German Marshall Fund, and the Soros Foundation). Until the conversion of millions of records is complete, the national libraries will not be able to access electronically one another's catalogs.

Since a centralized and integrated database will not assist researchers unless online access is available, the need for some dependable electronic linkage among libraries also becomes clear. Only then will the value of having each national bibliography in machine-readable form become apparent. Thus it will be necessary both to increase the machine-readable components of the region's national libraries and to link them electronically with each other and with global networks through, for example, connections to Internet and EARN (the European Academic Research Network).

Beginning in April 1991, a separate initiative arose from the United States congressional task force on the development of parliamentary institutions in Eastern Europe, known as the Frost Task Force, to reduce the information deficits faced by the newly constituted democratic legislatures of the region. In FY 1991

and FY 1992 Congress allocated $12 million to assist the legislatures of Poland, the Czech and Slovak Republic, Hungary, and Bulgaria, and an additional $3 million for the Baltic States, to create the kind of information and analytical systems required to sustain the legislative activity of a democracy. The Congressional Research Service of the Library of Congress was designated in September 1990 to implement these services. The assistance includes the purchase of books and journals, the acquisition of hardware and software, help in establishing a research capability and—crucially—the training of parliamentary librarians and legislative staff.

Other goals related to the development of information and analysis systems for each legislature include the ability of legislative staff in the different parliaments to be able to communicate with each other electronically—to share, for example, drafts of legislation concerning problems they face in common, such as pollution control, the transition to private-property rights, or the delineation of voting districts. Each parliamentary library also needs rapid access to the national library in its own country for in-depth historical, demographic, sociological, economic, and other information. Interconnection would allow access to an eventual central bibliographic utility holding, for instance, ten years' worth of citations to book, periodical, and newspaper literature on Eastern Europe in all European languages.

The Context of Culture

According to our Eastern European colleagues, the context of information services in Eastern Europe is very different from that in the United States. Although there is a thirst for information in some quarters—for instance, among the parliamentary staffs and among the many dedicated professionals in the national libraries—the East European populations in general do not value information. For forty years important and accurate information about these societies, to the extent it existed, was regarded as strategic and was available only to intelligence services and the ruling Communist elites; except for officially sanctioned material, the circulation of any hard information was prohibited. Publicly available information was so intermixed with lies and propaganda that one could hardly distinguish truth from falsehood. No one trusted public information. *What* one knew was clearly less important than *whom* one knew; the *nomenclatura* ran the system. Promises were not made to be kept, but as a way of smoothing over controversy: one could promise anything because one could falsify records—say, of production or fulfillment—later. Avoiding initiative, avoiding responsibility, avoiding decision, avoiding individuality was clearly an adaptive strategy during the communist era.[1] But such avoidance is not an adaptive strategy in an infor-

mation age. Nor do such habits of avoidance prepare one to inquire into the validity, comprehensiveness, and accuracy of the information one receives.

These cultural habits are offset to some extent in the contemporary context by the need for clarity of such data as property rights or tracking the status of current legislation. Accurate and current information, even the full text of recent statutes, becomes highly valued. Attitudes change toward information and the means of providing it. One can see in the parliamentary context that online systems with sophisticated search and retrieval capability become important tools for legislators, as do bill-tracking systems and legal bibliographic and reference systems.

Still, individual behavior patterns are resistant to change, and in the societies of Eastern Europe information is not regarded, as it is in the library culture of the United States, as a free good. For those concerned with bibliographic information retrieval in the United States, a major task is to design systems to sift intelligently through an information overload, whereas in the societies of Eastern Europe the task is to educate people about the value of information and the need to make informed decisions. People need to understand the imperative of avoiding deception, including self-deception, if one is to have the trust in one's peers upon which democracy crucially depends. The Communist regime delegitimized ideals, self-discipline, the desire to be self-motivated, the reality of trust. To bring about an open society means essentially the rebuilding of the fabric of civil society, of institutions one can trust; citizens must relearn a willingness to stand behind one's word, to inquire into options, to value informed choice.

Libraries and Networks

To achieve any depth or comprehensiveness of information, library resources must be brought to bear. History—real history—must be reconstructable; sources must be accessible. In Eastern Europe each national library functions as a repository of national material; serving as the copyright library for everything published within the country. Each library also collects material written *about* the country as well as material written either *in the language* of the country or *by its nationals* anywhere in the world. Even during the years of Communist rule national libraries tried sporadically to acquire materials published elsewhere in the national language, but their success in doing so was limited. Foreign-language materials are not collected comprehensively by Eastern European libraries. This means that literature about neighboring countries may be partial, spotty, or nonexistent.

The solution to these serious lacunae is to make the catalogs of each national library available to the others in some easily usable form—perhaps via CD-ROM

or, even better, online. The obstacles to a single *integrated* database of all the national catalogs are formidable: different character sets, different diacritics, different search terms or key words, different scope, different treatment of similar literature (e.g., periodicals at the article level). The availability of *The Unicode Standard* will simplify the computer translation of different character sets, but a fully integrated, machine-readable database for all of Eastern Europe is a monumental task. The development of technology suggests that such an integrated database is no longer necessary or even desirable. Suppose that each catalog could be consulted in its own machine-readable format using the search strategy established for it by its creators? And further, suppose that search results could be made available in the language of the catalog online over Internet or some equivalent network?

To effect this, a series of intelligent servers is required on the network to translate a user's inquiry into the appropriate technical form for each database, search multiple databases in their own formats, and then aggregate the responses. Though it would remain possible to identify the source of the responses according to database, to the user the system would seem transparent. The user's question first travels to a set of distributed databases, and relevant answers are collected from each database. The results are then retrieved and organized in a unified response. Each database is maintained by its creators through an agreed pattern of distributed responsibility, so that requirements for technical compatibility are much less stringent than is necessary for the creation of files within a unified database.

An equivalent system already exists through ASTRA on the Italian scientific research network. The responsibility for maintaining databases is divided among institutions in Pisa, Milan, Florence, Venice, Rome, etc.; databases vary in their subject matter and in the language of search—attractive features from an institutional as well as a technological point of view. When this system was demonstrated to the participants in our Budapest workshop through an Internet connection to Italy, we saw immediately that to extend such a system to Eastern Europe would solve many of the problems of an integrated database through cooperation and networking. We gave such a potential system the name WEBNET (*W*orld *E*ast *E*uropean *B*ibliographical *Net*work).

Radio Free Europe/Radio Liberty
Research Institute

In sum, a bibliographic database system requires a physical location where databases now built and maintained outside Eastern and Central Europe could be integrated and maintained. This should be tied into a system equipped with intelligent servers that could search the national bibliographies in each

country, creating for the user a bibliographic system covering all of Eastern Europe. For parliamentary libraries full text capability would be necessary in addition to bibliographical information. High-speed, high-capacity electronic communications would make possible user searches across the full range of distributed databases in a matter of minutes. Does this sound utopian?

What gives such a vision feasibility is the existence of Radio Free Europe/ Radio Liberty (RFE/RL) and its communication network. At its headquarters in Munich, RFE/RL created in November 1990 a research institute—separated from its broadcast activities—to include, *inter alia*, its archival and analytic services, its library of East European newspapers and periodicals collected over decades, and its large *samizdat* holdings from Poland and the Soviet Union. These library resources have an obvious compatibility with the purposes underlying our bibliographic project. The RFE/RL Research Institute might be an excellent location for the integrated bibliography created from North America, West European, and Russian files. An experimental integration of the three files was completed by the end of 1992, proving that it is feasible to mount a joint retrospective file to 1986. More significantly, RFE/RL has powerful and fast communication capabilities, including fiber optic links between Munich, New York, and Washington, with field offices in Moscow and in most East European capitals— where both national and parliamentary libraries are located. For its own purposes RFE/RL would like to upgrade its links between Munich and many East European capitals to V-sat, feeding into microwave or cable connections locally. Such a system could transmit broadcasts to the RFE/RL office and, through other local links, to transmit electronic text and other information to local institutions. A network of this kind could provide direct communication between libraries in East European capitals and Washington, so that access could be obtained to electronic files maintained in the United States. High-speed linkages with New York and Washington mean that much relevant material could be put at the disposal of parliamentary and national libraries in Eastern Europe rapidly and effectively. The value and feasibility of adding university and other research institutions in Eastern Europe to such a system once it is in place is apparent.

The Prospect

While this system is still a dream, it is a dream spun from a solid basis of institutional and technological accomplishment and a growing culture of cooperation. Several recent developments point to promising shortcuts that may well avert the necessity of waiting until East European telephone lines have been upgraded. Both microwave connections and packet radio technology have been tested at discrete sites in Eastern Europe; they are technologically feasible for multiplying local connections and could reduce costs substantially.

Thus the WEBNET group, growing from an original bibliographic project and working in combination with RFE/RL and the Frost Task Force, has pushed to close the gap between existing and potential technology. We believe that by doing so, we can strengthen the prospects for democratic legislatures in Eastern Europe and contribute to the growth of an open and informed society.

There are still issues to be faced concerning the governance of WEBNET once the technological barriers have been removed. The logic of the system suggests distributed responsibility and a cooperative, consensual mode of addressing choices rather than central control. With the gradual growth of the system (compare Internet) an appropriate management structure will evolve. It seems to me an exhilarating possibility that institutions supported by the United States Congress—such as the Library of Congress, Radio Free Europe/Radio Liberty, and the Frost Task Force—can foster the increasing effectiveness of institutions in Eastern Europe and enhance the cooperation among them.

Note

1. See Erazin Kohak, "Ashes, Ashes . . . Central Europe After Forty Years," *Daedalus* 121 (Spring 1992): 197–225. This entire issue of *Daedalus*, entitled *The Exit from Communism*, is relevant to our topic.

DOCUMENT

CATHY SIMON
A Civic Library for San Francisco

In 1988, the people of San Francisco voted overwhelmingly to construct a new main library for their city. Described as a "library for the twenty-first century" in the bond issue that funded it, the new library will occupy a site directly across the street from the existing 1919 Main Library, pairing with it to define the great forecourt to San Francisco's City Hall. The construction of the new library will complete the Beaux Arts Civic Center, the largest, most intact "city beautiful" assemblage of civic buildings in the United States. The library will serve a San Francisco population of 750,000 and a regional population of nearly three million.

The function of a library is elemental: it is the house of the book, a building used to store and conserve books. It is a promoter of books, words, and literacy. In simple terms, the mission of a library is to hold and willingly share the key that unlocks for all readers the world of knowledge, information, and culture through books and associated materials. In our history, libraries have played a role as guardians of precious ideas, always with the intention that through conservation, those ideas would have a life and currency beyond the walls of the library itself.

Implicit in designing a civic library is the memory of the great libraries of the past: the Alexandria library, with its collection of Aristotle and Plato; the Laurentian Library, with its cascading stair and inversion of wall and column; the library of the monastery at Melk, where the effect is almost as if the walls have become books; the Bibliothèque nationale, an internalized infill borrowing the light of the sky and joining with the fabric of Paris; the Bibliothèque Ste. Geneviève, with its walls carved like tombstones of heroic literary figures. While the importance and size of the collections in all these libraries varied with their place in time and with the advent of the printing press, the pattern of use was analogous. The privileged visitor to the library entered the sacred precinct, often ascended a staircase, consulted a catalog, requested a volume, and read it in secure confines.

In San Francisco, the simple mission of the library, together with its architectural design and traditional patterns of use, has been translated into an enormously complex program that reflects a series of often conflicting multivalent project goals and the multicultural, pluralistic community the library will serve. The architects' task was to arrive at a design that would meet the program on its

assigned site and that would accommodate the complex social and technological organization through which this program was meant to be effected well into the twenty-first century.

The Context:
Site and Program

The site designated for the new Main Library is the last remaining significant open space in San Francisco's Civic Center planned immediately after the 1906 earthquake. The plan anticipated two key features: a series of "wall buildings," framing a great civic space within which the City Hall should stand distinctly separated from other buildings, and a street pattern that reinforced the goal of maintaining a central open area. The only planned "object building" in the entire complex, City Hall, with its then dominant dome, faced the commercial district of San Francisco exemplified by Market Street at the far end of the Fulton Street axis. This axis connected the symbolic core of government services and the actual heart of the city.

Careful analysis shows that the architects of buildings such as the old Main Library and the State Building to the northwest designed them as wall buildings.

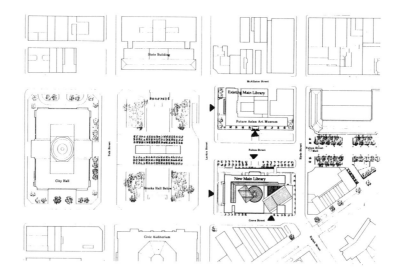

FIGURE 1. Site plan showing existing Library/future Asian Art Museum and New Main Library. Building entries are indicated. Credit: architects.

Characteristically, these structures had elaborate civic sides along major streets (McAllister and Grove) and axes (Fulton), and a more simplified, utilitarian "infill" behind. Courtyards and lightwells penetrate these early buildings to allow for daylighting and natural ventilation. The evidence of these thirty- to forty-foot-deep "occupied walls," in the scale of their formal elements, their massing and language, creates the backdrop appropriate to set off City Hall.

The property-line dimensions of the Marshall Square site are approximately two hundred by three hundred feet (fig. 1). In combination with a written program calling for approximately 400,000 square feet of new library space, the site implied a deep, dense building, touched by light only at its perimeter. Moreover, the new building had to appear to be the same size and scale as the old library across the street, future headquarters for San Francisco's Asian Art Museum. To fulfill its program in this restrictive dimensional envelope, the new library would need to occupy seven levels in contrast to the four housed in the existing building.

The San Francisco Main Library Program given to the architects documents the complexity of the contemporary urban public library. Paradoxically, it is described as a library for the twenty-first century, with all the requirements of the electronic library, but it remains strongly focused on traditions of literacy and the book. It is made up of hundreds of parts, each part serving a singular purpose but interrelated in innumerable ways: loan desks, reference departments, literacy services, book processing, conservation, receiving and binding, children's and young adults' departments, government documents, libraries for the blind and deaf, open, closed and special collections, microfilms and microfiche, video and audio collections, administration, a cultural-events complex consisting of auditorium, meeting rooms, galleries, a media studio and cafe, and staff services. The task was to find a principle for arranging these functions hierarchically to ensure their usefulness and intelligibility to patrons and staff alike.

Architecture of Movement

Viewed from the Civic Center, the massing of the new library mirrors the existing library, with an L-shaped "occupied wall" facing City Hall to the west and Fulton Street to the north. Together, the old and the new libraries complete the delineation of the public space between City Hall and Market Street. Embraced by this forty-foot-deep zone is the modern library, a field of highly serviced, flexible spaces and an informal set of parts related to the city as a whole.

The entries to the building and the circulation system within it provide the order of the plan. Within the occupied wall, two entries, one facing City Hall and one at the center of the Fulton Street facade, pair with the existing building to provide honorific access to the building from the symbolic ceremonial spaces between City Hall and Market Street. These two civic entries occur at a mezzanine

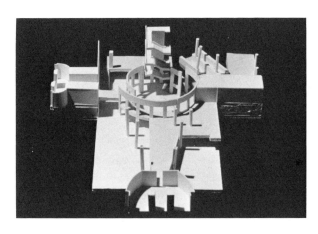

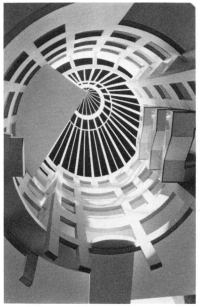

FIGURES 2 and 3. *Left:* diagrammatic model of entry sequence and circulation system. Fulton Street entry is to the left, Larkin Street entry at center, and Grove Street to the right. *Right:* view of five-story skylit open space with Periodical Room and Grand Stair. Photos: architects.

or bridge level, outside security, overlooking the reading rooms on the lower level. A third entry, opposite the transit stops on the corner of Market, Grove, and Hyde Streets, brings visitors in at a lower level. Here circulation paths from Fulton and Larkin Streets converge and step down a half level into the library through a single security point. Passing through shafts of light between the occupied wall and the rest of the building, drawn to the center by light, these pathways through sculptural space are separated physically from books but are immersed in the visible world of books all around, above and below, and on all sides.

The convergence of the three axes of entry and movement where the building joins the city determines the phenomenological center of the building (fig. 2). A five-story skylit court, sixty feet in diameter, catches the light like a gigantic lantern (fig. 3). Here the order of the building is revealed and the architecture of movement begins and ends. A grand stair moves through the space vertically, turning in and out of the illuminated central space. The stair starts at the edge of the circle and moves up, away from the light, to a broad gallery overlooking the space. From here the stair passes back through the ring and enters the court and the light, then passes back through the wall to the second floor. The

pattern of vertical passage, of emergence into the lighted space and return to the next floor, is repeated from the second to the fourth floors. At the fourth floor, the stair shifts away from the central court to a secondary pool of light that draws it to the top floor and the special collections housed there.

The choreography of this kinetic architecture not only serves as a means of access or a vertical connector, but forces a perception of the whole plan of the building. In this sense, the central court can be seen as the table of contents of a book, in which chapter headings outline the complexity contained within. Only upon immersion in the text, however, does the true depth or richness of the work unfold.

The sculpted space of the center and the circulation path combine to set the stage for the book, reinforcing the mission of the library, creating free access to a series of places for reading, working, studying, browsing, and researching. Between the occupied wall that houses the public-access stacks and reference areas is a five-story skylit street crossed by connecting bridges (fig. 4). Seen from the center, the color-coded metal and glass stack ends visually dominate the surrounding internal space. The rows of books constitute a continuous collection from 0 to 999 in the Dewey System. These rows of books dominate the visual aspects of the interior, literally and figuratively surrounding the internal space. Above the third floor hovers the glass and steel periodical room. Inflected to the geometry of Market Street, this room projects into the central court opposite the grand stair and rises in a butterfly shape through the roof, pulling light deep into

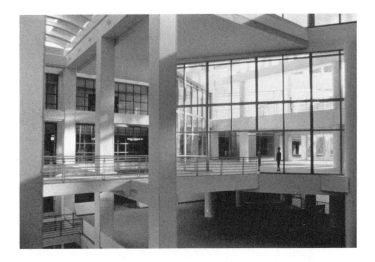

FIGURE 4. Periodical room connects to occupied wall with an open bridge. Photo: architects.

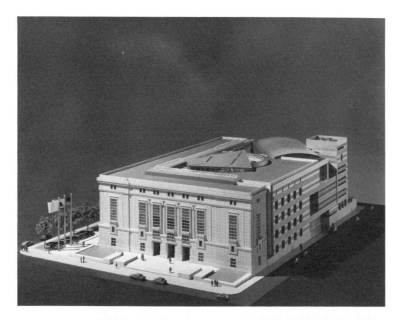

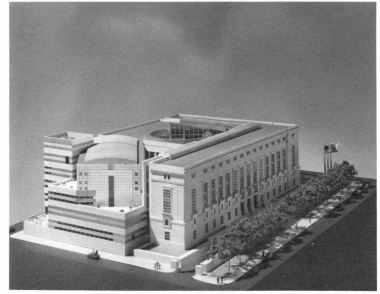

FIGURES 5 and 6. Schematic model. *Above:* view of Larkin and Grove Streets corner, showing "occupied wall" and contemporary Grove Street facade. *Below:* view of Hyde and Fulton Streets corner, with "house of books" emerging above second floor. Photos: Gerry Ratto.

the internal spaces below. It dramatizes the perception of the library's order by seeming to violate the building's otherwise traditional and rectilinear logic.

Design of the Exterior

The Fulton Street facade transforms the existing library's long wall (fig. 5). Like a number of American public-library exteriors of the late nineteenth and twentieth centuries, the design is freely based on Labrouste's Bibliothèque Ste. Geneviève. Atop a rusticated base, steel panels, rolled to resemble pewter in scale and color, contain small windows and support monumental two-story windows and an attic story, following the tripartite composition of the other Civic Center buildings. With their emphatic corner pavilions and thirteen reflected bays, the new and old libraries mirror one another, bookends for the beginning and end of the twentieth century.

The Grove and Larkin Street facades in turn transform the abstracted classical facades of the occupied wall (fig. 6). Their large figural windows and open structures make a clear distinction between the traditional library and the library of the future: the occupied wall, which contains the open-stack collections, the repository of past and present culture, contrasts with the library of the future, a center of communication, interaction, and electronic images.

Glass and steel stairwells separate the elaborated occupied wall from the contemporary facades along Grove and Hyde Streets. Here the granite wall, organized with bands of steel and polished stones, opens to the contemporary city, marking the entry with a monumental four-square of glass, a recessed circular entry, and a tower that echoes the three pavilions at the corners of the occupied wall. Above the second floor, aligned with Market Street, emerges the "house of books." With its gridded steel cladding and punched windows, it is the representational element of the closed collections.

Materials, proportions, and dimensional consistency contribute to the unity of the exterior. Above all, however, it is the three-foot grid, applied uniformly across all four facades, that ties the building together. This universal pattern clearly demonstrates the modern construction techniques of the curtain wall where stones are hung in panels, not laid up like the ashlar masonry of the existing library and other Civic Center buildings. The stones themselves, Sierra white granite, are quarried from the same source used to construct the neighboring buildings nearly one hundred years ago. They suggest the history of the site and the newness of this building.

Note

The City of San Francisco announced the project with a publicly advertised request for the submission of proposals, and in January 1989 thirty-two architectural firms responded. After a three-step review process and two interviews, the city selected two firms to design the new main library: Pei Cobb Freed & Partners, whose past projects include museums, institutions, and public buildings, and Simon Martin-Vegue Winkelstein Moris, a woman-owned San Francisco architecture and interior design firm that has designed thirteen institutional and public libraries.

James Ingo Freed served as principal design partner for Pei Cobb Freed & Partners and for the project, and Cathy Simon was the principal designer for Simon Martin-Vegue Winkelstein Moris. The architects were assisted by numerous technical consultant firms, primarily local and many minority owned.

ANTHONY VIDLER

Books in Space:
Tradition and Transparency
in the Bibliothèque de France

Je n'aime pas les murs, j'aime les transparences.
—Dominique Perrault

AMONG THE MANY COMPETITIONS launched over the last decade as a part of François Mitterrand's systematic construction program for the *grands projets*, none has perplexed and disturbed observers more than that for the Bibliothèque de France. The globe and garden of La Villette, the pyramids at the Louvre, the cubic arch at La Défense, the massive opera complex, the transparent exposition halls have all aroused criticism and political opposition; but their programmatic definition and architectural expression were at least explicable within a known repertory of forms, and their public success has ratified for democratic purposes the evident Colbertian premises of their conception. The library competition, however, conducted under the deadline of the president's last term of office, has been apparently marked by an ill-defined program, a hasty and over-controlled selection of contestants, and an unseemly rush to judgment, based on schematic proposals that, on the surface at least, seem flawed both functionally and architecturally from the outset. Professional librarians, researchers, and architectural critics have raised serious questions about the operating efficiencies of a library divided into four tower blocks, while a vociferous clientele has called for more study of the spatial conditions of reading.

Criticism of the architecture, moreover, has not been confined to a non-French group of researchers nostalgic for the cozy intimacy of the old Bibliothèque nationale, as supporters of the Perrault project would have it. Those familiar with recent debates over architectural style have been surprised by the uncompromising return to a neo-twenties modernism *pur et dur*, not only in the impulse toward a mythical "transparency" (a consistent tendency of the *grands projets*) but also to an urbanism à la Le Corbusier: both tendencies, as ossified in the corporate and municipal development programs of the fifties and sixties, have been in critical disfavor for over two decades.

For while many critics find no fault in the French state's contempt for the more caricatural, Disneyworld-like, historicist trappings of postmodernism, it was nevertheless assumed that the unhappy experiences of Les Halles and La Défense, not to mention the Jussieu faculty buildings, could never be repeated in

a climate that favored a more responsive approach to the urban context. The recent Centre du Monde Arabe by Jean Nouvel had, after all, successfully demonstrated a commitment to modern technology and urban contextuality without compromising either quality. Suddenly, the spectacle of Perrault's four glass towers, widely spaced on a concrete podium, directly contradicts the typological care and contextual premises taught by respected architectural ideologues like Bernard Huet and Aldo Rossi over the last twenty years, and returns us to a contempt for the urban street not voiced with such ferocity since Le Corbusier's fulminations in *L'Intransigeant* in 1929.[1] In the gradual redressment of modernism's dismal urban failures, and in the wake of bitterly fought struggles over government-directed plans for city-center development that would have razed the complex and tightly textured urban fabric in favor of commercial office and apartment blocks respecting neither scale nor historic street patterns, the asphalt wilderness projected by Perrault seems baffling.

Certainly, the serious reevaluation of institutional typologies stimulated by a revived interest in visual representation following the semiological interests of the seventies, combined with a critical attitude toward institutional programs framed by the writings of Michel Foucault, ought to have precluded any simplistic "functionalist" project and at least encouraged a public debate over the nature of the library and its roles in contemporary culture as a prelude to the competition. The very form of the competition, with its call for dossiers from a controlled selection of architects, its carefully selected group of twenty contestants, and its vague program, joined to an almost total absence of criteria publicly or privately espoused by the jurors, seemed against all socialist principles; indeed, the contest appeared to be loaded stylistically and ideologically from the beginning.

Yet despite such "mistakes," institutional and architectural, all the evidence points to a decision deliberately taken and a position clearly sustained on the part of both government and architect. Given the different approaches to the library illustrated by the twenty projects submitted in the final round of the competition, the selection of Perrault's scheme was evidently made with an understanding of all the ideological implications of its style and organizational principles. Indeed, the aspirations of Mitterrand's cultural advisers and the polemically stated basis of Perrault's design seem quite naturally to support each other, as if the architect had somehow divined the inner aesthetic drives of the jury and the president— given them form, so to speak, in a way that neither side could have predicted. As if the little plexiglass model, with its diagrammatic forms representing luminous **L**-shaped towers and vast courtyard, accompanied by photomontages and text, had the effect of crystallizing a still uncertain programmatic policy into an image, and thereby an object of obsession. Nothing else, it seems, would explain the fixity with which the administration and its architect have maintained (perversely, against every principle of modernist functionalist design) that the form will remain the same, no matter what changes are now introduced into the program.

Jack Lang explained this mutual fixation concisely: "Le projet de Dominique Perrault a séduit."[2] Confronted with a mandate to create "a library of an entirely new type," Perrault had, he claimed, "found an image that has the value of a symbol."

In this statement, Jack Lang, perhaps not entirely cynically, is using the very language of a movement that began as a critique of modernism and endorsed a revival of typological signification to explain his support of a scheme that seems, on the surface at least, precisely the opposite—that is, both modernist and anti-typological. Here we begin to discern the cleverly stage-managed status of Perrault's project that at once acts as a rhetorical device by which to speak of "the library" and, in its calculated level of nondefinition, allows itself to be used as a generic signified for a range of often contradictory administrative aims. Thus for Lang the design might be seen as an answer to the historicist desire to produce "a new monument representative of our epoch," even while it presents itself as a nonmonument—"a place and not a building." A countermonumental monument, a nonplace-place, the rhetoric of Perrault's presentation naturally holds resonance for a generation of socialists brought up abhorring the monumental forms of capitalist and (in Foucault's terms) disciplinary society. It would also, in Lang's terms, offer an answer to all the difficulties posed by the "machine in the garden," neatly resolving the problems of a traditional socialist commitment to the Garden City (inherited from William Morris) combined with a traditional suspicion of technology, by reversing the question and offering "the charms of a beautiful garden protected from the noise," surrounded by a machine that gives a "place for all the technologies of the future." The rhetorical level is raised still further by the President of the Association for the Library of France, Dominique Jamet, who seizes on the pleasurable play of *verre* and *vert* in the assemblage of Perrault's glass towers around the garden, in order to coin the double epigram: "It has been said that Rousseau put nature [*du vert*] into literature. It will be said that Perrault put glass [*du verre*] into contemporary architecture and nature [*du vert*] into old libraries."[3] He concludes, opening the way for a multitude of reflected associations *en abyme*, "This library, clothed in light, is made of the stuff from which dreams are woven."[4]

These formulations, and the many others that have wrapped this project, however, do not entirely derive from the literary imagination of high functionaries; they were at the outset presented ready-made by the architect himself. "A place and not a building," "a symbolic place," "a magical place," "towers encased in glass," "shifting of nature," these are the themes which punctuated the lyrically hubristic text that accompanied Perrault's drawings; a text that gains its force from the very abstraction of the designs it explicates, and initiates its own discourse of reception.

The tactical brilliance of Perrault's textual and visual presentation lies in the way in which the image of the new and unprecedented is constructed in the historical commonplaces of the traditional. And the tradition to which Perrault

repeatedly refers is, not coincidentally, that of French classicism. His supporters have not been blind to the happy homonymical relationship that joins Perrault to this tradition: "The project by a young Frenchman, whose name across three centuries echoes that of the author of the colonnade of the Louvre and of his brother the storyteller, has seduced by its monumentality, its minimalism, its simplicity, its audacity, its openness and its clarity."[5] The implications of a direct line of descent from Claude Perrault, the anatomist and engineer, classical scholar and translator of Vitruvius, architect of the Observatoire and Louvre, and brother of Charles Perrault, the theoretician of the moderns, puts into play all the possible virtues of the classical paradigm and its associations with Louis XIV. It further places his project in a line of *grands projets* that encompass not only monuments like the Louvre and the Invalides, but also those establishments of Colbertian foundation (hospitals, asylums) characteristic of the first age of public welfare. Thus Dominique Perrault himself opens his statement by situating his project among those that have combined "grandeur" and "generosity" in their planning; institutions (like the Hôpital Saint Martin or the Invalides) "that have been the fundamental signs of the advance of the city toward new territories." By this analogy, Perrault can at once flatter the ministers and their master (Colbert, Louis XIV; Lang, Mitterrand) while associating his own scheme with such public charity. The added respectability given to the development of the library's site (fig. 1) by subsuming it within the inevitable and historically confirmed movement of urban colonization from the center to the periphery further removes Perrault from any controversy associated with the government's plans for the east banks of the Seine—already blatantly in evidence on the Right Bank with the demolition of the village of *caves*, Bercy, to be replaced by a nondescript but overscaled recreation center, and the construction of the new Ministry of Finances aggressively jutting into the river like a broken concrete bridge.

But the classical tradition, for Perrault, also comprises its reformulation by modern classicism, and especially by Le Corbusier, whose appeals to the authority of Colbert and the abstract geometries of seventeenth-century classicism formed the acknowledged authority for his modern urban projects, from La Ville Contemporaine in 1923 to Ville Radieuse in 1933. As outlined in the series of essays published in his *Urbanisme* of 1924, the principles of Corbusian planning are simple enough: erase the existing city fabric, create a huge park crossed by elevated highways, and scatter widely spaced glass-faced office towers on a regular grid throughout the former center. The Plan Voisin for Paris of 1925 was paradigmatic, unabashed in its acknowledgment of contempt for the old city and celebration of the crystalline effect of the transparent towers glimmering among the trees. Resonating with the excitement of Futurist movement and Expressionist crystal mysticism, Le Corbusier's fantasized monuments dematerialized through an "ineffable" space (Le Corbusier called it "l'espace indicible") that, like the air and light liberated by the opening up of the city, penetrated and dissolved the

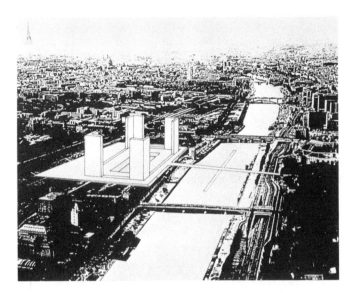

FIGURE 1. Dominique Perrault, Bibliothèque
de France, Competition entry,
aerial view, photomontage.

buildings themselves. Perrault's towers, similarly, "multiply reflections, amplify the shadows; absolute magic of the diffraction of light across the crystalline prisms," "defining a virtual volume that crystallizes all its magic, all its poetry."[6]

Le Corbusier's Rousseauesque, romantic, and anti-city vision was at the same time calibrated in plan on the strict geometries of classicism: the Louvre, the Palais-Royal, the Invalides, Versailles itself were all referred to in the massing of the apartment blocks, while the towers were spaced in patterns that evoked the *parterres* of Le Nôtre. The entire city was likewise controlled by a proportional system derived from his reading of the first classicists, François Blondel (first director of the Académie royale d'architecture under Colbert) and Claude Perrault.

Thus it is easy for Dominique Perrault to call himself at once a classicist and a modernist when he claims for his project, in the first of many similar sleights of hand, a nonmonumental status. In Perrault's eyes, his overscaled assemblage of towers set on a huge rectangular base is not in fact what it seems to be, but rather its opposite. Overtly paraphrasing Le Corbusier he writes, "the greatest *gift* that it is possible to make to Paris consists *today* in offering space, the void, in a word: an open place, free, emotionally moving."[7] What he is giving to the city of Paris in this monumental act of architectural charity—his emphatic characterization of his scheme as a gift or *don* seems to privilege the building as the ritual object of monarchical, presidential, and Maussian giving—is not in fact a building, but a

place, not an object but a space. "A place that is inscribed in the continuity of the succession of great empty spaces bordering the Seine, such as the Place de la Concorde, the Champ de Mars, les Invalides." The very work of the architect is characterized as "a work on empty space," and the result as an essay in "the immaterial, the non-ostentatious."[8]

The political implications of working with space and not with monuments have not, of course, escaped Perrault. For space—as confirmed by the successive appellations of the former Place Louis XV, then Place de la Révolution, then Place de la Concorde—is notoriously mutable, where monuments—as confirmed by the fate of the Bastille—are less susceptible to reinterpretation, or rather embarrassingly fixed in their connotations. Perhaps also, Perrault is conscious, as he designs for a Socialist president, of the long revolutionary tradition of "working with space" as a popular alternative to working with buildings, a tradition epitomized by Michelet's celebrated opening to his history of the French Revolution: "The Empire has its column and engrosses almost exclusively the Arc de Triomphe; royalty has its Louvre, its Hôpital des Invalides; the feudal church of the twelfth century is still enthroned at Notre Dame: nay the very Romans have their Imperial ruins, the thermae of the Caesars. And the Revolution has for her monument—empty space. Her monument is this sandy plain, flat as Arabia. A tumulus on either hand, resembling those which Gaul was accustomed to erect—obscure and equivocal testimony to her heroes' fame."[9] The faint memory of the revolutionary festivals on the Champ de Mars—a field close to nature, as the historian Mona Ozouf has observed—in the library-turned-garden would no doubt have had a certain resonance in the bicentennial year. Perrault reinforces

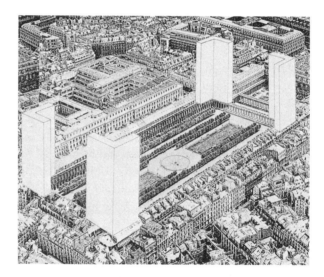

FIGURE 2. Dominique Perrault, Bibliothèque de France, photomontage of towers set on the corners of the Palais Royal.

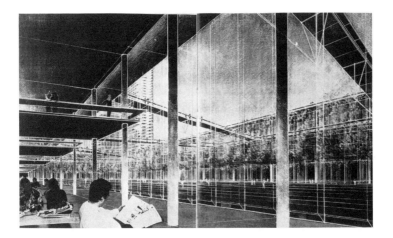

FIGURE 3. Dominique Perrault, Bibliothèque de
France, photomontage of library
reading room.

the point by deft photomontages, influenced by those of the twenties, that place
his towers on, for example, the corners of the Palais Royal (fig. 2), or transpose
his garden to the Place de la Concorde, in a sequence that ends with its final
resting place on the left-bank site.

If what Foucault characterized as the revolutionary dream of a "festive city,
inhabited by an open-air mankind"[10] forms one frame for viewing Perrault's oth-
erwise perplexing privileging of the space of the garden over that of the library,
and the anti-city urbanism of Le Corbusier forms another, both with their appeal
for a late twentieth-century social program of "greening the city," it is also true
that the garden and the library have had a respectable tradition of affiliation in
the history of Parisian public libraries, from the Bibliothèque Sainte-Geneviève
(1838–50) to the Bibliothèque nationale (1854–75). As Neil Levine has shown,
their architect Henri Labrouste construed his illusionistic garden for the vestibule
of the Bibliothèque Saint-Geneviève as a way of compensating for the impossi-
bility of a forecourt "planted with big trees and decorated with statues," to "shield
[the building] from the noise of the street outside and prepare those who came
there for contemplation." The painted garden, by contrast, offered "the advan-
tage of offering trees always green and in bloom."[11] Similarly in the Bibliothèque
nationale, the painted lunettes surrounding the Salle des imprimés were said to
recall the trees of a corner of the Jardin du Luxembourg, a favorite reading spot
for students.[12] A later reader, Walter Benjamin, was to look up from his indefa-
tigable transcription of quotations for the *Passagenwerk* long enough to reflect on
this mise-en-scène:

The editing of this text that deals with the Parisian passages was begun in the open air, beneath a blue sky without clouds that forms a vault above the foliage, but which had been covered over again with a dust many centuries old by the millions of pages among which rustle the fresh breeze of assiduous labor, the heavy breathing of the researcher, the tempest of youthful zeal and the nonchalant zephyr of curiosity. For the summer sky depicted in the arcades that dominates the reading room of the Bibliothèque nationale in Paris has extended over it its blind and dreaming covering.[13]

The link thus made between tradition (the Beaux-Arts, neo-Greek style, the "original" Bibliothèque nationale) and modernism (the arcade, glass and iron) was for Dominique Perrault's generation cemented by Sigfried Giedion's reading of Labrouste as a canonical precursor of iron construction in his *Space, Time, and Architecture* of 1941. For Giedion, the real "architecture" of Labrouste lay in his treatment, not of the reading room, but of the stack area behind: "Labrouste's masterpiece is the *grand magasin*. . . . The whole area was covered with a glass ceiling. Cast iron floor plates in a gridiron pattern permit the daylight to penetrate the stacks from top to bottom. . . . This hovering play of light and shadow appears as an artistic means in certain works of modern sculpture as well as in contemporary architecture."[14] From this to Perrault's transparent towers, offering the spectacle of the warehoused books to the public, was a short step.

Perrault, finally, transfers this overriding metaphor to the reading rooms themselves (fig. 3). They are, he states "completely glassed-in," "offering all the technical services of the modern world" and "lit naturally along their entire length by a top light." But in this final concern, for "a place of reading," we reach a limit in the interpretation of Perrault's scheme as an assemblage of traditional and modernist forms. For while his rhetoric speaks of "places protected and protecting" for readers, and draws an enticing picture of the "initiation" of the reader into the heart of the library, once reached, this heart is revealed not to be there. The project is, instead, dominated by the expression of books in *storage* (in the towers), and books *already read* (the meditation in the garden); the place of reading itself is strangely absent, or at least thoroughly disseminated throughout the universal space of the surrounding buildings. A single photomontage perspective among numerous other model photographs and sketches of the towers and garden shows merely five readers, nonchalantly leafing through (architecture?) magazines beside a glass wall looking onto the garden.

On one level, an explanation might be fabricated for this absence of a place of reading in the light of the "information revolution" celebrated in much of the literature surrounding the library; one might even speculate as to the appropriateness of the disappearance of the reader in a poststructuralist world. But Perrault himself offers no such reasoning; rather he imagines the reader "plunged" "in an exploratory voyage to the heart of human knowledge," and the library as "a place of initiation" dedicated to the "passion of the reader for *la chose écrite*," seemingly oblivious to the unceremonious unseating of his mythical client

FIGURES 4 and 5. James Stirling, Michael Wilford, and Associates.
Bibliothèque de France, competition entry, 1989. *Left:*
model; *right:* axonometric projection.

implied by his project. Against the central place taken up by the reading room in
the traditional national libraries—not only in Labrouste's Nationale, but also in
Sidney Smirke's British Museum Reading Room (1854–57), or more recently, in
Gunner Asplund's Stockholm City Library (1923–27)—the effacement of the
representation of reading by Perrault is striking.

Perrault's refusal of a central role for the reading room in the symbolic rep-
ertory of his library, is not, however, entirely perverse; indeed it is consistent with
his programmatic return to modernism. Modernism, after all, in the most general
terms, similarly refused any reference to the past, either stylistic or typological,
in favor of a universalist treatment of space that would simply articulate func-
tionally determined volumes by means of structure and envelope. But Perrault's
universalism would also apparently denote his rigorous refusal of a postmod-
ernism that had revalued the figurative aspects of architecture, drawing on tra-
ditional motifs and references to well-known forms in order to "re-semanticize"
an architecture deemed cold and abstract, if not antihumanist.

The contrast is clear when Perrault's scheme is compared to the most osten-
sibly postmodernist entry of all, that submitted by James Stirling, Michael Wil-
ford, and Associates. Stirling's design takes each of the four libraries of the
program and gives them individual form around differentiated reading rooms:
a domed acquisitions library, a conical film and sound library, a hexagonal
pavilion for the research library, and finally a long, barrel-vaulted hall for the
study library (figs. 4 and 5). Apparently anticipating the spate of neomodernist
solutions inspired by the competition, Stirling wrote: "This concept allows each
of the four libraries its own separate identity and avoids an unattractive 'Kafka-

esque' experience, which such a large building could produce if planned as a single volume." Huge, undifferentiated block solutions (preferred by the modernists Bernard Tschumi, Rem Koolhaas, Henri Ciriani, Richard Meier, Francis Soler, Günther Domenig and Hermann Eisenköck, Philippe Chaix and Jean-Paul Morel, and Fumihiko Maki, as well as by the more traditionalist architects Bernard Huet, Ricardo Bofill, and Alvaro Siza Vieira), equally generic spine-and-slab solutions (Jean Nouvel, Herman Hertzberger, Nicholas Grimshaw, and Arquitectonica), and repetitive pavilion schemes (Mario Botta, Future Systems) are rejected in favor of an assemblage of identifiable and semiautonomous buildings. Stirling's plan, in fact, sees the library as a kind of academic village, a research park or festival site, with each purpose marked from the next and treated as a separate architectural entity.

Stirling further deliberately selects his architectural repertory from a non-modernist canon: the implicit ziggurat of the Tower of Babel, and more directly, the project for a vaulted Bibliothèque du Roi by Etienne-Louis Boullée (1784–85), and inevitably, the domed reading room of the British Museum Library. Here Stirling is making direct reference to the notion, advanced by the architect Aldo Rossi and other theoreticians of architectural typology in the 1960s and 1970s, that the coincidence of neoclassicism and the invention of public institutions at the beginning of the modern period in some way invests the dramatic

FIGURES 6 and 7. *Left:* Ko Young Hoon, untitled painting. *Right:* Wolfgang Nieblich, untitled sculpture.

projects of Boullée, Ledoux, Schinkel, and Smirke with protomodern authority; endows them with a signifying power that might be mobilized for the present; and offers these first types of public building to the contemporary architect as the emblems of continuity and as the "building blocks" of a renewed classical language.

Perrault, by contrast, caustically dismisses any such signifying practice based on prototypes; echoing the classicist distaste for "monsters" evinced in Horace's *Ars Poetica*, he disclaims all resemblance to the historical hybrids of the past: his is "not a building-monster crossed between a temple and a supermarket."[15] As Jamet put it, "all the candidates had to respond to the same question. All did not respond in the same way. There exists no fixed ideal form for a library. At least one could wish that it did not look too much like a railway station, a gymnasium, an airport, a hippodrome. The confusion is sometimes possible."[16] It would seem that Perrault has, as the organizers wished, succeeded in creating "a completely new type of library," unhindered by the fetters of history.[17]

Yet, the very success of Perrault's design rests, as we have seen, on its explicit aim of creating a symbolic form. Perrault himself is clear enough; beyond the "void" of the garden, the central metaphor is afforded by the four towers that, in the architect's words, imitate *"four open books placed face to face"* and form "urban beacons that valorize the *book* with an aleatory mode of occupation of towers that present themselves as an accumulation of wisdom, of a never-finished knowledge, of a sedimentation, slow but permanent."[18] Illustrating this vision of a geological deposit of books, slowly congealing in their glass warehouses, are two equally symbolic images: the one, of a painting by Ko Young Hoon, shows an open book with its pages weighed down by four stones, artistically placed on the pages (fig. 6); the other, of a sculpture by Wolfgang Nieblich, shows a closed book, with stalks of grain growing from its cover (fig. 7). Both represent the static sense of a book "as object" returned to stone or earth, transformed into aesthetic artifact or green ground. In this context, the four towers simply extend the metaphor. In the search to characterize the new library, Perrault has, not surprisingly, fastened on its most static and architectural elements—books, closed and buried—in the process forgetting, consciously or not, the process of reading and research the library itself is designed to facilitate. Even the host of parallel associations that he allows reinforces this sense of immobility, of the book fixed, so to speak, in stone: "Other complementary metaphors, whether they be named towers of book, or silos, or immense stacks with innumerable shelves, or vertical labyrinths—the sum of these images without ambiguity converges toward a strong identity for these architectural objects."[19]

But this kind of symbolism seems entirely at odds with the modernist affect of Perrault's style. Modernism, at least of the kind espoused by Perrault, either refused all forms of characterization in the attempt to subsume every function in universal space, or tried to match its forms with their functional equivalents.

Thus, for Le Corbusier, any semantic residue that remained after the social needs and technical requirements had found their "organic" structuring was to be a natural result of that very structure. The most symbolic of all Le Corbusier's designs of the twenties, that for the Musée mondial, associated with the Mundaneum or Cité mondiale proposed by the Belgian social reformer Paul Otlet for a site above the League of Nations in Geneva, took the form of a giant pyramid constructed by wrapping the "aisles" of the museum around each other in a spiral. When criticized by functionalist purists for having created an antimodern, hierarchical monument with sacred and oligarchic overtones, Le Corbusier was quite willing to demonstrate the "natural" and machinelike unfolding of his design as a way of leading the visitor through the unfolding panorama of human history; the functionalist explanation was borne out by the form of the circulation pattern. Perrault, by contrast, forces his towers into the outer form of open books without respect for their inner functioning; and his garden is gratuitously introduced without reference to its typological place within the system of the library per se.

Indeed, with this gesture, Perrault seems to be reversing the modern tradition, first framed by Victor Hugo's ringing assertion in *Notre Dame de Paris*, that the printed book had finally overthrown the hegemony of building, in order to reassert the failing powers of architecture. Hugo, we remember, contrasts the huge, grotesque, lowering hulk of the cathedral, silent and closed, symbolic of the old hieratic order of priest and prince, to the emerging voices of the crowd, the first anarchic stirrings of freedom that will find its voice, not in cathedrals and their stone gospels, but in books and their mobile propaganda: "This will kill that. The book will kill the building. That is to say, Printing will kill Architecture."[20]

Hugo's obituary for architecture was justified and explained by history itself. For if the political and social history of civilizations was calibrated with the history of written language, then it was evident that, at a certain moment, architecture, which from the earliest times had served to memorialize and teach by means of signs and symbols, had lost its primary role as "social book." It was now usurped by the book itself, rendered ubiquitous by the techniques of printing. From the time of Gutenberg, architecture had suffered a progressive loss of cultural power and significant form in proportion to the implacable ascendence of the book, which, "second Tower of Babel," had found its popular audience and political role in the nineteenth century. The ringing conclusion to Hugo's chapter entitled "Ceci tuera cela" gave the lie to any nostalgia for a return to the Middle Ages. Architecture as a prisoner of history might perhaps be repaired but never revived. The subtitle of *Notre Dame de Paris* underlined such a refusal of revivalism: 1482, a year when the publication of the first printed Bible had rendered the medieval world a museum. All previous books of stone returned to their own past, there to remain as witnesses to a dead epoch. There was left only the laborious task of the historian, deciphering lost languages as Claude Frollo in the empty Notre Dame. Architecture, its theory drawn from the irrefutable evidence

of cultural revolution and social change, could never, in Hugo's terms, regain its ancient status. As a language its meanings were lost; as a repertoire of types it had failed to keep up with historical change.

What Hugo meant by this enigmatic statement, apparently more satisfying in its rhetorical symmetry with "this will kill that" than in its implications for architecture, is not entirely clear, but his dramatic conclusion was certainly registered by a number of architects at the time.[21] Of them, Henri Labrouste, who knew Hugo, and who very probably read this chapter in draft form in 1831, provided the most thoughtful and, in retrospect, consistent response.[22] With its walls literally inscribed with the names of authors, as if the building had taken on the form of a giant catalog, the Bibliothèque Sainte-Geneviève seems almost to confirm and monumentalize the triumph of literature over architecture, books over buildings.[23] As Labrouste stated: "This monumental catalog is the principal decoration of the facade as the books themselves are the most beautiful ornament of the interior."[24]

In his insistence on the architectural reification of the book in the towers, as opposed to its celebration in the reading rooms, Perrault would seem then to be returning to a pre-Gutenberg, or at least a pre-Laboustian, sense of the building as message. Where for Labrouste the task was to frame reading by architecture, for Perrault the task seems to be to create an architecture symbolic of books. In this sense, his towers in the form of open books belong to the category of what the Romantics of Hugo's generation scornfully called *architecture parlante*, a genre of architecture associated with some of the wildest flights of caricature invented by the previous "revolutionary" generation—Ledoux, Boullée, and Lequeu, all architects who believed that a building should, in Ledoux's words, "speak to the eyes," to all intents like a hieroglyphic sign of its purpose. Thus Ledoux was infamous for his design of a barrelmakers' workshop in the shape of a barrel; Hugo's acquaintance Léon Vaudoyer caustically remarked that he would no doubt have designed the house of a drunkard in the shape of a wine bottle.

Boullée, to whom both Labrouste and Perrault pay different kinds of architectural homage, was more subtle, but equally committed to symbolic form, in his own project for the Bibliothèque du roi of 1785. In his justificatory memoir published in 1785, and later included as a part of the text describing the design (renamed "Bibliothèque publique" after 1789) in his *Architecture; Essai sur l'art*, Boullée, indeed, set the terms of reference by which the symbolic power of the library as architecture might be measured.[25] His premises were both functional and representational. Bound by the site of the existing library and determined to utilize its buildings for the sake of economy, he was concerned with the ever-present question of *surveillance* and speedy service, while cognizant of the increasing demand for book storage; to this was added the architectural problem of "joining [these considerations] to a noble and imposing decoration." The solution he advanced was at once breathtakingly simple as a spatial and economic

form, and powerfully symbolic of the library's humanistic roots. Boullée's project consisted in roofing over the existing courtyard of the Bibliothèque royale (the site that was ultimately to be partially occupied by Labrouste's extension) with a single coffered barrel-vault, thus forming a huge rectangular space lit from above by a long central skylight. Economic of building resources and easy to oversee, this space also acted as a reminder of the antique foundations of knowledge. An architectural rendering of the space depicted in Raphael's *School of Athens*, a painting cited by Boullée as inspiring him in his design, it also presented the aspect of an enclosed amphitheater. By placing the stacks in stepped tiers along the sides, Boullée created the illusion of a classical stadium, theatrically presenting the books as the only decoration of the building while ensuring easy service for the reader:

I have thus wanted our literary riches to be presented in the most beautiful ensemble possible. This is why I thought that nothing could be grander, nobler, more extraordinary and with a more magnificent aspect, than a vast amphitheater of books. In this vast amphitheater one makes out persons placed on the different levels and distributed so as to be able to pass the books from hand to hand. One will admit that the service will be almost as prompt as speech, without the ever-present fear of the dangers that could result from stepladders.[26]

In the notion of a service "as prompt as speech" and a surveillance transparent to the gaze of a single librarian, Boullée anticipated the more instrumental and post-panoptical concerns of the nineteenth and twentieth centuries. In its presentation as a single spatial image, his project marked those of Labrouste—who even painted a reproduction of the *School of Athens* in the stair leading to the long barrel-vaulted reading room of the Bibliothèque Sainte-Geneviève—and Perrault, whose "garden" seems to take the place of the enclosed amphitheater, and whose books transparently stored in towers seem to echo the display of learning in Boullée's terraces. One almost awaits a modern Boullée to suggest the vaulting of the garden to provide more space for readers.

In postmodern theory, Robert Venturi and Denise Scott-Brown have characterized the symbolic approach to architecture by referring to a roadside stall on Long Island that sells ducks and is, in the tradition of "speaking architecture," built in the form of a duck. Venturi and Scott-Brown contrast this with the alternative, modern, tradition of what they call the "decorated shed," the container that is universal on the inside and figurative only by virtue of its exterior detailing. In these terms, Perrault's symbolism, taking on the semblance of a giant, almost sign-like caricature, with all the air of a "one-liner," seems to be a "duck" masquerading as a "decorated shed." In this Perrault reveals himself to be a faux-moderniste—and more of a postmodernist than he would like to admit. Indeed, read as a cunning collage of modernist, classicist, and postmodernist quotations, framed within a dominant image that refers to its contents rather than deriving from their form, the Perrault scheme takes its natural place within the advertising

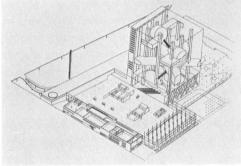

FIGURES 8, 9, and 10. Rem Koolhaas, Bibliothèque de France, competition entry, 1989. *Top and center:* photos of model; *bottom:* axonometric projection.

architecture that, beginning with love of Las Vegas (Robert Venturi and Denise Scott-Brown) and ending with the lure of Disney (Michael Graves, Robert Stern), has largely dominated international practice in the last two decades.

The difference between these architecturally licentious examples of post-modernism and Perrault's "minimalism" is, of course, that the first concern of architects like Venturi or Graves is for the creation of an individualist "signature" architecture that demonstrates the architect's skill in formal manipulation and historical sophistication. For Perrault, on the other hand, the question was pre-

cisely the production of a *universal* object, one that might serve as the open signifier of a host of universalisms: the universalism of the classical tradition; the universalism of knowledge; and, more importantly for the scheme's immediate resonance in the Mitterrand circle, social if not Socialist universalism. Supporters of this latter form of universalism, identified with the French republican tradition and more generally with the values of the French Enlightenment, have found in the Perrault library a rallying point against a host of contemporary particularisms based in identity politics and given special urgency by the pressures of the postcolonial condition. Its reassuringly abstract forms, tied to no specific agenda, provide an implicit solution—or at least an impartial and undifferentiated coverall—to the multiple and violently competing visions of "France" and "Europe" currently breaking up the traditional Socialist coalition.

In this context, it is now possible to discern why Perrault's apparently barren version of modernism would have been preferred over so many other enticing, richly articulated, reformulated modernisms and modern-classicisms offered by the other contestants. Richard Meier's elaborately refined Corbusian vocabulary, with its references to the High Court Building at Chandigarh; Mario Botta's Kahnian towers; Bernard Tschumi's constructivist running track; Arquitectonica's neo–*Miami-Vice* deco; Ricardo Bofill's and Bernard Huet's neo–New Deal modern classicisms; all these projects are framed in known architectural terms, and are, ultimately, more *about* architecture (and architects) than about the library or what it might signify to France. Even the other French modernists, notably Jean Nouvel, produced designs that celebrated technology (à la Centre Pompidou) rather than an institution; the British entries, save for Stirling's, offered much the same. Perrault, in this company, can be seen as the only nonarchitect; hence the force of his own characterization of his project not as a building but "as a piece of urban art, a minimalist installation, the *less is more* of emotion, where the objects and their materials are nothing without the lights [*les lumières*] that transcend them."[27]

Only Rem Koolhaas, the ironic modernist, author of the Barthes-inspired *Delirious New York*, and runner-up in the competition for the Park of La Villette, produced a design that might have presented serious competition to Perrault (figs. 8–10). For Koolhaas took seriously the mandate to produce a library for the electronic present, at the same time as he was concerned to reveal the limits of "architecture" to resolve the problems of information. Further, he produced an architectural solution that worked brilliantly at all levels from the symbolic to the functional. Conscious of the "precarious" venture in imagining the "ultimate library" at a moment when "the electronic revolution seems to have dissolved all that is solid," Koolhaas accepted the liberty implicit in freeing architecture from its originally solid tasks. Basing his project on what he called "technological scenarios" developed in coordination with systems analysts, he concluded that archi-

tecture as traditionally conceived will have little role in their operation. Freed from functionalist duty, he asserted, "the last function of architecture will be to create symbolic spaces responding to the persistent envy of the collectivity." Accordingly, the library is conceived like some vast three-dimensional information chip: "The library is interpreted as a solid block of information, a warehouse of all forms of memory: books, disks, optical instruments, microfiches, computers."[28] The ironic symbolic program has thus formed solids out of the most empty of forms (information) while the public spaces (normally solid) are now dissolved into "absences of building, voids carved out of the block of information."

But the solid block of information is in fact conceived as a translucent cube, luminous, and radiating the secrets of its interior to the exterior. On this outside surface, the shadows of the public spaces within are projected like ghostly manifestations—Koolhaas uses the biological analogy of "multiple embryos"—in a "specter of spatial experiences." Suspended, as in aspic, the different libraries float in the cube as if transgressing the very laws of gravity. Koolhaas has thus revised the functionalist directive to express on the outside what is on the inside, as well as turning inside-out the traditional notions of solid and void. The result is a brilliant and architecturally original evocation of the poetics and pragmatics of information technology, and by far the most successful of all the competition entries. It was also, as a member of the jury, François Chaslin, noted, "the most radical."[29]

That, in the event, the jury selected, not a radical invention of a library of "an entirely new type," but rather the insertion of the library in a generic form that avoided architectural articulation altogether, was entirely predictable. Under the presidency of the conservative modernist I. M. Pei, champion of the transparent Pyramide du Louvre, the process sent four projects for consideration by the president of the republic: one postmodernist (James Stirling and Associates), one technologically utopian neoexpressionist (Future Systems), and one high-tech modernist (Philippe Chaix and Jean-Paul Morel), together with Perrault's scheme. Perrault's submission, according to one of the twenty-nine-member jury, had already received unanimous approval on the first day of deliberations, and the other three selected projects were, in the context of Mitterrand's choices for the preceding *grands projets*, hardly contenders. The sphere at La Villette, the cube at La Défense, and the pyramid at the Louvre would now be joined in this simplistic play of simple forms by the four books of the Bibliothèque, investing Paris with a series of Socialist markers, architecturally expressing the tradition of universality through primary geometric solids that were, moreover, transparent. Koolhaas's mistake was to configure information under the sign of translucency and shadowy obscurity; the politics of the moment insisted, and still insist, on the illusion that light and enlightenment, transparency and openness, permeability

and social democracy are not only symbolized but also effected by glass. Such simple wisdom, effective enough in the rhetoric of ideology, is well served by an architect who asserts: "I dislike walls; I like transparencies."

The relations of architecture to ideology have been well documented—the political connotations of monumentality and of style, the definition of institutional programs, the allocation of resources, the implicit class divisions between high architecture and building construction, the politics of patronage—but rarely has architecture been so fundamentally reduced to the status of an ideological sign. Such a radical transformation has generally been effected in the domain of temporary structures, such as those erected for festivals and processionals; it would not be too remote a fantasy to place Perrault's towers in a garden in the series of similar geometrically abstract objects that began with the pyramids, spheres, and obelisks of the Revolutionary fêtes, each form denoting a particular idea, in the same way as the philosophes imagined the hieroglyphs of Egypt communicating with the populace. This sense of a Paris once more seeded by the boundary stones of a festival, a notion not entirely anachronistic in the context of the bicentennial celebrations, might be supported by the Pei pyramid, itself prefigured by the pyramid designed by Jacques-Louis David and set up in the Tuileries garden to memorialize the dead of 1792. Equally it might be confirmed by the spherical Géode at La Villette, inheritor of the didactic ideals of Etienne-Louis Boullée's spherical Newton Monument of 1785, a project dedicated to disseminating the knowledge of the Enlightenment through a vast planetarium built in stone. It cannot be by accident that a popular opera now plays on the site of the demolished Bastille. With the addition of the Bibliothèque, itself conceived in its present form by the Revolution, Mitterrand would seem to have completed the cultural revolution left unfinished by the Revolution of 1789 by transforming the plaster and lathe stage props of the Revolution into permanent monuments, albeit of glass, and with the end of his second *septennat*, perhaps to have finished off the Revolution itself.

Notes

1. Le Corbusier, "La Rue," *L'Intransigeant*, May 1929; republished in Le Corbusier, *Le Corbusier et Pierre Jeanneret: Oeuvre complète de 1910–1929* (Zurich, 1937), 112–15.
2. Jack Lang, in *Bibliothèque de France: Premiers Volumes* (Paris, 1989), 17.
3. Dominique Jamet, "Du vert dans la bibliothèque," in *Bibliothèque de France*, 23.
4. Ibid.
5. Ibid. Another supporter, Emile J. Biasini, secretary in charge of large-scale works, wrote, "Dominique Perrault has chosen in favor of an open, classical ensemble of clean simplicity and majestic elegance—a very French choice, in the sense once ascribed to that adjective." Ibid., 18.

6. Dominique Perrault, "Une Place pour Paris," in *Bibliothèque de France*, 110, 106.

7. Ibid., 104. 8. Ibid.

9. Jules Michelet, *Histoire de la Révolution française* (1847; reprint, Paris, 1979), 31.

10. Michel Foucault, *The Birth of the Clinic* (New York, 1973), 34.

11. Henri Labrouste, "A M. le Directeur de la Revue d'Architecture," *Revue générale de l'architecture et des travaux publics* 10 (1852): col. 382; cited in Neil Levine, "The Romantic Idea of Architectural Intelligibility: Henri Labrouste and the Neo-Grec," in Arthur Drexler, ed., *The Architecture of the Ecole des Beaux-Arts* (New York, 1977), 334 and 338. For a full discussion of Labrouste's proto-modern use of "transparency" and a detailed analysis of the two libraries in the context of romantic theories of architectural representation, see David Van Zanten, *Designing Paris* (Cambridge, Mass., 1987), esp. 83–98, 236–46.

12. Drexler, *Architecture of Ecole des Beaux-Arts*, 431; as recalled by Labrouste's architect friend A.-N.-L. Bailly in 1876. David Van Zanten, however, points out that the Pépinière in the Luxembourg Garden to which Labrouste referred was not demolished until 1866, and thus after the conception of the Bibliothèque as a garden; see *Designing Paris*, 243.

13. Walter Benjamin, *Das Passagenwerk*, in *Gesammelte Schriften*, vol. 5, ed. by Rolf Tiedemann (Frankfurt, 1982), 571.

14. Sigfried Giedion, *Space, Time, and Architecture: The Growth of a New Tradition* (Cambridge, Mass., 1941), 161–62.

15. Perrault, "Une Place pour Paris," 106.

16. Jamet, "Du vert dans la bibliothèque," 23.

17. Lang, 16.

18. Perrault, "Une Place pour Paris," 106.

19. Ibid., 110.

20. Victor Hugo, *Notre Dame de Paris* (Paris, 1831).

21. The preface to the eighth edition of *Notre Dame de Paris* was added by Hugo in 1832 in order to explain the insertion of three new chapters, including "Ceci tuera cela"; that is, those sections containing the most extended architectural-aesthetic arguments. His claim that they had been "mislaid" at the time of the first printing has been examined by Neil Levine, "The Book and the Building: Hugo's Theory of Architecture and Labrouste's Bibliothèque Ste.-Geneviève," in Robin Middleton, ed., *The Beaux-Arts and Nineteenth-Century French Architecture* (London, 1982). Levine provides convincing arguments to link Labrouste's and Hugo's architectural ideas.

22. Hugo, himself, had been concerned not to be misunderstood: both in *Notre Dame* and in his preface to the eighth edition of 1832, perhaps itself in response to Labrouste's comments on his text, he left an opening for the contemporary architect. But it was a possibility without false hopes or misplaced theoretical application. Modern architecture, "if it was to be revived again by accident," would have to recognize its changed cultural position and "submit to the law of literature."

23. That Labrouste understood the implications of *Notre Dame* is clear. The frontispiece that he designed for César Daly's *Revue générale de l'architecture et des travaux publics*, was set in the form of a tombstone; in the bas-relief across the center, the figure of the architect stands somewhat uncertainly beside a philosopher reading a book. The designer looks toward this reader, and away from the team of silent builders in the background. Philosopher, architect, and builders: architecture has been divided up into its component parts, listed above the bas-relief, and while specialists plan, according to the dictates of the programmatic text, craftsmen are transformed by this division of labor into laborers.

24. Henri Labrouste, in a letter to César Daly, *Revue générale de l'architecture et des travaux publics* 10 (1852): cols. 381–82; cited in Van Zanten, *Designing Paris*, 93.
25. Published in Etienne-Louis Boullée, *Architecture: Essai sur l'art*, ed. with notes by Pérouse de Montclos (Paris, 1968), 126–32.
26. Boullée, *Essai*, 130.
27. Dominique Perrault, "Une Place pour Paris," 110.
28. Rem Koolhaas, in *Bibliothèque de France*, 175–77.
29. François Chaslin, "Souvenirs de l'éclectisme," *Bibliothèque de France*, 91.

CONTRIBUTORS

R. HOWARD BLOCH is Professor of French at Columbia University. University of Chicago Press recently published his *Medieval Misogyny and the Invention of Western Romantic Love* (Chicago, 1992) and *God's Plagiarist: Being an Account of the Fabulous Industry and the Regular Commerce of the Abbé Migne* (Chicago, 1994).

CARLA HESSE is the author of *Publishing and Cultural Politics in Revolutionary Paris, 1789–1810* (California, 1991), and is now writing on legal aspects of the Terror in the French Revolution. She is Associate Professor of History at the University of California, Berkeley.

GEOFFREY NUNBERG is a researcher at the Xerox Palo Alto Research Center and a Consulting Associate Professor of Linguistics at Stanford University. He has worked on linguistic technology, semantics, and the history and use of written language. His publications include *The Pragmatics of Reference* and *The Linguistics of Punctuation.*

ROGER CHARTIER is Professor at the Ecole des hautes études en sciences sociales in Paris, Director of the Presidential Committee for the Bibliothèque de France, and General Editor of *Histoire de l'édition française.* He is the author of *Cultural History: Between Practices and Representations; L'Ordre du livre,* from which the present article is excerpted; it was published in English by Polity Press as *Order of Books* (1994).

JANE C. GINSBURG is Morton L. Janklow Professor of Literary and Artistic Property Law, Columbia University School of Law, and has written numerous articles on domestic and international copyright issues. She is also a member of the Association of American Universities' Task Force on Intellectual Property Rights in an Electronic Environment, but the views expressed here are her own.

DOMINIQUE JAMET was President and Chief Administrative Officer of the Etablissement public de la Bibliothèque de France; HÉLÈNE WAYSBORD served as its Chief Scientific Consultant; ALAIN GIFFARD and GÉRALD GRUNBERG are, respectively, Head of Informational Services and Head Librarian.

ROBERT C. BERRING is Professor of Law and Law Librarian at Boalt Hall School of Law, University of California, Berkeley. He has written numerous articles on information and on legal research. He is a former president of the American Association of Law Libraries and also served for three years as Dean of the School of Library and Information Studies at Berkeley.

EMMANUEL LE ROY LADURIE is Administrator of the Bibliothèque Nationale and Professor at the Collège de France. He is the author of numerous historical works, including *The Peasants of Languedoc, Montaillou*, and, most recently, a book on the Ancien Régime.

PROSSER GIFFORD is currently Director of Scholarly Programs at the Library of Congress. From 1980 through 1988 he served as Deputy Director of the Woodrow Wilson International Center for Scholars in Washington. His academic interest is the process of decolonization of Africa, India, and, most recently, in Eastern Europe.

CATHY SIMON is Design Partner for Simon Martin-Vegue Winkelstein Moris, architects of the new San Francisco Main Library in association with Pei Cobb Freed & Partners. Other current projects include the Newport Beach Central Library and the Lawrence Hall of Science Addition and Alterations at the University of California, Berkeley.

ANTHONY VIDLER is Chair of the Department of Art History at the University of California, Los Angeles, where he teaches architectural history and theory. His publications include *Claude-Nicolas Ledoux: Architecture and Social Reform at the End of the Ancien Régime* and *The Architectural Uncanny: Essays in the Modern Unhomely*, both from MIT Press.

ACKNOWLEDGMENTS

This volume grew out of a conference on "The Très Grande Bibliothèque and the Future of the Library" held at the University of California, Berkeley, and made possible by the Florence J. Gould Foundation, the French Consulate of San Francisco, and the Dean of International and Area Studies of the University of California, Berkeley. We would like to thank the conference participants, especially Caroline Eades, then cultural attaché in San Francisco, whose energy and finesse made possible a genuinely global dialogue. Thanks go as well to the editorial board of *Representations* for its critical engagement and commitment to a special issue of the journal and to Doris Kretschmer who oversaw its transformation into this book.

Compositor: Wilsted & Taylor
Text: Baskerville
Display: Baskerville
Printer: Malloy Lithographing, Inc.
Binder: John H. Dekker & Sons